WHITE-TIPPED ORANGE MASTS

WHITE-TIPPED ORANGE MASTS

The Gloucester Dragger Fleet That Is No More

PETER K. PRYBOT

THE
History
PRESS

Published by The History Press
Charleston, SC 29403
www.historypress.net

Front cover: In January, eerie sea smoke envelops the *Judith Lee Rose* while fishing for deep-sea lobsters off of Georges Bank. This sea smoke was created by arctic air riding over warm Gulf Stream water. Gus Doyle pauses to warm his hands.
Back cover: A winter scene of part of the 1970 Gloucester dragger fleet docked at the Rocky Neck Marine Railways. Notice the white-tipped orange masts on some of the boats. *Courtesy Peter Prybot.*

First published 1998
The History Press edition 2007

Manufactured in the United States

ISBN 978.1.59629.225.3

Library of Congress Cataloging-in-Publication Data

Prybot, Peter K.
White-tipped orange masts: The gloucester dragger fleet that is no more / Peter Prybot.
p. cm.
Includes index.
ISBN 978-1-59629-225-3 (alk. paper)
1. Fisheries--Massachusetts--Gloucester--History. 2. Fishers--Massachusetts--Gloucester--History. 3. Fishing boats--Massachusetts--Gloucester--History. 4. Gloucester (Mass.)--History.
I. Title.
SH222.M4P79 2007
338.3'727097445--dc22
2007009803

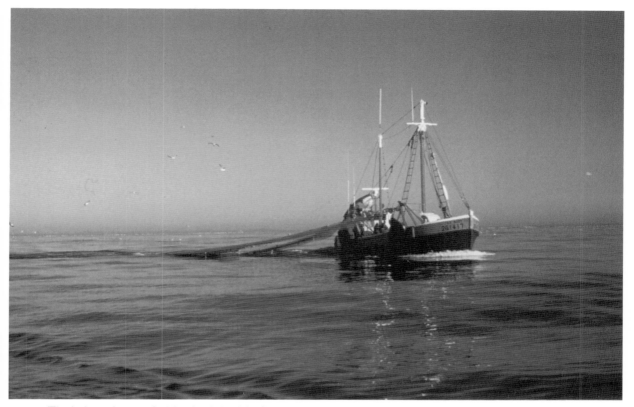

The inshore dragger *St. Mary* hauls back its fishing gear in Ipswich Bay.

CONTENTS

ACKNOWLEDGEMENTS

I dedicate this book first and foremost to my wife Anne and my son Tom. Both have put my life into focus. This book would never have happened without Anne's intelligence and her editorial, secretarial and computer skills. Tom, you have kept me young at heart.

My brother, John, and late parents, Eleanor T. and Roman J. Prybot, also deserve credit for this book. My mother and father gave me the big gift of life along with faith, compassion, appreciation, creativity and love of life. John is responsible for my deep love of nature.

I also dedicate this book to the city of Gloucester, its centuries-old fishing industry, and the fishermen and waterfront workers from 1970 to 1972—especially fishing captains and vessel owners Frank Rose Jr. of the *Judith Lee Rose*, Salvatore Ferrara and Salvatore Costanzo of the *Vincie & Josephine*, Phil Nicastro of the *Serafina N*, and Winthrop "Bunt" Davis of the *Carolyn Rene*. I am sad to say that all of these men, except for Ferrara and Costanzo, had passed away by 2006.

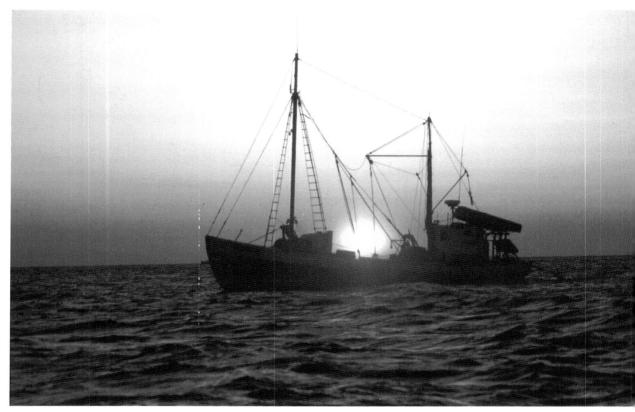

Sunrise in July catches the *St. Jude* fishing for whiting in Ipswich Bay.

INTRODUCTION

I majored in marine fisheries biology at the University of Massachusetts. The requirements included many zoology courses, including invertebrate zoology and ichthyology (the study of fish). Between 1969 and 1970, during my senior year, a marine fisheries biology course required a thesis on a fisheries-related subject chosen by the student. I planned an in-depth written and photographic study of the 1970 Gloucester dragger fleet centered on photographs of all of approximately ninety-five vessels and crews. I would interview captains to gather information about their targeted species and fishing grounds, their fishing likes and dislikes, boat and crew statistics and their views on the future of the industry. I would then analyze the data and draw conclusions.

As a student lobsterman who began lobstering out of Lane's Cove in Gloucester in 1960, I became familiar with the Gloucester waterfront, buying lobster bait at different fish plants. I soon fell in love with the waterfront and the fishing fleet there and became curious about them. My urge to take photographs emerged while I was a junior at UMass. I am the first generation lobsterman in my family. My father was a liturgical artist, and my mother was an architect before becoming a full-time mother.

The sea and the prospect of making Saturday shrimping trips aboard either the late Captain Bunt Davis' 31-foot dragger *Carolyn Rene* out of Pigeon Cove Harbor or the late Captain Phil Nicastro's 104-foot *Serafina N.* out of Gloucester lured me home on many college weekends. On the fishing grounds within twenty-five miles of Cape Ann, I got to see first-hand how draggers caught fish and shrimp, what species lived there, and what the inshore grounds were like. Besides taking pictures, I also collected unusual fish including shannys, alligator fish and American John Dories and preserved them in formaldehyde for the UMass zoology department's fish collection. "What are you collecting that junk for?" kidded puzzled fishermen.

Student idealism is great, but the reality of this study soon set in. The project required spending most of my spring semester weekend and vacation time on the waterfront photographing vessels coming and going. Crews' shots were usually taken

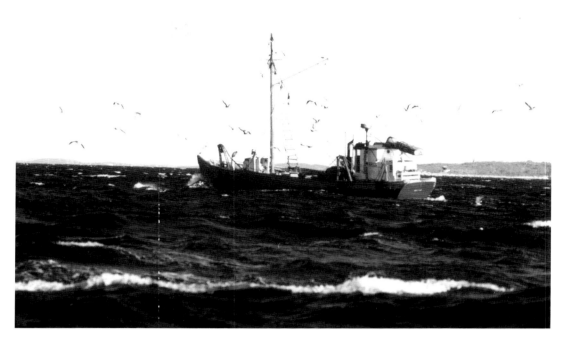

American Eagle drags its fishing gear on the bottom in Ipswich Bay for northern shrimp during the winter.

while their boats docked between trips. Most of the interviewing was also done then. Word spread quickly in the close-knit fishing community about this college kid's project. Most of the fishermen were very cooperative.

The project earned me an A. *National Fisherman*, a monthly fisheries trade journal, then published in Camden, Maine, even published this study's results later on, minus most of the photographs. This created a desire in me to write, although I have never taken either a writing or photography course. Many fishermen couldn't grasp the term paper concept; any kind of paper was a book in their minds. In the ensuing years, they kept asking me, "How's the book?"

After college, I wasn't ready to put the data into a book form. This would be a future project. The photos were stored alphabetically in folders, and their black-and-white negatives were placed and labeled in special negative sheets.

After graduating from college in 1970, I got a job as a lab technician at the University of Massachusetts Marine Station at Bay View, Massachusetts. For the first time in my life I worked from 8:30 a.m. to 5:00 p.m. five days a week. I also taught marine science in a special summer science enrichment program for elementary school children. I still lobstered after work and on weekends, and my love of the Gloucester waterfront and fleet continued.

A year and a half of the eight-to-five job was enough for me. The pull of the sea, a fascination with different fishing methods, and a desire to write, photograph and travel returned me to full-time lobstering where the time was mine. I was still a seasonal lobsterman then, and hauled my boat and traps out of the water in late October.

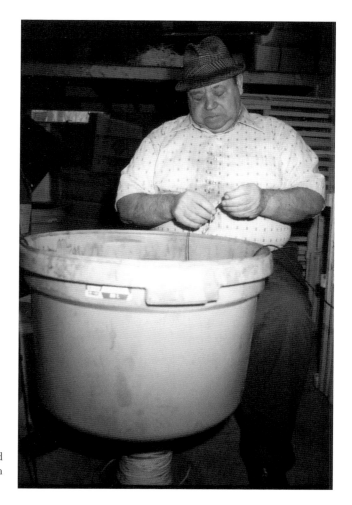

"Every dollar made offshore has a blood spot on it," said retired fisherman John Aiello—who speaks from experience.

Next, several offshore winter lobster dragging trips aboard Captain Frank Rose Jr.'s Gloucester dragger *Judith Lee Rose*, a pioneer in the offshore lobster fishery, afforded me the opportunity of a lifetime—to photograph and write about offshore fishing. One of those trips is described in Chapter 7. Riding out several fierce winter storms two hundred and fifty miles offshore made me fully comprehend why retired Gloucester fisherman John Aiello strongly felt, "Every dollar made offshore has a blood spot on it."

During the springs when my lobster business resumed, I often tub trawled, or longlined with baited hooks, out of my small fiberglass lobster boat in Ipswich Bay. I'll never forget one calm morning catching over one thousand pounds of fifty- to sixty-pound apiece "whale" cod "hook n' hook" (one fish hooked after another about nine feet apart on a long line). How exhilarating it was to hand haul the long line and feel fish fighting and see their bubbles rise and their white bellies below the surface. Another time I hooked some "bull" haddock, a large fish, off of Thacher's Island, Rockport, in February around 1975. The Boston fish price was $3.58 per pound for haddock that day.

I couldn't get enough of the ocean in those days. My love of both the Gloucester waterfront and the fishing industry grew as I continued to make almost daily drives there to take note of any changes.

During the early 1980s, winter wanderlust got me back on offshore fishing vessels, this time aboard Captain Salvatore Ferrara's and Salvatore Costanzo's ultra-modern stern trawler, the 105-foot *Vincie & Josephine*. The new dragger's fishing operation's ease and speed, as well as hydraulic net reels, winches, wire spools, new electronics and an 850 horsepower Caterpillar main engine awed me deep to the backbone. That January on the southeast part of Georges Bank, I witnessed several 30,000-pound codfish sets. The other offshore Gloucester draggers, *Mary Grace*, *Giacamo F.*, *Stella del Mare*, *Paul & Domenic*, *Taormina B.*, *Andromeda*, and *Vito C.* fished close by, often within shouting distance.

Another trip right after New Year's Day, the *Vincie & Josephine* towed its net on the hard bottom one hundred fathoms down on the northeast peak of Georges Bank (which now belongs to Canada) for cod and haddock. The Boston stern trawlers *Tremont* and *Old Colony*, with their lime-green hulls and white towering gantries, and the maroon-hulled, semi-eastern-rigged stern trawler *Powhatan* from Portland, Maine, also dragged close by while yawing feverishly in the big swells of a recent northeaster. The strong tides going into the seas made the swells even bigger. The fishing photos, memories and written accounts piled up.

Gloucester's three hundred and seventy-fifth anniversary in 1998 prompted me to finally put all of my data into book form. By now I had already been married for sixteen years to a Gloucester girl, Anne Medico, the daughter of a Portuguese former fisherman who later worked for the National Marine Fisheries Service. My son, Tom, was born in 1989. I did the photography and writing for this book, but Anne did the equally important typing and computer work. Little did I know in 1970 that this project captured the beginning of the end of the eastern-rig side trawler fleet in Gloucester. I extended the fleet survey period to 1972 in the book.

A cloud of pessimism enshrouded the Gloucester fishermen then. They worried about foreign fleets working off the Northeast, especially on Georges Bank. They also worried about declining groundfish stocks (namely haddock), Canadian fish exports deflating local prices, apparent federal government apathy toward the industry, and rising insurance and operating costs. The fishermen's observations and colorful quotes that follow not only tell of those worries, but also of the pros and cons of their industry and what they believe the future holds for it.

First, the worry over foreign fleets. According to National Marine Fisheries Service statistics, "In 1970 between 900 and 1,000 foreign vessels operated off the east coast of the United States between Nova Scotia and Cape Hatteras." These vessels came from approximately twenty-six different countries, including East and West Germany, Russia and Poland. These 200-foot-long side trawlers and 270-foot-long factory stern trawlers and even 550-foot-long mother ships first arrived here during the early 1960s and their arrivals had increased steadily by the mid-1970s. These trawlers often "pulse fished," or concentrated their fishing efforts close together, whenever fish were found. They sought groundfish like cod, haddock and flounder

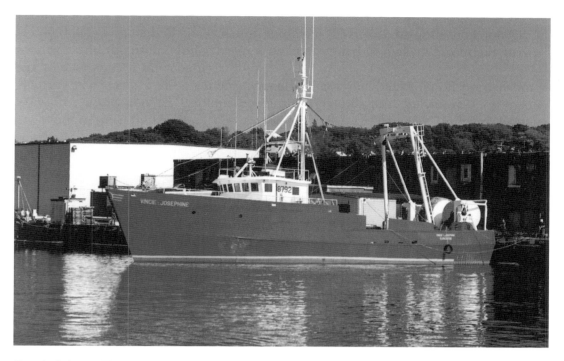

Captain Salvatore Ferrara and Salvatore Costanzo's modern 105-foot *Vincie & Josephine.*

The Boston stern trawler, *Old Colony*, ground fishes on the northeast peak of Georges Bank in January of 1983.

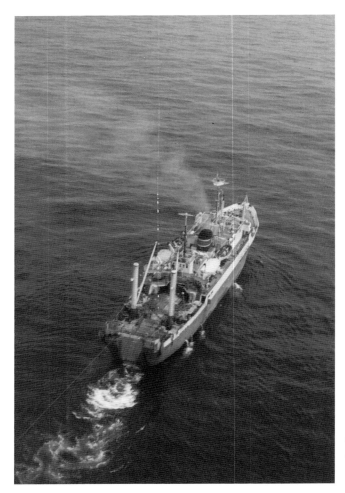

This 270-foot Russian factory stern trawler was mid-water trawling for herring on Georges Bank around 1973.

and also small pelagic fish like mackerel and herring. The Gloucester fishermen called all foreign boats "the Russians."

Charles Philbrook, an enforcement agent for the National Marine Fisheries Service in Gloucester, arranged for me to take a six-hour, co-sponsored NMFS/U.S. Coast Guard "foreign fleet fisheries surveillance flight" aboard a twin-engine prop plane—dubbed "the whistling trash can or flying goat" by the Coast Guardsmen. After taking off from Otis Air Force Base (since renamed Air Station Cape Cod) on Cape Cod that June day in 1974, the crew of the low-flying craft spotted (despite some fogginess) approximately seventy foreign vessels ranging from factory stern trawlers to side trawlers and even one Russian mother ship. On many of the decks, curious crewmen could be seen looking up at the plane. Russian trawlers' red smoke stacks emblazoned with yellow hammers and sickles could also be seen from up above.

In November of 1972, while a guest aboard the *Judith Lee Rose*, I witnessed one humorous foreign trawler encounter. The dragger was fishing for yellowtail

flounder on "the leg," or southeast part of Georges Bank. Captain Frank Rose Jr. stared out of his pilothouse door through binoculars at a huge Russian factory stern trawler fishing for herring just south of him in the deeper water. Lo and behold, that ship's inquisitive Russian captain was looking right back at the *Judith Lee Rose* from his wheelhouse.

After listening to Portuguese, Russians, Italians, Germans, Poles, Spaniards and Canadians communicate over their ship-to-ship radios during that trip, I realized what a melting pot Georges Bank was then.

The Gloucester men held strong beliefs about the foreign fishing vessels. Captain Antonio Genovese of the *Santa Maria* said:

> *The foreign vessels are not only slowly destroying the fishing industry, but are also endangering our lives. They don't seem to give a damn for us, especially in the fog; I've already had several near collisions with them in the fog. These boats use nets with the smallest mesh size possible. I know this because we have dragged up many lost foreign nets. You can't even stick your tiny finger through their small netting; young fish don't have a chance with them.*

> *The foreign fleets are killing our industry. Our boats are no contest to theirs: we look like boys standing up against men. The North Atlantic was one of the richest oceans in the world. Now it's getting to be one of the worst.*
> ~*Leonard & Nancy* engineer and owner Sal Ferrigno

> *In many cases we can't even work in our favorite fishing spots because of all the foreign boats. If there's a problem, we can't even communicate their language over the radio.*
> ~Salvatore Lovasco, skipper of the *Holy Cross*

> *The foreign fishing situation off our shores is pathetic. It's hard to believe that these boats are allowed to fish here.*
> ~Captain Don Sutherland of the *Cape May*

> *I loved fishing eight years ago; now I hate it because of the foreign boats. They have ruined the haddock fishery. Now the haddock is like the halibut; if you catch one, you frame it.*
> ~*Lady In Blue* skipper Sam Frontierro

> *The U.S. fishermen are often harassed and pushed out of their conventional fishing grounds by the many foreign vessels. These trawlers are cleaning up the feed fish, too, including whiting and herring, which cod, haddock and pollock depend on.*
> ~ Captain Vince Ciarametaro of the *Baby Rose*

> *There are two possible solutions for conserving and increasing the declining groundfish populations: one is for the U.S. Government to extend its territorial waters out to 200 miles, and the other is to ban mid-water trawlers. The foreign vessels' mid-water*

trawls scoop up everything including baby fish. Even if Gloucester had five times its present fleet, it could not do half the fish damage that the foreign vessels are doing.
~Captain Thomas Parisi of the *St. Nicholas*

Ironically, Gil Roderick, the cook on the *Joseph & Lucia III*, felt that foreign fishing vessels actually helped the Gloucester fishermen indirectly by depleting the supplies of fish in Massachusetts and driving up the prices for them. "We started to get some money for our fish when the foreign fleets were off our coast," recalled Roderick.

Fishermen had a number of concerns about rising operating costs, especially that of insurance.

Yearly insurance costs are murdering us. It costs me $12,000 a year to insure [the approximately 92' long] Our Lady of Fatima. *On the average, operating costs for a large boat this size amount to approximately $60,000 a year.*
~Captain Cecilio J. Cecilio of the *Our Lady of Fatima*

Annual maintenance costs for a large size wooden dragger like the 82-foot Mother Grace *are out of this world; they total up to about $65,000 a year. Insurance alone costs $18,000. The food, ice and fuel add up to about $2,000 for each eight-to-nine-day-long fishing trip. Recently, the boat was tied up for three months for an overhaul. That bill amounted to $45,000.*
~Captain Sebastian "Busty" Moceri

The yearly hauling, painting and light maintenance work bill just added up to $4,000, while regular boat upkeep costs around $12,000. Running expenses [food, fuel and ice] *for each six-to seven-day-long trip add up to about $1,500.*
~Sal Ferrigno, engineer and skipper of the approximately 75-foot long *Leonard & Nancy*

The fishermen also felt that the government largely ignored their concerns.

As fishermen we feel that Washington would have one less headache without the fishing industry.
~Captain Joe Novello of the *Vincie N.*

The federal government is selling us down the river; we are the lowest man on their totem pole.
~Captain Joe Parisi, captain of the *Gaetano S.*

All we want from our government is fishing ground protection.
~Gus Sanfilippo, skipper of the *Theresa R.*

The Gloucester fishermen also explained unusual parameters of their livelihood.

Fishing is the cleanest life; it's continuous, rugged and often monotonous. In contrast to people working ashore, we do not work with the clock. You're finished when the job is done. With fishing, a person is always working.
 ~Captain Joe Novello of the *Vincie N.*

Fishing is quite a life. We are twice at sea and only once at home. Once the boat's lines have been cast off, we are out to get a good trip.
 ~Cecilio J. Cecilio

When we're making money, everything is good. But nothing is good—the boat—the captain—the cook—when you're not making money.
 ~Sal Ferrigno

It seems as though no sooner am I laying my head on my home pillow, than am I sleeping again on my boat bunk pillow.
 ~William Russell, a crewman on the *Our Lady of Fatima*

This is our living; we have to take the good with the bad.
 ~Rosario "Salvi" Testaverde, the skipper of the *Linda B.*

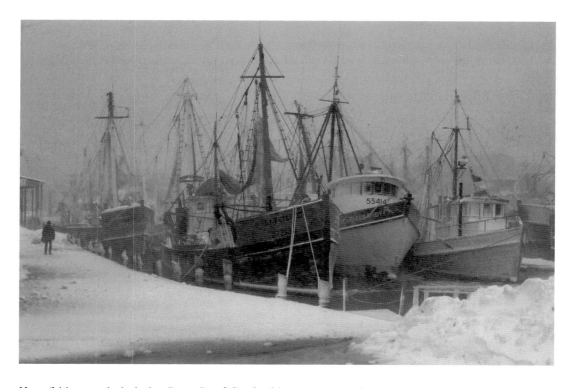

Here, fishing vessels docked at Seven Seas Wharf safely ride out the infamous Blizzard of 1978.

Nowadays, the only good things left about fishing are plenty of fresh air, good food and coming home after a trip.
~Owner and skipper of the *Ida & Joseph*, Joseph Calomo

Fishing is a lousy life. The engine's crankshaft went last May while fishing off of Seal Island [Nova Scotia], and I ended up buying a new engine for $120,000. At first, the banks wouldn't give me a loan, so I had to go to the government. I wasted a full year with all the red tape.
~Captain Salvatore Lovasco

Fishing is for the birds. When the weather is fine, everyone likes it. But, when the wind is blowing and the air is cold, no one likes it. If we got paid a dollar for every hour we worked, we would all be millionaires. I followed my father's footsteps into the business. Fishing is my livelihood. I would never go into it again if I had it to do all over again.
~Joe Parisi

Making money is the best thing about fishing. The way things have been going lately, I no longer know what that looks like.
~Captain James "Spaba" Bertolino of the *Clinton*

The best part about fishing is coming home and settling up. Out there a person has to work for his money. Bad weather is something you learn to accept; the weather is always a challenge. In my heart, I actually enjoy riding out storms.
~Captain Don Sutherland

What I like best about fishing is eating haddock chowder, coming home after a hard day out fishing, and relaxing.
~Jim Madruga, owner and skipper of the *Belinda II*

I like the adventure of going out fishing. Every trip is different: one day you're running against the fog; the next day you're avoiding foreign fishing boats. You are always thinking of ways to get around the adversities. Fishing is such a change of pace from living ashore.
~Chris Cecilio, captain of the *Beatrice & Ida*

If a stranger came aboard and made a couple of offshore trips, he would either jump overboard or go crazy. My father's father was a fisherman; my father brought me up to fishing; we are used to this lifestyle. At times fishing is miserable. We are often out during holidays and in every type of weather, but that's part of this business. If things get tough, fishermen will always be able to catch enough fish to eat, then we would only have to worry about buying bread.
~Captain Santo Mineo of the *Antonina*

I have fished for thirty-five years, and I'm in the same place and position that I was thirty-five years ago. Just take a look at the Gloucester fishing vessels; most are ready to sink.
 ~Captain Sam Orlando of the *St. Bernadette*

Fishing is our livelihood; we have no other trade. We are carrying on our fathers' trades. Fishing is one of the few businesses that a person can work all day and still lose money. If I ever had to start all over again, I would never go fishing.
 ~Tom Randazza, skipper of the *Peppy*

Fishing used to be a lot of fun. Now that spirit has vanished. The fish are gone, and we would be starving without the few shrimp around.
 ~Captain Anthony Linquata of the *Natalie III*

I was born into fishing. I love it and would never change this occupation.
 ~Charles Frontiero, captain of the *Njorth*

What we like most about fishing is coming home and settling up and staying in as long as possible.
 ~*Curlew* skipper, the late Dominic Montagnino

The fishermen made these future predictions about their industry:

Rising prices will continue to make up for dwindling fish landings. In six years the wholesale haddock price will be $1.50 per pound. Despite the heavy fishing pressure, the fish will never be cleaned out of the ocean.
 ~Captain Chris Cecilio

Twenty-five years from now, the offshore fishing fleet will cease to exist. Inshore boats will be the only survivors in Gloucester.
 ~Captain Carlo Moceri of the *Holy Family*

If the foreign fleets are still fishing off our coasts, fishing will be a dream for some and a thing of the past for others within the next five years. In the future, there will be one-to-two-man crew boats having low overheads; prices will be sky-high, and the species few.
 ~Captain Joe Novello

In a few years we will have to take down the mast rigging and go long-lining and party boating. The fish are practically gone now and are getting scarcer.
 ~Captain Rosario "Salvi" Testaverde

We should have followed the footsteps of the old-time tub trawlers. Present day fishing gear is too efficient. Many spawn fish are netted before having a chance to drop their eggs. If this continues, there will be very few fish left.
 ~The late Captain Sebastian "Busty" Scola of the *St. Peter*

Under present lines fishing will become a curiosity; it will fall with the haddock into extinction.
 ~Tom Aiello, skipper of the *St. Providenza*

I don't believe the fishing industry will die; instead, there will be fewer fish landed, and higher prices paid for the goods.
 ~Captain of the *Sea Buddy*, Anthony Pallazola

Despite those fishermen's concerns, Gloucester Harbor teemed with activities. Its heartbeat was still strong between 1970 and 1972. The 95-vessel fleet was divided into inshore, mid-shore and offshore components. There was very little of the big Portuguese fleet of the 1930s and 1940s left. Most of the early 1970s fleet was owned and operated by Italian fishermen. Vessels arrived and departed just about all hours of the day.

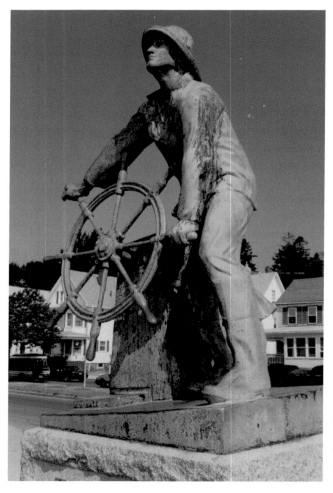

The famous Man at the Wheel statue along Stacey Boulevard stands vigilant of vessels coming and going from Gloucester Harbor.

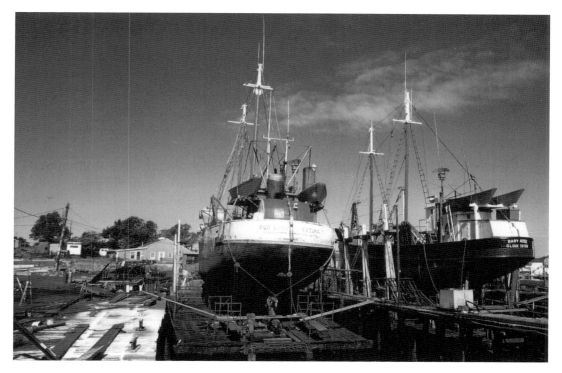

The *Our Lady of Fatima* and *Baby Rose* are dry-docked at Rocky Neck Marine Railways for annual painting and any needed repairs.

The fleet created work for many businesses, as well as for the individuals who offloaded and marketed its catches and maintained or resupplied the fleet. Rocky Neck Marine Railways along with its branch at Harbor Loop always had fishing vessels dry-docked for structural repairs and annual painting. Jimmy Nugent, Parisi Plastic Fishing Company, Westerbeke Fishing Gear Company and Gloucester Grocery and Supply Company took care of the fleet's fishing gear needs, ranging from cables to nets. Nelson's kept the fishermen warm and dry with their outerwear and clothing. Vessels took on crushed ice and fresh water at Cape Pond Ice Company and at the Rocky Neck Marine Railways ice plant at Harbor Loop. The oil boat, *Captain Dave*, run by Tom Glenn Sr., and later Tony Rose, refilled the fuel tanks of many of the docked vessels along the harbor. Diesel mechanics—Ray Chandanais, the Caterpillar diesel man; Buzzy Parisi, the Detroit diesel man; and Ozzie Hammond, the all-around diesel man—kept the fleet's engines running, while welders John Bennett, Roy Coull and John Love made metal repairs and additions aboard the vessels. Independent Machine Company straightened out many of the bent shafts, and rebuilt pumps, motors and winches. Gorman Refrigeration Company kept much of the fleet's refrigerators going. Ron Gilson insured most of the fleet then.

The vessels berthed at a number of big wharfs along Gloucester Harbor, like Felicia Oil Company Wharf, Frontierro Brothers, Inc., Wharf, Fishermen's Wharf,

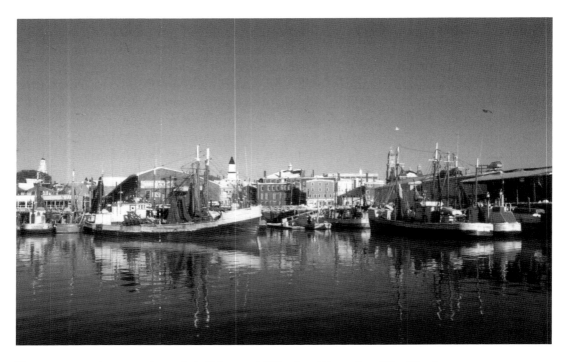

Draggers rest up between trips at their Fishermen's Wharf and Seven Seas Wharf berths.

Seven Seas Wharf, Star Fisheries Wharf, State Fish Pier and Rocky Neck Marine Railways. The fishermen usually bought lube oil, fuel and filters from the owners of the wharves. The fleet supplied a number of fish companies and processors, including Atlantic Seafood Company, Empire Fish Company, Ocean Crest Seafoods, Oceanside Fisheries, Fabet Fish Company, Star Fisheries Wharf, Producers' Fish Co., American Fillet Corp., John B. Wright Fish Company, and Capt. Joe & Sons, with raw product.

The vessels also provided work for lumpers, or longshoremen, to unload their catches. Lumpers like George Ingersol, Matt Cooney, Mel Mason, Paddy Bryan had their particular vessels which they took care of. J&P Trucking even trucked boxed fish out of Gloucester to Fulton Fish Market.

The waterfront was like one big family. Everybody knew one another. The fishermen's children played with one another. Later on, many of these kids married one another, and their children play with one another, continuing the cycle. "Walking down the street, you would easily say 'Hi' to ten people you knew," explained Antonino "Tony" Sanfilippo, a crewman on the *Maria G.S.*

The Gloucester fishermen desperately needed a collective voice to make their concerns—especially their displeasure of the foreign fleets working off the coast—known to the federal government during the early 1970s. Historically, most fishermen were doers, not public speakers. Many spoke in broken English and lacked public speaking skills. Fishermen were naturally good at speaking "fish talk," their universal language, to their families and especially to their fellow fishermen. The

fishermen's demanding occupation also didn't leave them either the extra time or energy to attend meetings and give speeches.

But, a group of Gloucester fishermen's wives soon got together and became the voice of the Gloucester fishermen. The original organization, The United Fishermen's Wives Association, was formed in 1969 by Action, Inc., in Gloucester, community organizers Carmine Gorga and Grace Parsons, along with about fifty Gloucester women and the leaders of a fishermen's wives organization in New Bedford, Massachusetts. "The major focus of the organization was political action at local, state, regional and federal levels to make officials aware of the economic difficulties confronting the fishermen." (*Managing Uncertainty in Gloucester, Mass.*, by Margaret Elwyn Clark). The local organization reorganized in 1976 as the Gloucester Fishermen's Wives Association (GFWA). Two of the most famous members and colorful speakers are Angela Sanfilippo and Lena Novello.

The Association's accomplishments over the years have been impressive. According to the GFWA leaflet, they have "Promoted enactment and reauthorization of the

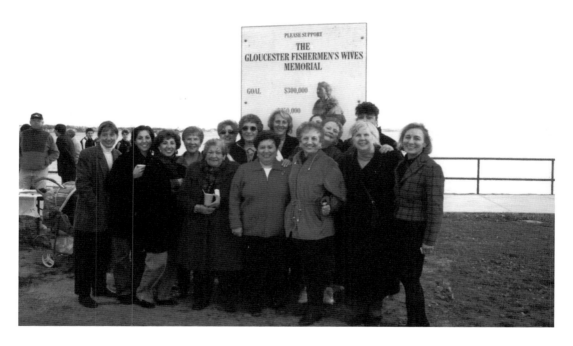

People associated with the Gloucester Fishermen's Wives Memorial pose at the site during the groundbreaking ceremony in 2000. From left to right are sculptor Morgan Faulds-Pike, GFWA members Maria (Groppo) Carpenter, Nina Groppo, Rosalie LoIachino, Lena Novello, Treasurer Rossalie Vitale, Grace Favazza, Mary Brancaleone, Connie Condon, Vice-President Sefatia Romeo, President Angela Sanfilippo, Geri Lovasco and Betty Knott and landscape architect Ann Johnson. Missing are GFWA members of the board Mary Favazza, Mary Ann Perry, Serafina Ferrara, Rochelle McManus-Genovese, Mary Jo Montagnino, Lilla Sanfilippo, Catherine Wallius, Jeanne Gallo, Josephine Russo, Josephine Taormina and Clerk Vincie Bertolino.

Magnuson-Stevens Fisheries Conservation & Management Act which extended the fisheries jurisdiction of the U.S. to two hundred miles off its coasts; successfully fought oil drilling on Georges Bank; advocated new laws to stop ocean dumping; promoted underutilized species by developing new gourmet recipes for lesser-known species of fish; supported establishment of the Stellwagen Bank Marine Sanctuary; and published *The Taste of Gloucester* cookbook [over 100,000 copies sold] to promote all species." The group later helped set up an affordable health insurance plan for the fishermen and fulfilled a longtime dream of building a fishermen's wives memorial along the Stacey Boulevard overlooking Gloucester Harbor in 2001, and even published a second book, *The Gloucester Fishermen's Wives Cook Book*, written by Susan Pollack in 2006. The Gloucester Fishermen's Wives Memorial was dedicated in August of 2001. I'm sad to report that Lena Novello passed away in 2004.

Dive back in time. Read about and look at the 1970 fishing fleet and its fishermen, the eastern rig side trawler, fishing method, sought-after species and fishing grounds. Imagine yourself making a day trip to fish for northern shrimp during the winter off Cape Ann and even an offshore, over ten-day-long trip to harvest lobsters from one thousand feet down, two hundred miles from Gloucester. Find out what happened to that fleet and which way the Gloucester fleet of 2006 is headed. You will be surprised.

Finally, thirty years later, came "the book," largely told by the fishermen themselves through the eyes, ears and camera lens of this fisherman. Now in 2007, here is the second edition of "the book," thanks to popular demand from the fishing community. Both editions are my tribute to the beautiful city of Gloucester and its fishing industry.

CHAPTER 1
THE EASTERN-RIGGED SIDE TRAWLER

The eastern-rigged side trawler—which began showing up in the Gloucester fleet in the 1920s and 1930s and gradually replaced the famed Gloucester dory schooner and its tub-trawling fishing method—had proven itself by 1970 as the big producer of the fleet. These deep-draft, motorized vessels with different dimensions, ages and hull designs were all controlled from rear-positioned pilothouses, and their gear was all worked from the side.

In essence a floating company and hotel, the side trawler, or dragger, was built to get the fishermen out to the grounds and back to port; provide livelihoods, living quarters and working platforms; withstand the northwest Atlantic's many moods; scoop up fish and shellfish off of the bottom; and store and carry catches—usually tons of iced-down fish. They bore beautiful names, often in tribute to saints, places, seabirds and creatures, and females, especially daughters, in fishing families. Specific statistics on the fleet, including the average age of crew members, are provided in Chapter 5.

Most of the vessels in the 1970 to 1972 fleet were built out of wood, the rest out of steel at shipyards primarily in Maine and Massachusetts, including right in Gloucester and in nearby Essex and Ipswich. Dana Story, a retired, renowned boat builder and shipyard owner from Essex, Massachusetts, built or helped build ten large (85 feet long or longer) draggers, including the *Holy Family*, *Kingfisher* and *Julie Ann*, and knows very well the rugged construction of the many wooden draggers that were put together in the 1940s. "Their hulls were made from 2 ¾-inch-thick oak planking fastened to 12-inch-square double-sawn oak frames, placed every two feet on center, by 5-inch-long, 3/8-inch-thick galvanized spikes and also 1 1/8-inch-thick locust treenails. Their decks were made from 2 ¾-inch-thick by 4 ¾-inch-wide native white pine planking," Story recalled. He estimates one of these large draggers cost about one hundred thousand dollars to complete in the 1940s.

These draggers needed to be constantly worked to prevent fresh water from rotting the top sides of idled wooden vessels. They also had to be maintained each year with a fresh coat of paint, new zincs on the hull, oil changes and grease

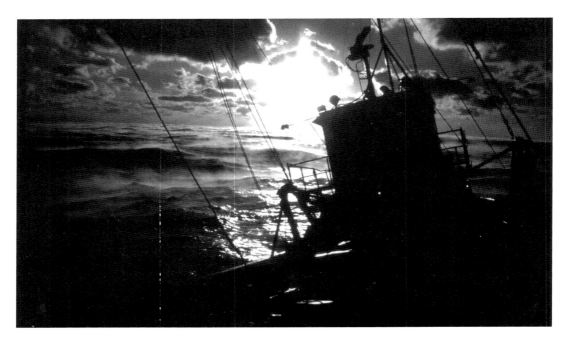

In January, eerie sea smoke envelops the *Judith Lee Rose* while fishing for deep-sea lobsters off of Georges Bank. This sea smoke was created by arctic air riding over warm Gulf Stream water.

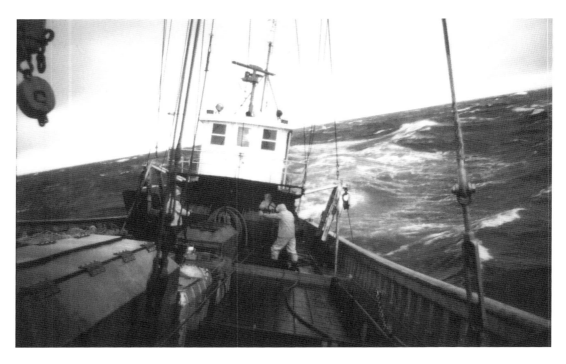

The *Judith Lee Rose* crew hauls back their fishing gear during a 40 mile per hour southeaster on Corsair Canyon, 250 miles from Cape Ann, in January.

lubrications, occasional bearing and pump replacements, shaft and propeller reconditionings and even engine overhauls.

Preventative maintenance offered the best and most inexpensive insurance policy against costly downtime and, above all, personal injury and even loss of life.

After the 1950s, wood became scarcer and more expensive and steel became the boat-building material of choice. In 2006, very few fishing vessels of any type were built out of wood.

The Gloucester draggers behaved differently on the ocean. Some were "good sea boats," going into the wind and waves, especially with a load of fish aboard, but "wet," or taking on water on deck from the boat's rolling action, laying to them. The 105-foot-long *St. George* had a lofty, broad bow with a nice flare, but low sides near its heavy pilothouse. Waves often crashed aboard there as the crew worked the fishing gear from the side, and the vessel drifted sideways. The crew wore hip boots rather than knee-high boots to help stay dry on deck.

Other vessels, like the 104-foot-long high-bowed and -sided *Judith Lee Rose*, were "dry boats" going into and laying sideways to the elements. On the other hand, the *Antonina*, a seventy-footer with a real round bottom, was notorious in Gloucester for rolling even in calm conditions.

Mother Nature regularly tested the draggers' seaworthiness throughout the year. I was aboard the *Judith Lee Rose* for one such challenge in February of 1972. The vessel had just finished fishing for deep-sea lobsters in Corsair Canyon about two hundred and fifty miles southeast of Cape Ann, when a severe arctic cold front, packing 70 mile per hour winds out of the northwest arrived and forced her to head to port—in this case, Newport, Rhode Island. This port then offered top prices for lobster. The normal travel time to Newport took about twenty-five hours.

The *Judith Lee Rose* soon found herself slogging ahead at just five knots directly into a seemingly endless mountain range of twenty- to twenty-five-foot-high silvery-white, frothing waves. As the bow repeatedly rose up and crashed down, I remember saying to myself, while looking yonder at the mountain range from the pilothouse, "This is serious. If one thing goes wrong, we're done." I can also recall the vessel's captain, Frank Rose Jr. and a crewman, Gus Doyle, telling me: "Don't worry; we're in our backyard." This same vessel had bucked into storm-force winds out of the northwest and their mountainous waves four or more straight days many times during her thousand-mile-long return trip from the Grand Banks during her redfishing days in the 1950s and 1960s. Then, she also iced up due to freezing spray many times, and her crew often had to go out on deck and break off the ice with wooden mallets.

During my trip, when the *Judith Lee Rose* was about seventy-five miles from land, spray began freezing on rigging, pilothouse, and deck. So close to land, the ocean's warming effect had diminished. Her rolling and pitching movements soon slowed down as she only took on more ice getting closer to port. But, the crew did not feel the need to "break ice." An "iced-up" *Judith Lee Rose* finally arrived in Newport fifty hours later at 2 a.m. The air temperature was only eight degrees, and the winds were still storm force. The ice around her lower mast rigging had built up to a two-foot diameter.

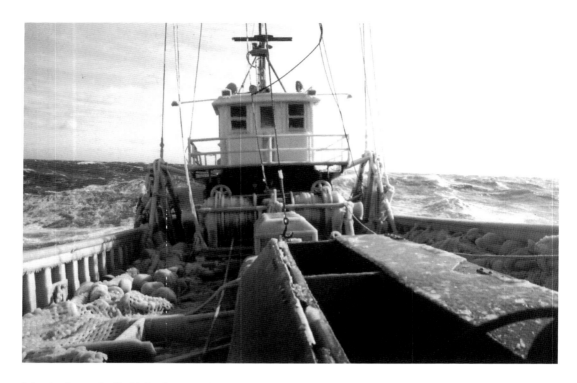

Icing begins as the *Judith Lee Rose* slogs into 15- to 20-foot waves, powered by a severe arctic cold front's 70 mile per hour winds out of the northwest.

By 1970 high-speed diesels with transmissions had largely replaced the direct-drive, heavy-duty diesels bearing such brand names as Cooper-Bessemer, Atlas Imperial, Fairbanks-Morse, and Enterprise, which largely powered the fleet built prior to the mid-1950s. The heavy-duty diesels, which only turned over about 375 revolutions per minute and produced from 200 to 625 horsepower, took the place of the steam engine.

Curious about what a heavy-duty diesel looked like, I remember going into the 95-foot-long *Curlew*'s engine room one Saturday in 1970, expecting to see an automobile-size engine. I left amazed after viewing and standing alongside its approximately 25-foot-long by 6-foot-high and 3-foot-wide, 400 horsepower, 6-cylinder Atlas Imperial diesel.

The new diesels, primarily made by Caterpillar, Cummins and General Motors, had transmissions and could be controlled from the pilothouses. Most turned over around 2,000 rpm, producing anywhere from roughly 150 to over 1,000 horsepower. More horsepower was needed to tow the fishing gear faster and also to tow larger gear. "Horsepower catches fish," reasoned the fishermen.

Most of the eastern-rig side trawlers of the 1970 to 1972 fleet had at least six subsections—the fo'c'stle, open deck, break, fish hold, pilothouse and engine room. The majority of the larger vessels also had a whaleback, lazarette and turtleback. Draggers that lacked whalebacks were called "open boats." Most of the larger

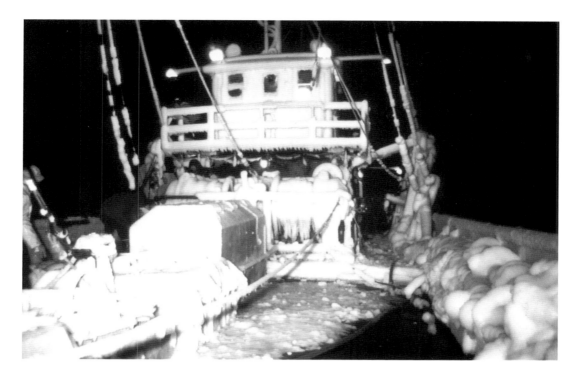

Fifty hours later, the "iced-up" trawler arrived in Newport, Rhode Island at 2:00 a.m. under a star-clustered sky with the temperature at just eight degrees Fahrenheit.

vessels were "double rigged," having a set of forward and aft gallous frames on both the starboard and port sides. Smaller boats usually had one set of gallous frames on the starboard side.

Daryl Richter, an artistic graduate student at the University of Massachusetts Marine Station at the same time I briefly worked there, drew me the sketch of the *Joseph & Lucia II* to illustrate all nine subsections. These subsections are described, moving from front to back, in the rest of this chapter.

THE WHALEBACK—This additional, covered bow tier not only added height to the bow but also sheltered the open deck from head-on wind and waves and reduced the impact of waves breaking over the bow. But, rogue waves have occasionally broken over the bows of large draggers with whalebacks, flooded their decks and punched out the pilothouse windows. The 95-foot-long *Cape May*, a lobster dragger out of Gloucester, had one such wave do that and more while pounding home against storm-force northwesterly winds one January in the 1970s. That wave even short-circuited the navigational electronics in the pilothouse and cut its captain, Don Sutherland's, face there with glass shards as he slept in his bunk. The *Cape May* limped back to port by compass after its shaken crew stuffed the broken window frames with mattresses.

31

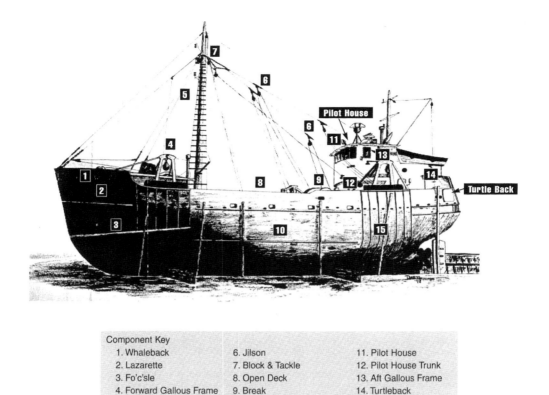

Component Key		
1. Whaleback	6. Jilson	11. Pilot House
2. Lazarette	7. Block & Tackle	12. Pilot House Trunk
3. Fo'c'sle	8. Open Deck	13. Aft Gallous Frame
4. Forward Gallous Frame	9. Break	14. Turtleback
5. Mast	10. Fish Hold	15. Engine Room

The eastern-rigged side trawler. *Diagram by Daryl Richter.*

THE LAZARETTE—The lazarette provided storage for fishing gear like netting, twines, ropes, floats, cables and chains under the whaleback. Crewmen accessed the lazarette from the open deck.

THE FO'C'STLE—This subsection, located in the forward quarter of the vessel below deck, provided the main living, food storage and food preparation area. This was the fishermen's home away from home. The fo'c'stle was equipped with tiered bunks, a galley table, a sink, refrigerator and cabinets, as well as that big, important oil stove used for heat and cooking. Snacks and plenty of hot coffee were always available in the fo'c'stle. Crewmen entered the fo'c'stle from a hook-like "doghouse" on deck. From here they climbed down a nearly vertical ladder to get to the fo'c'stle floor. Waves have occasionally crashed over a vessel's stern, flooded its deck and sent seawater running into the doghouse and down the fo'c'stle. After working long hours on deck in the pitch dark, wee hours of a bitter cold January morning and getting chilled to the bone, a warm fo'c'stle, a hot meal and drink and a cozy bunk meant everything in the world to those crew members. Fishermen sometimes had to brace

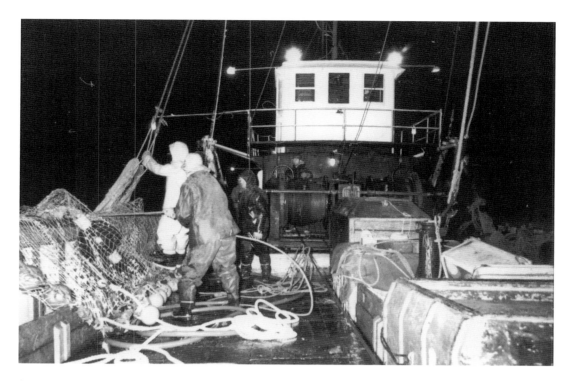

Shown here is the open deck—the amidships, penned off, tiled main working area where the net and doors were "set out" and "hauled back" and the catches were hauled aboard, emptied, "dressed," washed, and lowered into the fish hold.

themselves in their bunks or risk getting tossed out of them. I remember doing that as the *Judith Lee Rose* rode out a northeaster with winds gusting to 60 miles per hour and twenty-five-foot waves on Georges Bank. The vessel's huge bow repeatedly rose and then paused momentarily before suddenly crashing down and shuddering.

THE OPEN DECK—The open deck was the main work area where the fishing gear was set out, hauled back, emptied and repaired and the catch was sorted, cleaned and lowered or tossed into the fish hold below. Much of the open deck was penned off into grids by oak boards and its surface was tiled for good footing. The area had a number of deck plates, which were periodically opened to fill their underlying pens with ice in port or fish at sea. The middle of the open deck also carried the load of one or two masts. Guide wires further steadied the spars, which were mainly used for lifting fishing gear and catches. The crew thoroughly washed down the open deck every time after the catch had been cleared off and stored below. This water—along with any trash fish and viscera—exited the deck through a series of scuppers.

THE BREAK—The break was the raised part of the open deck directly in front of the pilothouse trunk. The main trawl winch was mounted on the break.

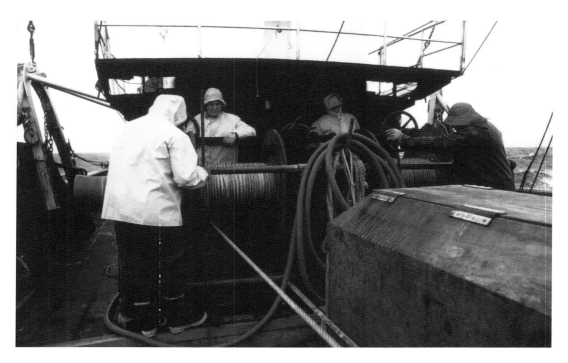

Here is the break—the area just forward of the wheelhouse trunk, where the trawl winches were mounted.

THE FISH HOLD—The catch was stored in the large fish hold area directly below much of the open deck. The hold was further divided into pens. One or two of the crewmen, usually a newcomer, doubled as the "hold man." "Hold men" accessed the hold by entering a hatchway on deck and climbing down a steep aluminum ladder. The hold men iced down and stored the catches, which were lowered in baskets, thrown down to them through the hatchways or dumped below through the deck plates, according to species and size into different pens. As a particular pen filled, the hold men added pen boards to increase its size. Lobster draggers flooded their lower fish holds with circulating seawater to keep their crustacean catch alive at sea. Many fishing boats only out for the day stored their iced-down catch on deck in boxes and covered it with a large canvas. Most small draggers could carry fifty to one hundred thousand pounds of catch in their holds, while vessels over ninety feet long could carry between two and three hundred thousand pounds. Incidentally, superstitious fishermen believed leaving a hatchway uncovered on deck would bring about bad luck.

THE PILOTHOUSE—This was the vessel's command center toward the rear of the boat. Most pilothouses, or wheelhouses, sat atop a "trunk" fitted with portholes. The "trunk" on older and larger draggers often housed a separate diesel to power the trawl winches. Pilothouses faced the open deck and the tip of the bow. Their height also gave good views of deck activity and what lay ahead of the bow. Most of the wheelhouses were equipped with engine controls and

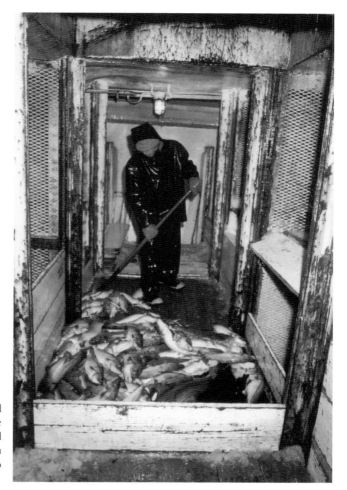

The "hold man's" job in the fish hold was to store iced-down fish in separate bins here. The "hold man" often had to descend twenty feet on an aluminum ladder from a hatchway on deck to get to the floor of the fish hold.

gauges, a large wooden or brass spoked wheel, electronics, including LORAN As (Long Range Aid to Navigation), radars, paper sounding machines, VHF (Very High Frequency) and single side band radios, air horns, a "time to haul back" wall clock, a barometer or glass, and a magnetic compass, and a chart table stacked with nautical charts for specific fishing areas to aid with fishing, communicating and navigating. Captains also kept dated records and locations of big catches, net hang-ups and wrecks in notebooks in the wheelhouses. Since the captains spent most of their sea time in the pilothouses, their quarters were also located here. Most draggers had one or two lifeboats—usually dories— stored atop their pilothouses amid a cluster of radio, LORAN antennas, horns, deck lights, running lights and spotlights. Many pilothouse walls had pictures of Jesus Christ and the Blessed Mother hanging on them. A few pilothouses also contained shrines. The *Our Lady of Fatima* had a beautiful shrine with a statue of that Portuguese saint.

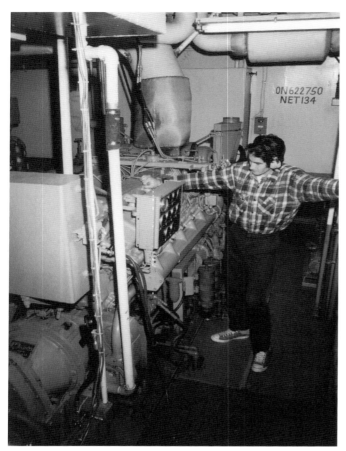

The engine room is always deep in the vessel's innards. Here Kadri Kurgun, the former engineer on the *Alliance*, checks gauges on the 850 horsepower main diesel.

THE ENGINE ROOM—The often hot and noisy, but well-lit section directly below the pilothouse was home to the main engine, generators, batteries, air compressors, "saddle" fuel tanks, tool cabinets, and benches with a vice or two. Some vessels' fuel tanks held approximately ten thousand gallons. Doorways on either side of the pilothouse trunk led down into the engine room. Shutting a single, watertight door at its entrance could seal off the engine room. Most engineers had living quarters near the engine room.

THE TURTLEBACK—This was the last farthest aft subsection, which ran from the top of the stern to the back of the pilothouse. The turtleback helped shield the back of the boat from breaking waves and seas. Most small draggers lacked a turtleback.

CHAPTER 2
THE FISHING METHOD—
THE OTTER TRAWL AND DOORS

The Gloucester dragger fleet of 1970 to 1972 harvested fish like cod, haddock, pollock, flounders, redfish and hake, and invertebrates like shrimp and lobster by towing funnel-shaped otter trawls, or nets, on the bottom. Gil Roderick, an offshore fisherman, estimated that the net, doors and towing wire cost about three thousand dollars. Each net had a set of paraplane-like "doors" which both spread its opening, or "mouth," apart and weighed the trawl down on the bottom.

Like a finely tuned instrument, every component of the net and doors had to function correctly for successful fishing. Fishermen regularly checked the steel shoes of their doors to make sure they weren't leaning over too far to one side or their fronts or backs weren't digging in. Properly working doors always had the bottoms of their steel shoes shining uniformly. The shoes rode over the ocean floor.

Captains of vessels fishing the same area frequently compared catches over the radio to make sure their gear was working properly. Many a fisherman lost hair wondering what was wrong with his net and doors. Sometimes his gear was fine, but he just wasn't on the fish, and the guy next to him was.

The different components of the trawl, from its opening to its end, are as follows. The "mouth," the big entrance of the funnel, contained a "belly" on its bottom, a top "square" and a "wing" on each side. These parts tapered into an "extension" which further led to the "cod end," which collected the catch. "Chafing gear", either a piece of cow hide or a mat of wig-like rope strands, was laced onto the underside of the cod end and prevented it from being torn while towed over the bottom.

The netting of the otter trawl's opening was laced to a 1¼ to 1½-inch-thick combination wire and rope frame which consisted of a "foot rope," a "head rope" and a pair of "up and down ropes." The smooth-bottom nets' "foot rope" had chain laced to it. The chain dug into the bottom and helped rout out fish, shrimp and lobster living on the bottom.

Years ago, using my scuba gear, I held onto an otter trawl's "head rope" and witnessed first-hand the catching of fish on a sandy bottom about forty feet deep in Ipswich Bay. This trawl had chain laced to its footrope. The trawl immediately

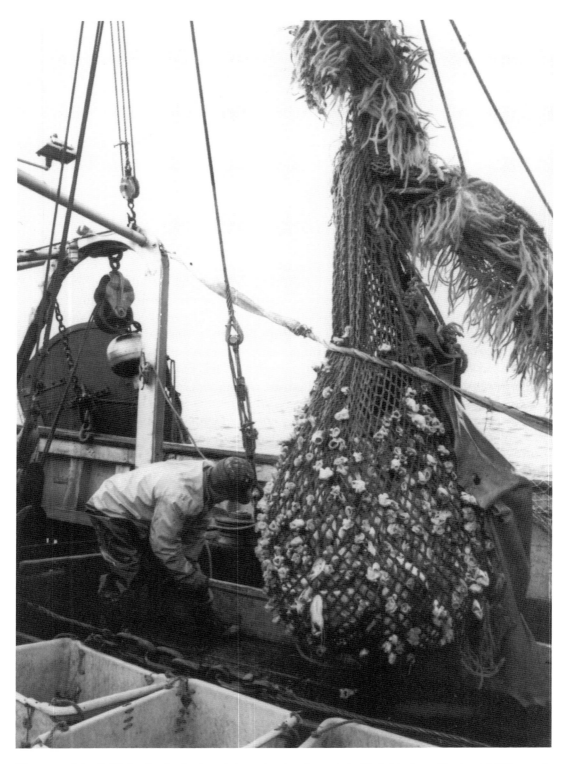

The crew of the *Judith Lee Rose* hauls aboard the cod end, only partially filled this time with about 1,000 pounds of fish.

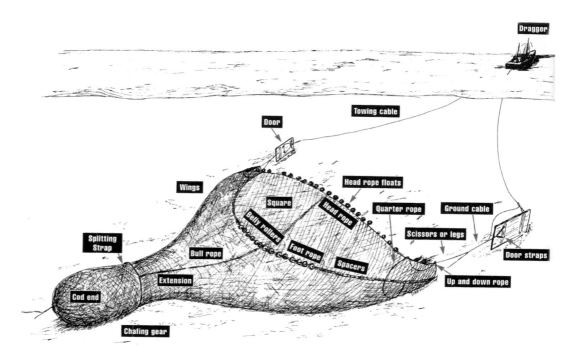

The otter trawl and doors in operation. *Diagram by Daryl Richter.*

scooped up some flounders, while others swam slowly ahead of the footrope for a while before tiring and then flipping over into the net. Other flounders darted off to the side for a final escape attempt, while some flounders and many goosefish or monkfish just stayed put on the bottom and let the net pass over them. The moving trawl kicked up clouds of silt, while the water pressure bowed out its insides right down to the "cod end."

On the other hand, trawls working the hard bottom had sweeps made of a length of middle, wooden rubber-strapped "belly rollers" flanked by a section of plain wood "spacers" shackled to it This sweep helped the mouth of the net roll and bounce over hard bottom. The wooden rollers and spacers often cracked and had to be replaced. In later years, much more resilient plastic and rubber took the place of wood.

A series of aluminum (later plastic) floats or "cans" laced onto the "head rope" helped keep the top of the net up. Hard-bottom nets had more head rope floats than smooth-bottom nets. The extra floats made the hard-bottom net more buoyant and easier to bounce over the bottom. Lastly, the "wings" had their "up and down ropes."

In addition to the wire and rope frame, the trawl also had a pair of generally under 1-inch-diameter "quarter ropes" and a 1-inch-diameter or greater "bull rope." The "quarter ropes" ran from the sides of the "head rope," around the "wings" down to the "foot rope." Crews used the quarter ropes to help haul aboard or lower overboard the trawl's "mouth" during the "setting out" and "hauling back" processes.

The long "bull rope" linked the middle of the "head rope" to the "cod end" where it was tied into a "splitting strap" that looped around the "cod end." Side trawlers

could safely haul aboard 5,000 to 10,000 pounds of fish at a time. If the "cod end" contained more than that amount, the crew used the bull rope and splitting strap to "split the bag" and yank the catch aboard in two hauls rather than one.

On the other hand, if the net had scooped up rocks or part of a wreck and was too heavy to haul aboard, then the crew would haul up what they could, tie off the "bull rope" to the vessel and tow in what they couldn't get aboard. The "bull rope" would take much of the towing strain off the netting.

A large dragger in 1970 commonly towed an 80-foot ("head rope" length) by 100-foot ("foot rope" length) groundfish net, while smaller vessels worked a 50-foot by 70-foot shrimp net. The International Conference for North Atlantic Fisheries (ICNAF) then regulated the size of netting that U.S. vessels could use off the northeast coast. Groundfish nets could have mesh with a stretch size no smaller than four inches. The shrimp nets used a smaller mesh with a 1½-inch stretch size. Most of the netting was made from nylon or polypropylene rather than sisal or cotton.

While towed, the trawl's 12- to 18-foot-high "mouth" became U-shaped. This way, fish attempting sideways or vertical escapes got caught too. The chances of swimming away were even slimmer once the water pressure pushed the fish back into the tapered "extension" and "cod end."

Most crews made their own nets, quite often on the dock their vessels were tied to. Each net had a paper plan, used by the fishermen to cut out the different net sections. Each section contained so many meshes of netting. Fishermen constantly experimented with new net designs, hoping that they would work better than the old nets.

The otter trawl "doors," weighing one hundred and fifty to two thousand pounds apiece, were made of thick oak boards that were held in place by straps of steel welded and bolted together. Each door had a thick steel shoe and a pair of both brackets on its front side and "door straps" on its back side. The doors frequently bounced over the hard bottom. Those bangs traveled for hundreds of feet along the towing cables right to the boat, and they could be felt onboard.

Sharp rocks often gouged huge chunks out of the doors as they were towed over the bottom. Later on, most doors were made entirely out of steel. Even these steel doors got bent at times. Most vessels had spare sets of doors aboard or ashore. After so much use, the doors often had to be taken off and reconditioned, which included new steel shoes.

A pair of towing wires or "warps" connected the fishing vessel to its gear on the bottom. Each of the cables ran from the main trawl winch and through deck and gallous frame blocks down to the doors' brackets, which acted as a pivotal point. Here one connection was made, but the cables ran through the "kelly eyes" on the back sides of the doors and continued 30 to 120 feet back toward the net as single "ground cables" before splitting into two 30-foot "scissor" or "leg" cables and attaching to each side of the trawl's mouth.

When setting out the trawl, the vessel briefly drifted sideways. The crew first lowered the "cod end" over the gunwhale and then "extension." The tide would quickly carry these components away from the boat. Last of all, they winched the mouth of the trawl into the water. The dragger would then make several high-speed circles with the doors

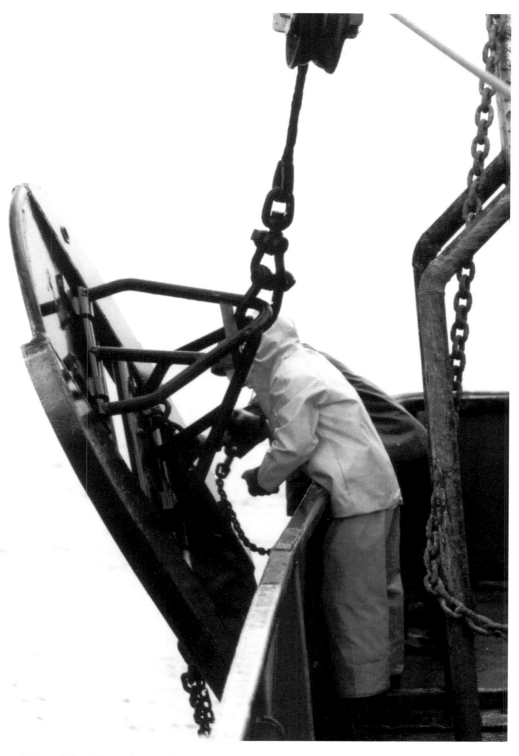

Steel trawl "doors" like this one later replaced the older style wooden ones bolted and strapped together with steel.

suspended in mid-air from their gallous frame blocks and the net trailing behind them partially submerged in the water. The captain in the pilothouse would then head the vessel straight ahead at full speed and check the gear a final time to make sure it had no twists or turns before ringing a bell or shouting an "okay." Both sounds signaled the crew to release the brakes of the main trawl winch, and the doors plunged into the ocean, taking the net with it.

Once the correct amount of cable for the area's depth—three times the depth of the bottom—had been let out and their rope markers had been lined up astern, the crew locked the brakes of the main trawl winch and joined the towing wires together in the "hook up block" there. The wires were marked every twenty-five and fifty fathoms. If the markers weren't lined up, the net would be towed unevenly and wouldn't work well. The "hook-up block" created a good pivotal point which allowed the vessel, harnessed by the gear in the water, to turn.

"Hauling back" the net and doors was just the reverse. The doors first broke the surface. The crew winched them tight to their gallous frame blocks and then hauled aboard the mouth of the trawl, followed by the "extension" and the "cod end." The crew emptied the cod end by untying a chain knot there.

Once the fishing was finished on the grounds, the crew stored the gear on board. They not only hoisted the doors to the inside of the railing and blocked them tight to their gallous frames, but tucked the net along the railing with its cod end up and tied it down with rail straps.

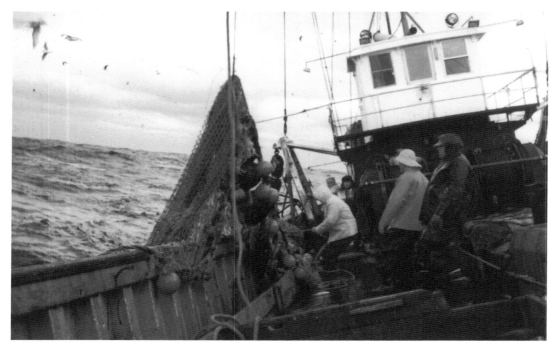

The crew of the *Judith Lee Rose* hauls back the net. The first part of the net to come aboard was the "mouth" with its belly rollers and head rope floats.

Draggers in the early 1970s typically towed nets for two to three hours before hauling them back and emptying their catches. A three-hour tow covered about nine miles of bottom. Most large draggers would cease fishing when the wind blew about 40 miles per hour and the seas were around twenty feet high. Rough conditions increased the chance of a crewman getting hurt or the fishing gear getting damaged or lost.

The *Joseph & Lucia II* and the *Joseph & Lucia III*, two sister ships in the 1970 to 1972 fleet, were famous for staying out and fishing when bad weather forced most of the fleet back to port, for landing fish when very few other fish hit the market and for getting top dollar for their catches. "As long as we (the crew of the *Joseph & Lucia III*) could fish, we would. I didn't want to know how big the seas were some of the time we fished," said Roderick, who was also the cook on that vessel.

That same fisherman witnessed a net filled from its cod end to its mouth with over thirty-five thousand pounds of redfish. Once the net neared the surface, it popped up out of the water and then floated. Redfish have swim bladders that inflate when the seawater pressure decreases.

In 1979 Captain Leo Vitale and his brother, Pasquale, saw sixty thousand pounds of haddock netted during just one tow aboard their 97-foot Gloucester stern trawler, *Stella Del Mare* on Georges Bank. The crew managed to get the fish aboard after splitting the bag several times. This shows how many fish can get packed into a net.

Shrimp draggers have occasionally filled their nets with too many of the crustaceans, which lack swim bladders, and are heavy in the water. Such nets have either been too heavy for the vessel to haul up or have exploded apart away from their rope frames.

Otter trawls are used to harvest groundfish, herring, shrimp, lobster and squid, but the nets have often caught less marketable species such as old engines, huge anchors (up to ten thousand pounds), whale carcasses, live ordnance, huge rocks, propellers, shipwrecks, human bodies, 20-foot squid and even the occasional submarine.

Captain James Madruga, Walter Blair, and an unidentified crewman were dragging off the Isles of Shoals along the Maine/New Hampshire coast aboard their 60 foot-long *Ariel* in 1946 when their net and doors snagged the conning tower of the U.S. submarine *Sea Owl*. "My husband [Jim Madruga] got the biggest catch ever in Ipswich Bay," joked his wife, Olive. Initially "the snagged sub spun the wooden dragger completely around, and then towed it backwards for awhile. To avoid sinking, my husband immediately slackened the two towing wires and then traveled in the sub's direction. After a few minutes, the submarine realized something was wrong and then surfaced nearby. Next the crew cut the towing wires. Fortunately, there were no injuries, but the dragger lost its gear."

"Rimracking" or "tearing up" was part of just about any offshore groundfishing trip. "We never came back with the same net we went out with," said Roderick. The *Joseph & Lucia III* was notorious for fishing the hard bottom—where fish often bunched up—and doing a lot of net damage there. On a boat like that, fast mending and good twine men were a must. "Double rigged" vessels had the option of getting back to fishing quickly by simply switching over to the other side and setting out the spare net and "doors."

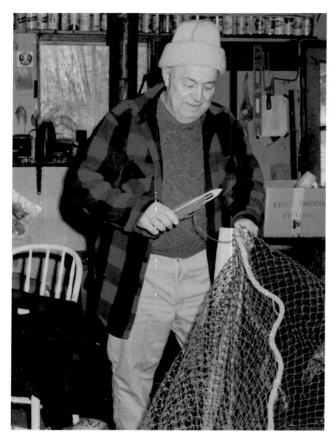

Gil Roderick, the former cook on the highline ground fish dragger *Joseph & Lucia III*, works on a shrimp net. Besides being a good cook, Roderick was also one of the best twine men in the Gloucester fleet.

Jagged hard bottom and old anchors frequently tore up the "bellies" of moving nets. The net's "square" could get ripped, too, especially by the big underwater sand dunes on "the Leg" section of the southeastern part of Georges Bank. One November as the *Judith Lee Rose* fished here at a depth of twenty-five fathoms for yellowtail flounder, lobster and lemon sole, the big boat's towing was slowed each time its net sifted through the dunes. Quite often the net's top somehow got torn, too.

Even worse than getting "rimracked," the net and "doors" often hung down solidly. In this case, the skipper immediately backed the boat right over the spot, and the crew "hauled back" as much as possible. If this didn't work, they resorted to the more drastic measure of letting out more wire, reversing the boat's direction and gunning the engine to build momentum. Most of the time this worked to free the boat. Many times the towing wires parted, and the net and doors got left behind.

"I was on the *Joseph & Lucia II*, and we made one set for pollock off of Shelbourne, Nova Scotia, on the hardest kind of bottom. Consequently, we hung up and left the whole works [net, doors and some of the towing cables] there. That was the easiest trip I ever made; we just reeled in the parted towing cables. Not surprisingly, the captain never set a net there again," said Roderick.

THE FISHING GROUNDS

During the early 1970s the Gloucester fleet was practically free to fish any of the grounds from the Carolinas to the Maritimes. Aside from ICNAF's temporary haddock spawning closures each year on Browns and Georges Banks, the weather largely controlled when and where the fleet could fish. There was also no Hague Line then. This line split up the fishing grounds off of the U.S. coast and the Maritimes. Canadian fishing grounds became off limits to U.S. fishermen, and vice versa, after the World Court's Hague Line Decision in 1984.

Gloucester skippers had their favorite targeted species and grounds to catch them. As vast as the east coast continental shelf and slope appear, only certain areas, especially banks where upwelling regularly occurs, are seasonally productive. Besides banks, other grounds included basins, ledges, canyons, ridges and swells. Experienced captains with priceless gut instincts knew their fishing grounds' tidal patterns, storm dangers and bottom topographies and had the "whens" and "wheres" of their targeted species memorized and written on charts and in notebooks. They "knew the bottom like you know your neighborhood streets; this is a [ship] wreck; that's a wreck. The good skippers could tow between the wrecks," said Roderick.

Many fishermen spent much of their careers working the same grounds. But any novice fishing a strange bottom could lose his shirt just like that by sacrificing a net to a wreck. Many obstacles like submarine cables, shipwrecks and rock piles lurked on the bottom.

Getting to the grounds was the easiest part of each trip; finding and staying on the fish was the hardest. Once on the grounds, captains commonly sampled areas for good signs of fish before staying put. Being in the right place at the right time meant everything. Fish often bunch up, either to spawn or to feed. "Fish have tails," said Roderick. One January in 1982, I saw fish come and go in just a few hours while groundfishing aboard the *Vincie & Josephine* on the southeast part of Georges Bank. That vessel got two early-night sets—ten to twenty thousand pounds apiece—of market and large cod before 'bango' the fish just vanished.

Various bottoms too hard for many boats to work were once sanctuaries where fish such as cod, pollock and redfish massed. The *Joseph & Lucia II* and *Joseph & Lucia*

III, which both had plenty of horsepower, frequently sacrificed gear to harvest those fish there. "We could fish the Rock of Gibraltar; we had the crew that could mend the twine," said Roderick.

Fishing such bottoms often meant towing the gear just a short time before hanging up and then having to haul back to either clear the net and doors or repair the damage before setting out again. But if the fish were there, the brief tows often proved profitable.

The vessels had black-and-white paper sounding machines to display the bottom depth and topography. These often showed the spiked or ball-shaped schools of cod, pollock, redfish, herring and mackerel just off the bottom. Later, more sophisticated color machines took the place of the old sounders.

Boats often fished near one another. Fishermen felt that by fishing close together, more fish could be caught. Most of the captains continually compared catches over the radio. Frequently, if a skipper got on some fish, he would relay that information to friends who might be twenty to thirty miles away, so that they could cash in, too. In addition, homebound captains would pass on fish catch information to friends heading out so that they could get right to the productive grounds.

In contrast, the deep-sea lobster draggers *Judith Lee Rose* and *Cape May* always worked alone. The captains of the *Joseph & Lucia II* and *Joseph & Lucia III*—brothers Nino and Tommy Brancaleone—usually shared information with each other and not with the rest of the fleet. To many captains, catches and fishing grounds were top-secret information!

Fishing required steady effort and often produced small catches, though occasional surprise sets would all but fill the boat. "One tow off of Cape Cod we [the crew of the *Paul & Domenic*] caught 40,000 pounds of large cod; I didn't even see anything on the sounding machine," said skipper and owner Gaetano "Tommy" G. Brancaleone.

Typical grounds of the inshore and middle fleets fell within twenty-five miles of Cape Ann, while the big draggers worked the offshore grounds most of the time. In many cases if they spotted fish inshore while steaming home, the big boats would stop and make a couple of extra tows. The little vessels did not like the big draggers using their grounds, but some offshore vessels including the *Leonard & Nancy* and *Theresa R.* switched over to inshore shrimping when the groundfish were scarce during the early 1970s.

The inshore grounds included:
MIDDLE BANK or Stellwagen Bank, dubbed "the Rhubarb" because of its rhubarb stalk-like shape. This bank, some twenty miles long, begins about twelve miles off Gloucester and runs south-southeast to within about ten miles southwest of Provincetown. Middle Bank's top hundred-foot depth has sandy and rocky bottoms; its edges drop sharply to 250-foot muddy bottom. This bank is famous for its sand eels, also called sand lances, upon which huge schools of pollock and cod often gorge themselves. During the summertime, tuna and whales also feed on the lance-like fish. Gloucestermen seasonally fish for whiting and shrimp in the deep muddy bottom

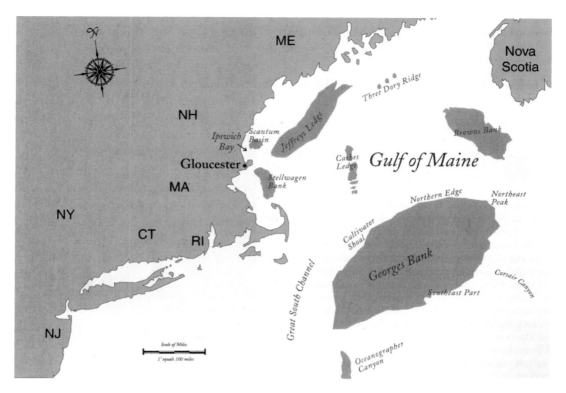

The fishing grounds off Gloucester.

just west of Stellwagen Bank. Gloucester boats steam south-southeast for about an hour and twenty minutes to get to the bank's northwest corner.

SCANTUM BASIN—a popular fishing spot in winter and spring. This round, 350-foot deep area of muddy bottom lies between New Hampshire and northern Cape Ann. It is surrounded by humps, ridges and other hard bottom, along the edges of which many boats often drag their nets for cod. Other boats fish for shrimp here in winter and spring, and for whiting during summer and fall on the muddy bottom. Gloucester boats steam north to northeast for about an hour and forty minutes to get there.

"THE BAY" (IPSWICH BAY) Much of Scantum Basin's fishing schedule applies here since most of the same species spill over into the shallower adjacent bay. This area runs just inside the deeper Scantum Basin. Its southern end starts off Rockport and curves north along the coast of New Hampshire. "The Bay" has a mixture of sandy, muddy and rocky bottoms, as well as beds of mussels and scallops. Its humps offer excellent spring codfishing. This is especially true of the "Three Sisters," "Whaleback" and "Randy's," all southwest of the Isles of Shoals (an island cluster about nine miles off Portsmouth, New Hampshire). The Gloucester day boat dragger *St. Mary* used to tow its net over the saddle-shaped Whaleback and Randy's during the spring. "You could see the fish on the sounding machine; we used to

47

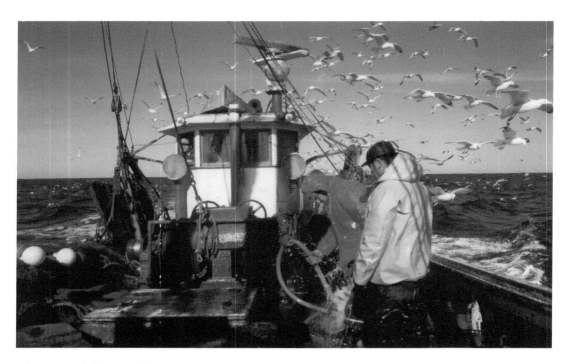

After a day of fishing on Stellwagen Bank, the *Little Flower* steams home under gull escort as the crew washes down the deck.

make only five- to six-minute tows," said crewman and engineer Mike Spinola. One of those short tows yielded the *St. Mary* a whopping 30,000 pounds of big cod. "Some fish were five to six feet long and weighed up to eighty pounds each. The net was white and full of bubbles when we hauled back," said Spinola. Two common Ipswich Bay dragging tows are "the Eleanor Tow" and "the 38-Fathom Wreck Tow." With the latter, vessels set out their nets and doors in thirty-eight fathoms of water and tow north going by "the 38-fathom wreck" all the way north to the humps. From Gloucester, boats head north and then northwest for about an hour to get to the Bay.

JEFFREY'S LEDGE is a very popular fishing area about thirty miles long. Jeffreys' northern end—"the Fingers"—begins approximately twenty-five miles off Cape Porpoise, Maine. The Ledge then runs south-southwest and ends just off Rockport as the "Shoal Ground." Pigeon Hill and Rose and Lucy Hole are also popular southern end fishing areas of Jeffrey's. The water depth on much of the top of the ledge is often twenty-eight fathoms deep, while many of its edges drop sharply down to muddy bottom over one hundred fathoms deep. Bottom types on the ledge vary from sand to mud to rock to clay ("horse pipe"). "Jeffrey's Basin is one of the main shrimp areas for the coast of Maine," said Steve Perkins, captain and owner of *David James*. Jeffrey's, like the other inshore fishing grounds, is host to many seasonal migrations of fish and invertebrates. Gloucester vessels steam about three hours to the northeast to reach the middle of Jeffrey's Ledge.

In addition to these main inshore grounds, some daring fishermen sporadically snuck inside the State's three-mile limit and made good livings there, especially catching yellowtail and blackback flounder and cod during January nights off Plum Island. Other boats made inside tows for lobster. It's still illegal for groundfish draggers to fish inside the three-mile limit.

Gloucester's middle and offshore fleets used many parts of the vast Gulf of Maine. Maine draggerman Lendall Alexander Jr., from Cundy's Harbor, ME, beautifully describes this area in his *Commercial Fisheries News* article, "Every year is the year of the ocean," which appeared in the March 1998 issue. "If the Gulf of Maine were drained and you could stand at Ammen Rock on Cashes Ledge, you would be at the highest point within the offshore shoals. To the southeast, on a clear day, Georges Bank would lie low on the horizon. To the east would be boulder fields punctuated by high sharp peaks, like sentinels on watch towers guarding the entrance to the rich, deep valley that is Jordan Basin.

"Looking north, three pinnacles loom; Three Dory Ridge points the way to Platts Bank to the northwest. Fippennies Ledge is west, a plateau rising up from the abyssal depths of Wilkinson Basin. Farther to the west brings you to Stellwagen Bank and Jeffrey's Ledge.

"The bottom predominately runs in a north-northeast, south-southwest direction. There are some areas where there is no rhyme nor reason to the layout of the bottom, a minefield, if you will, of rocks and gravel that has cost many of us sore fingers from mending our nets. Every day that I go fishing, I marvel at the thriving beauty of it all."

Georges Bank, approximately two hundred miles long, one hundred miles wide and shaped like a football, lies about one hundred and fifty miles off Gloucester and parallels the shoreline from Cape Cod to Yarmouth, Nova Scotia. Georges is, without question, the Gloucester offshore fleet's main fishing ground. High in primary productivity, this bank also produces vast schools of herring and mackerel along with all sorts of commercially important fin fish and shellfish including cod, haddock, flounder, lobsters and sea scallops. The Bank is also seasonally home to tuna, whales and swordfish.

The Great South Channel borders the southwest corner of Georges, while the Great Northeast Channel runs between the bank's northeast peak and Brown's Bank farther to the east. The Gulf of Maine runs into the northern edge of this productive bank, while the outer continental slope and its submarine canyons border its south. Sandy shoals—some barely below the surface at low tide—make up much of the top of Georges Bank. Experienced fishermen know that the top of the bank is no place to be during a storm, for there, waves steepen dramatically and frequently spill over. A good part of any tidal wave originating in mid-ocean and heading toward Gloucester would break on Georges Bank.

Numerous Gloucester boats use the following popular Georges Bank sections throughout the year for different catches:

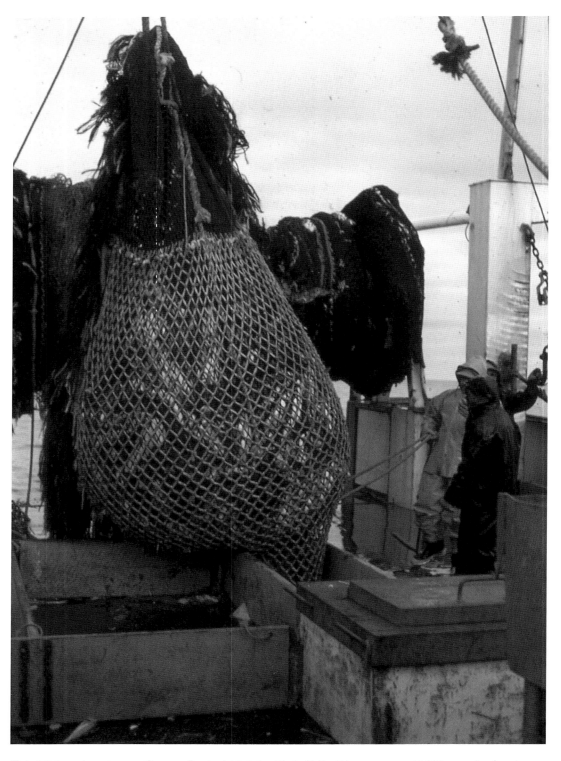

This 2½-hour-long tow on Georges Bank yielded the *Vincie & Josephine* crew over 10,000 pounds of cod, seen in the bulging cod end.

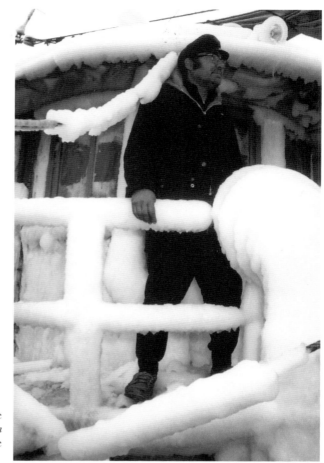

Captain Cecilio J. Cecilio stands on the "iced-up" bridge of his *Our Lady of Fatima* after a rough and cold ride home from the Northern Edge of Georges Bank in January.

THE NORTHERN EDGE—its mid-point is about a nine-hour steam southeast from Gloucester. The *Our Lady of Fatima* skipper and owner, Capt. Cecilio J. Cecilio, spent many of his forty-seven years of commercial fishing here. "I used to tow the muddy bottom ninety-five to one hundred fathoms down for dabs, greysole and lobsters. Starting on the northern edge's western corner, I would tow east all the way to the tip of the northeast peak, and then turn around and do the same thing in reverse, hauling back every two hours for days on end," said Cecilio.

THE NORTHEAST PEAK requires an eighteen- to nineteen-hour east-by-south steam from Gloucester to get here. Many Boston and Portland, Maine, draggers fished here, too, especially in the 100-fathom depths, for cod and haddock during January and February. Because of the Hague Line, much of this area is now off-limits to U.S. vessels.

THE SOUTHEAST PART, especially "the Leg" is a twenty-hour steam southeast from Gloucester. Numerous Gloucester and New Bedford draggers fished its twenty-five

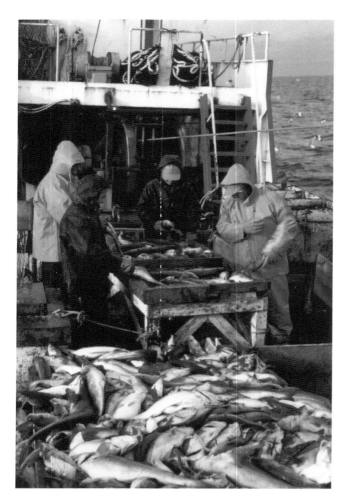

The *Vincie & Josephine* crew dresses the last set's cod and haddock catch.

to thirty-fathom sandy bottom for yellowtail and blackback flounders, lemon sole, lobster, scallops and later cod. This area was notorious for its abundance of longhorn sculpins (*Myoxocephalus octodecimspinosus*) whose needle-like head spines not only punctured fishermen's hands as they handled the sculpin-meshed nets, but even punctured their rubber boots as they walked over them on deck. Huge schools of spawning codfish often bunched up here during January and February. Part of this area is now also off-limits to U.S. vessels.

CULTIVATOR SHOAL is twelve hours southeast of Gloucester. Joe Testaverde and his brother Tommy often fished this area's sandy, shelly bottom at thirty to fifty fathoms for whiting during the summer. Typically, starting from the west'ard, "I tow from west to east right to the northeast peak and back again over and over again," said Joe Testaverde. Numerous longhorn sculpins, crabs, conger eels or ocean pout, and starfish get caught with the whiting. "The tides here often roar at three to four knots;

many boats don't fight the tide and tow with it. I towed into it once for an hour and a half and didn't move more than a mile. The fish cling to the bottom when the tide rips," said Joe Testaverde. Cod, haddock and whiting were fished here in winter.

OUTER GEORGES BANK'S SUBMARINE CANYONS is often over one thousand feet deep. Surprisingly, a few Gloucester boats tow their nets in the canyons here, bearing such names as Corsair and Oceanographer's, for lobster during the winter and spring. The furthest eastern canyon, Corsair, was well known for its "coral trees," with their cucumber-like smell, and its huge "horse" male lobsters, which often weigh over twenty pounds apiece. Corsair Canyon is a twenty-four to twenty-six-hour steam southeast of Gloucester. "This was a big canyon; we fished its hard bottom having coral trees which often tore up the net's belly. We'd tow along one of Corsair Canyon's fingers starting out two hundred to two hundred and fifty fathoms deep following it in to fifty- to sixty-fathom shoaler water depths before going back out again. The tides here were terrific. We'd lobster here during the winter and spring

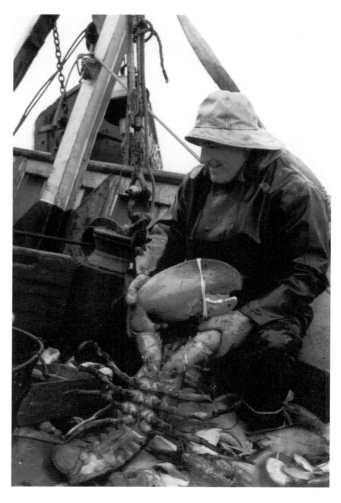

Judith Lee Rose crew member, Gus Doyle, holds onto a 20-pound lobster dragged up from Corsair Canyon.

and then gradually follow the lobsters into the shoal water where they would shed their shells," said Frank Rose Jr., captain and owner of the *Judith Lee Rose*. This vessel was one of Gloucester's pioneer deep-sea lobster draggers to fish on these once-virgin grounds. "On our very first two-hour tow here, we netted four thousand to five thousand pounds of lobsters. I almost fainted then," recalled Rose.

Other grounds to the eastward were used off and on by the offshore Gloucester fleet. They included:

BROWN'S BANK—at its closest point, eighteen to twenty hours due east of Gloucester. This was an excellent spring haddock fishing ground.

ST. PAUL ISLAND/ST. LAWRENCE WATERWAY—this ground was a five-day steam due east by northeast. This was a good greysole area.

EMERALD BANK—due east for three days—an excellent haddock area over seven hundred miles from Gloucester.

GRAND BANKS—Gloucester boats had to steam some ninety hours—over nine hundred miles from port—east by south to reach here. This area was famous for its groundfish, including flounders and redfish. During her redfishing days, the *Judith Lee Rose* used to redfish here after traveling four days and three nights—a little over one thousand miles just to get here. That trawler often fished on the Grand Bank's eastern side including "the Tail of the Bank's" hard bottom two hundred fathoms below.

All of these grounds became off-limits to U.S. groundfish boats after 1984. However, U.S. swordfish boats still fish parts of the Grand Banks that fall outside of Canada's jurisdiction.

CHAPTER 4
THE SOUGHT-AFTER SPECIES

What seafoods did the early 1970s fleet target? What did they look like? What were their dollar values? And what happened to the catches once they reached the wharf? Of the ninety-five vessels, about fifty-eight inshore and middle fleet vessels seasonally fished for northern shrimp, whiting, herring and groundfish. Of the offshore trawlers, thirty-two mainly sought groundfish, while the other five big boats harvested deep-sea lobster. The available markets pretty much determined the fleet's fisheries, but in 1970 the program for harvesting "underutilized species" kicked in, and soon many former "trash" fish like ocean pout, monkfish and pollock were worth money to the fishermen. Overall, fish were very inexpensive in the late 1960s and early 1970s.

The National Marine Fisheries Service statistics show the 1970 Gloucester fleet landed 92,330,790 pounds (thirty-six different fish species along with several shellfish) worth $8,362,172. But, of that total, only six major species had individual landings above five million pounds. In 1964, 121,351,869 pounds were worth $7,042,375. In 1975 122,139,875 pounds had a value of $14,503,977. No doubt, the 1970 and 1975 groundfish landings would have been higher if Gloucester vessel landings at other ports, especially Boston, had been included.

Gloucester usually paid the boats between five and ten cents less per pound for the fish than Boston. The Boston Fish Auction usually set the daily groundfish prices for not only Boston but also for Gloucester. The dealers had their regular boats as well as occasional visitors to supply them. Some of the vessels could choose to whom they wanted to sell, but others were obligated to do so, often because of docking arrangements. Some of the dealers also paid vessel captains and owners "under-the-table" kickbacks, frequently at the rest of the crew's expense, to sell there.

In addition, herring and pogie (menhaden) seiners—*Ida & Joseph, Rockaway, Barnegat, Kingfisher* and *St. Anthony*—contributed to the big numbers, as did a handful of gill-netters, including *Moby, Phyllis A., Naomi Bruce III* and *Liberty,* long liners such as *Sou'Wester, Odessa* and *Guy R.* and offshore lobster trap vessels like the *Red Diamond* and *Homarus I & II.*

In 1970 there was also a very limited swordfish fishery in Gloucester. Aided by a spotter plane, Danvers ophthalmologist, Dr. Frederick Breed harpooned swordfish on Georges Bank from June through October aboard his 67-foot schooner *Jaguar.* But the

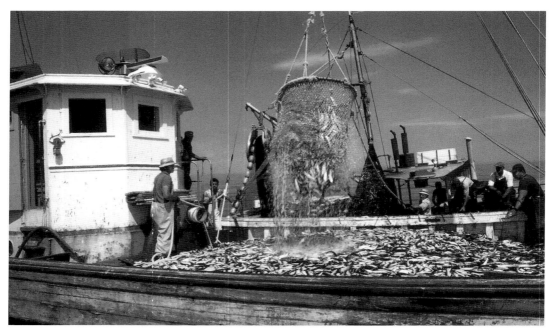

After a successful seine set, the *Ida & Joseph* crew load aboard over 200,000 pounds of pogies, or menhaden.

early 1970s mercury scare pretty much drove him out of this seasonal business, which he had been in for about ten years. By 1972 the 50-foot *Sweet Sue* and 60-foot *Mabel Susan* were long-lining swordfish on Georges Bank during summers. In subsequent years Gloucester's longline swordfish fleet increased in size, including such vessels as *Andrea Gail, Anne Rowe, Gannet, Hannah Boden, Kristen Lee, Sea Dog V* and *Sunshine*. Most of these swordboats worked the Grand Banks from July through October.

The following landings illustrate some interesting trends in fishing effort and the state of the fishery. The top 1965 species with landings of five million pounds or more, in ascending order, were:

Cod:	5,707,269 pounds
Alewife:	6,332,200 pounds
Redfish:	22,486,597 pounds
Haddock:	24,373,550 pounds
Silver Hake:	36,705,272 pounds

The top 1970 species with landings of five million pounds or greater, in ascending order, were:

Haddock:	5,402,218 pounds
Shrimp:	6,383,940 pounds
Redfish:	7,467,393 pounds

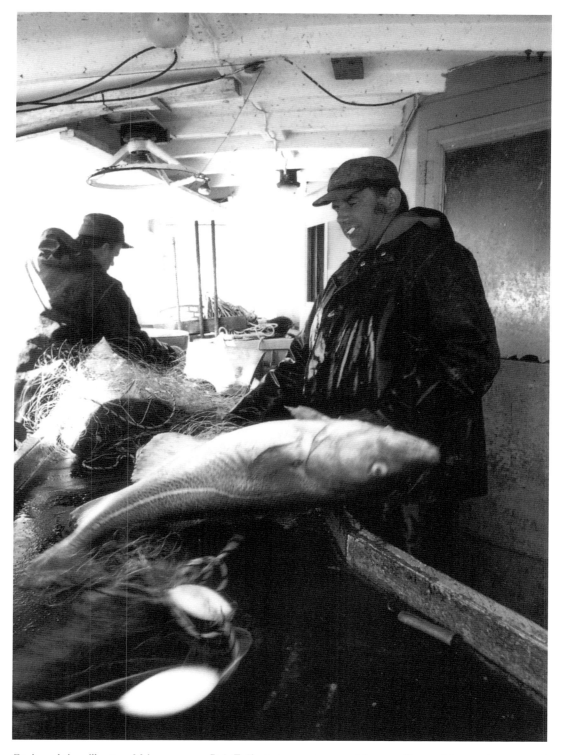

On board the gillnetter, *Moby*, crewman Bob Fulford clears a large cod from a gillnet, while vessel owner and operator Tom Morse steers the boat and hauls in more gillnets.

WHITE-TIPPED ORANGE MASTS

Cod:	10,564,014 pounds
Silver Hake:	19,718,309 pounds
Atlantic Herring:	23,101,214 pounds

Compare those two years' landings to the 1975 major species landings:

Pollock:	6,178,977 pounds
Redfish:	8,144,500 pounds
Cod:	12,148,377 pounds
Menhaden:	20,325,583 pounds
Silver Hake:	22,877,167 pounds
Atlantic Herring:	28,237,909 pounds

Those catch comparisons not only show haddock landings down dramatically by 1975, but also show slight declines in redfish and whiting catches. Catches of the slow-growing and slow-reproducing redfish, the fleet's mainstay from the 1940s to the early 1960s, really plummeted after that. Consequently, vessels had to steam further to the east'ard, often over one thousand miles, to catch redfish. The draggers would fish for whatever they could earn the most money selling.

In 1970 the Gloucester fleet began to target underutilized species, including northern shrimp, Atlantic herring, pollock, ocean pout, skates—and later on even monkfish and dogfish sharks. Going after these species would keep the boats operating while reducing the domestic fleet's fishing pressure on haddock and redfish stocks.

Over the years, fish prices paid to the vessels rose ever so slowly. The following prices are yearly averages. In the short term they often fluctuated wildly, supposedly based on supply and demand. From 1965 to 1970 to 1975:

Cod went from 9¢ to 13¢ to 26¢ per pound.
Haddock jumped from 11¢ to 27¢ to 36¢ per pound.
Silver hake (whiting) went from 3¢ to 8¢ per pound, but stayed at 8¢ for the last two periods.
Herring crept from 1¢ to 2¢ to 3¢ per pound.
Lobster went from 51¢ to 90¢ to $1.69 per pound.
Shrimp prices rose from 13¢ to 18¢ to 24¢ per pound.

Steadily high prices for fish such as halibut meant little to the fishermen, since they couldn't catch many of these scarce species anyway. Profitability for targeting whiting, herring and menhaden translated into landing volume—either all at once or cumulatively over a week's time. During summer, big whiting draggers had to make at least two offshore trips per week, bringing in at least one hundred thousand pounds of catch at a time. The inshore boats fished day after day and landed moderate quantities of whiting. The catches added up at week's end. Conversely, lobster draggers had to catch fewer of the higher-priced crustaceans on each trip to

Cod (*Gadus callarias*), Eastport, Maine. From Goode. Drawing by H. L. Todd.
Maximum weight: 211 ¼ lbs. Maximum length: 72 inches

Haddock (*Melanogrammus aeglefinus*).
Maximum weight: 37 lbs. Maximum length: 44 inches

American pollock (*Pollachius virens*), Eastport, Maine. From Goode. Drawing by H. L. Todd.
Maximum weight: 35 lbs. Maximum length: 42 inches

From − *Fishes of The Gulf of Maine* by Bigelow and Schroeder

Sought-after species: Cod, Haddock and Pollock.

Witch flounder (*Glyptocephalus cynoglossus*). From Goode. Drawing by H. L. Todd.
Maximum weight: 4 lbs. Maximum length: 25 inches

Canadian plaice, or Dab (*Hippoglossoides plattessoides*), La Have Bank. From Goode. Drawing by H. L. Todd.
Maximum weight: 6 lbs. Maximum length: 24 inches

Yellowtail (*Limanda ferruginea*), Gloucester, Mass. From Jordan and Evermann. Drawing by H. L. Todd.
Maximum weight: 2 lbs. Maximum length: 18 inches

From − *Fishes of The Gulf of Maine* by Bigelow and Schroeder

Sought-after species: Greysole, Dab and Yellowtail Flounder.

Herring (*Clupea harengus*). From Goode. Drawing by H. L. Todd.
Maximum weight: 1 ½ lbs. Maximum length: 17 inches

Silver Hake (*Merluccius bilinaeris*).
Maximum weight: 5 lbs. Maximum length: 30 inches

Menhaden (*Brevoortia tyrannus*).
Maximum weight: 1 lb. Maximum length: 15 inches
From – *Fishes of The Gulf of Maine* by Bigelow and Schroeder

Sought-after species: Herring, Whiting and Menhaden.

Rosefish (*Sebasta marinus*), Eastport, Maine. From Goode. Drawing by H. L. Todd.
Maximum weight: 5 lbs. Maximum length: 22 inches

Goosefish (*Lophius americanus*), oblique-dorsal view, Gulf of Maine specimen. From Bigelow and Welsh
Maximum weight: 50 lbs. Maximum length: 48 inches

Wolffish (*Anarhichas lupus*), Georges Bank. From Goode. Drawing by H. L. Todd.
Maximum weight: 40 lbs. Maximum length: 60 inches

From − *Fishes of The Gulf of Maine* by Bigelow and Schroeder

Sought-after species: Redfish, Goosefish and Wolffish.

Northern Shrimp (*Pandalus borealis*)
Maximum approximate weight: .6 oz. Maximum approximate length: 4 inches

American Lobster (*Homarus americans*)
Maximum approximate weight: 40 lbs. Maximum approximate length: 42 inches

Courtesy the National Marine Fisheries Service

Sought-after species: Northern Shrimp and American Lobster.

make their ventures profitable. All in all, there seemed to be no magic formula for getting rich; every fishery required steady hard work.

The 1970 and 1975 landings kept the fishermen, along with the fish dealers, processors and different supply companies going. But, many fishermen weren't happy with their industry and felt they were doing a lot of hard work for little return. Fishermen have always been notorious for never being satisfied, but I believe that's human nature.

Fish processors and dealers lining the waterfront from the Fort all the way around to East Gloucester purchased entire fishing trips. They also processed redfish, groundfish and whiting or redistributed them whole. Herring and menhaden were also processed in Gloucester then.

The many fish plants provided year-round employment for Gloucester residents and badly needed summer work for students. Getting the preferred lobster bait, redfish, along with other groundfish wracks—the fish body minus the fillets—was no problem for the lobsterman then; he had his pick of plants from which to choose.

Gloucester fish plants processed a variety of fresh fish and shellfish in many ways. Whiting was headed and gutted, packed into five-pound boxes and frozen. Redfish was filleted and sold either fresh or frozen, especially to the U.S. military. A local plant once cooked northern shrimp and peeled the meats out of their tails. The meat was individually quick-frozen and packaged. A herring plant on the Jodrey State Fish Pier headed, gutted and butterflied fresh herring and then packaged and froze them. A dehydrating process plant, also on the pier, processed pogies (menhaden) into oil and fishmeal. Traditional groundfish like cod, haddock and flounder were filleted in town. Many of the processors did the common "fresh, frozen and Canadian salt fish" trade with their finished products. Brokers handled these seafoods and redistributed them, mainly throughout the south and mid-west. The Scandinavian countries bought much of the processed herring to fill their demand, which could not be met by dwindling Baltic Sea herring stocks. The fresh fish fillets also supplied area fish markets and restaurants.

Dealers and processors followed the most profitable course of action. Filleting, heading and gutting, packaging and freezing were labor-intensive. It was much cheaper to ship out whole fish to higher-priced markets, so processors, and especially traditional fish dealers, also sold their fresh fish and shellfish products whole. The dealers and processors were always challenged to keep a balance between their two marketing options. They also had to move their perishable products quickly.

Later, much of the large cod, pollock and hake "went to Canada for its salt fish industry. Every day I often remember sending up two trailer truck loads of fish to Canada," said Brian Wright, current president and co-owner of the John B. Wright Fish Company, Inc., of Gloucester. Other purveyors also trucked yellowtail flounder to New Bedford and cod and haddock to Boston, while many shipped large greysole, whiting, and market and large cod to New York's higher-paying Fulton Fish Market. Shrimp were also shipped there during the Christmas season.

Fish have always been broken down according to species and size. Generally, the larger the fish size the greater the worth. Here are just some of Gloucester fish size and weight breakdowns that pertained at least to the late 1990s. Today, most

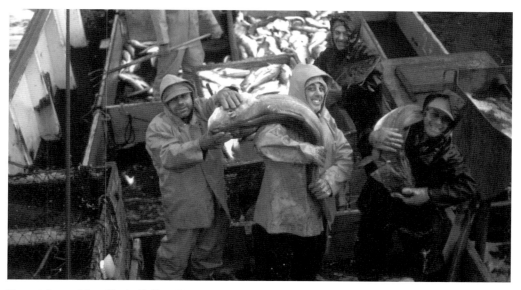

From left to right, *Vincie & Josephine* crewmen Filippo Cusumano, Salvatore Costanzo, Simone and Giuseppe Sanfilippo (rear) hold up three of the last set's codfish giants.

fish weighing is done with digital scales, and not with the often less-than-accurate balance scales of the past. Note the definition of scrod or schrod.

Haddock:	3.5 lbs and over
Scrod haddock:	3.4 lbs and under to legal size
Large cod:	10 lbs and over
Market cod:	4 to 9.9 lbs
Scrod cod:	3.9 lbs and under
Large Pollock:	8 lbs and over
Medium Pollock:	3.6 to 7.9 lbs
Small Pollock:	3.5 lbs and under
Large hake:	4 lbs. and over
Medium hake:	2 to 3.9 lbs.
Small hake:	2 lbs and under
Cusk:	3.5 lbs and over
Small cusk:	3.4 lbs and under
Large greysole (flounder):	2 lbs and over
Medium greysole:	1.5 to 1.9 lbs.
Small greysole:	1.4 lbs. and under

CHAPTER 5

ALL ABOUT THE FLEET—
VESSEL AND CREW PHOTOS

The 95-vessel dragger fleet of the early 1970s was a potpourri of vessel shapes, sizes, colors and ages. Five were steel-hulled vessels and the rest were wooden. Much of the vessel data came from "Merchant Vessels of the U.S." (1950, 1970, 1971 and 1972). Apparently, the U.S. Coast Guard Documentation Officer's measurements were done from the bow to the stern at the waterline.

The fleet was in a constant state of change as recruits—primarily second-hand vessels—arrived while others left, mainly by sinking. Many draggers were repowered, usually with bigger diesels. The Gloucester fleet then was also regularly visited by the Boston draggers *Sole*, *Salvi & Joe*, *Alba*, *Clipper*, *Agatha* and *Paul & Maria*. New Bedford's *Cape Ann*, *Nine* and *Sea Horse* also home-ported here off and on. Sometimes these draggers were crewed by Gloucester fishermen. Here are some interesting summary conclusions:

The 31.1-foot-long *Carolyn René* was the smallest dragger. The largest were nearly a three-way tie among the 103.9 foot *Judith Lee Rose*, the 104.1-foot *Serafina N.* and the 105.5-foot long *St. George*. The mean length of a dragger in this fleet was 66.9 feet.

The average age of a dragger in the 1972 Gloucester fleet was 28.4 years. The 55-year-old, 104.1-foot *Serafina N.* and the 59.8-foot *Isaac Fass*, both built in 1917, were the oldest trawlers, while the 60.4-foot *Acme*, constructed in 1972, was the newest. Two boats were built in the 1910s; ten each during the 1920s and 1930s; a staggering forty-seven boats in the 1940s; nineteen in the 1950s; five in the 1960s; and only one in the early 1970s. The big 1940s and 1950s buildups coincided with the redfish boom. These vessels not only had to be large, at least eighty feet long, but had to be able to carry between two and three hundred thousand pounds of the redfish and travel great distances from port—sometimes over one thousand miles away. As the redfish got scarcer nearby, vessels began fishing further eastward to find sizeable numbers of them.

Various Massachusetts boatyards, especially in Gloucester, Essex and Ipswich, made twenty-nine of those draggers. Maine shipyards, mainly at South Bristol, Southwest

Harbor and Thomaston, constructed forty-five; scattered boatyards in Connecticut, Florida, Maryland, New Jersey, New York, Ohio, Rhode Island, Virginia and Nova Scotia built the remaining vessels. Besides having new vessels built, Gloucester fishermen also purchased U.S. Government surplus, ex-World War II sub-chasers and World War II mine sweepers and converted these into fishing vessels.

Photos of all 95 vessels and about 90 percent of their crews are included in this chapter. For this second edition, I obtained photos of some of the missing fishermen from their families. To the fishermen and their families these boats often symbolized a lifetime of good and bad memories. No doubt seeing these photos of both the boats and the crews will bring out a host of emotions ranging from love to hate and from happiness to sadness. Each photograph is accompanied by a data page containing each vessel's individual horsepower, gross and net tonnage, dimensions, year built, where built, most of the crew's names, the vessel owner, sought-after species, fate of vessel, sub-fleet category and hull material. The majority of the Gloucester vessels were owned by individuals or family-formed corporations. Chapter 6 contains more crew specifics.

The majority of the early 1970s Gloucester vessels painted their masts orange with white tips. Most of my waterfront sources did not know exactly why, but according to Captain Cecilio J. Cecilio,

> *The white mast tip and also the bow white water line stripe were always Portuguese; you could always tell a Portuguese ship in the distance by this. To the best of my knowledge the orange part was started by the U.S. Coast Guard years ago to help them see us in the distance. The orange later spread to the top of the pilothouse and the turtleback.*

Apparently, numerous Italian fishermen also carried on that tradition. Also, many Italian fishermen painted their mast tips and railing tops black out of respect for deceased family members. The Gloucester fleet, especially back in the 1930s, 40s and 50s, was broken down into "the Portuguese fleet" and "the Italian fleet." The white-tipped orange masts obviously caught my attention in the early 1970s. Hence, I decided to name this book after them and their vessels.

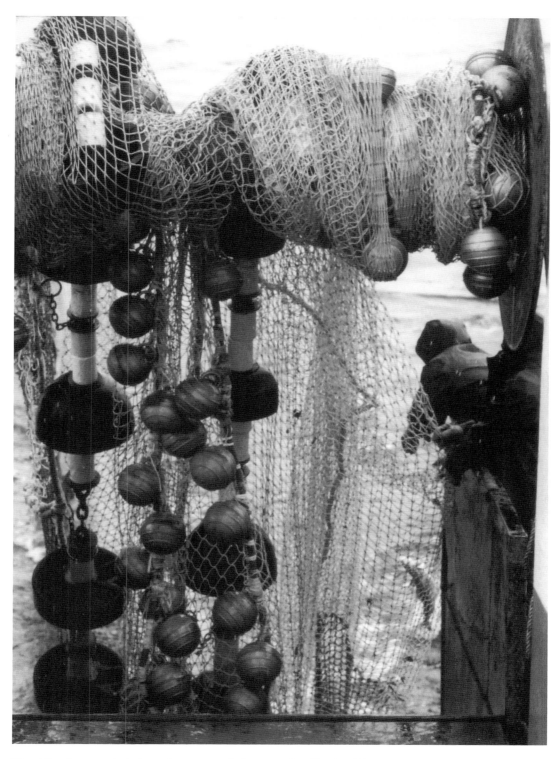

The *Alliance*'s net reel winds up the otter trawl. Stern trawlers like the *Alliance* were equipped with hydraulic net reels, which sped up both "hauling back" and "setting out" the net.

FISHING VESSEL STATISTICS

ACME

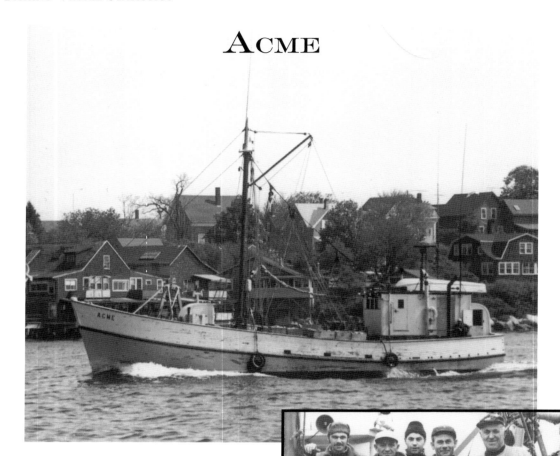

BOAT: *Acme*
HORSEPOWER: 325
GROSS: 56
NET: 42
DIMENSIONS: 60.4 x 17 x 8.3
WHEN BUILT: 1972
WHERE BUILT: South Bristol, Maine
OWNER: Boat Alden, Inc., Massachusetts
CREW: Captain John Cusumano and sons
Phil and Fillippo, Natale Gabriele and
Sebastian Ciolino
SOUGHT-AFTER SPECIES: shrimp, whiting and groundfish
FATE: Sold to Maine and still afloat
FLEET SUB-CATEGORY: inshore
HULL MATERIAL: wood

AMERICAN EAGLE

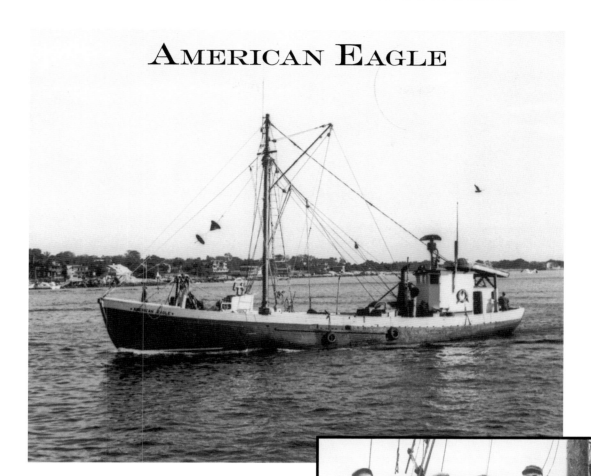

BOAT: *American Eagle*
HORSEPOWER: 380
GROSS: 70
NET: 47
DIMENSIONS: 76.4 x 19.3 x 10
WHEN BUILT: 1930
WHERE BUILT: Gloucester, Massachusetts
OWNER: Schooner American Eagle, Inc., Massachusetts
CREW: Captain John Piscitello and brothers Joe (Engineer) and Gus (Cook), Mike Militello and Salvatore Aiello
SOUGHT-AFTER SPECIES: shrimp, whiting and groundfish
FATE: Sold, refurbished as a schooner, presently the Maine windjammer *American Eagle*
FLEET SUB-CATEGORY: middle fleet
HULL MATERIAL: wood

ANNIE

BOAT: *Annie*
HORSEPOWER: 165
GROSS: 26
NET: 17
DIMENSIONS: 46.6 x 13.7 x 6.9
WHEN BUILT: 1929
WHERE BUILT: Boston, Massachusetts
OWNER: Steverino Inc., Massachusetts
CREW: Captain John Sinagra, Mariano SanParolo and Mark Ferrante
SOUGHT-AFTER SPECIES: shrimp, whiting and groundfish
FATE: Sank
FLEET SUB-CATEGORY: inshore
HULL MATERIAL: wood

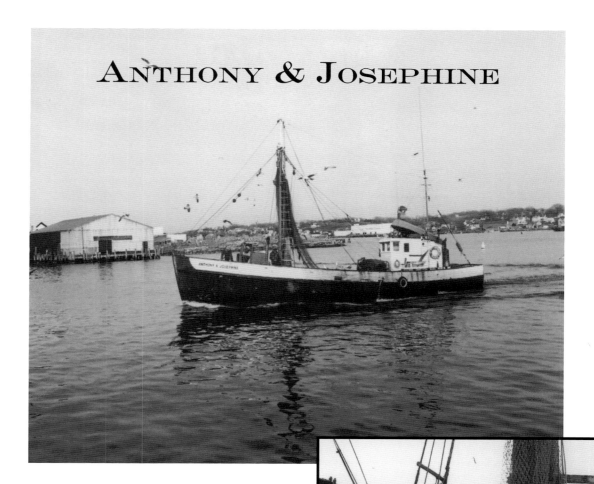

ANTHONY & JOSEPHINE

BOAT: *Anthony & Josephine*
HORSEPOWER: 165
GROSS: 40
NET: 27
DIMENSIONS: 58.0 x 16.8 x 8.0
WHEN BUILT: 1946
WHERE BUILT: Southwest Harbor, Maine
OWNER: Boat Anthony & Josephine Inc., Massachusetts
CREW: Captain Vito Favaloro and brothers Salvatore ("Red") and Serafino Favaloro and Claude Souza
SOUGHT-AFTER SPECIES: shrimp, whiting and groundfish
FATE: Sold to another Gloucester fisherman, currently still afloat and fishing out of Gloucester as *Little Sandra*
FLEET SUB-CATEGORY: inshore
HULL MATERIAL: wood

ANTONINA

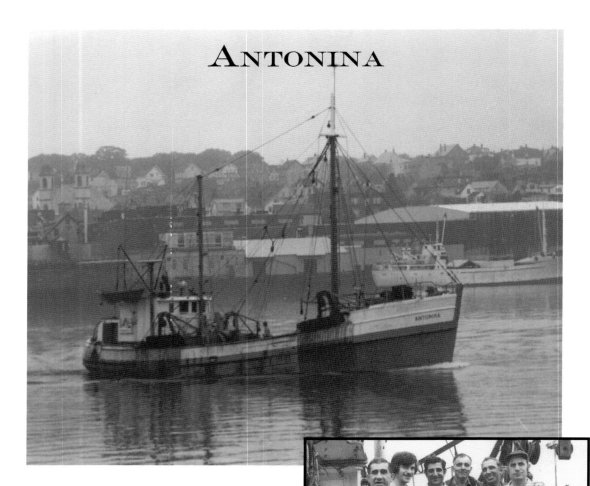

BOAT: *Antonina*
HORSEPOWER: 510
GROSS: 92
NET: 63
DIMENSIONS: 69.7 x 19.4 x 9.8
WHEN BUILT: 1961
WHERE BUILT: South Bristol, Maine
OWNER: Blue Waters, Inc., Massachusetts
CREW: Captain Santo Mineo, Cook Anthony Curreri, Jerry Grillo, Joseph Giamanco, Engineer Anthony Orlando and Ed Rivers
SOUGHT-AFTER SPECIES: groundfish
FATE: Sank
FLEET SUB-CATEGORY: offshore
HULL MATERIAL: wood

BABY JERRY

BOAT: *Baby Jerry*
HORSEPOWER: 280
GROSS: 36
NET: 15
DIMENSIONS: 61.5 x 15.4 x 7.4
WHEN BUILT: 1925
WHERE BUILT: Damariscotta, Maine
OWNER: Baby Jerry Inc., Massachusetts
CREW: Captain Sam Ciolino, Antonio Ciolino and Paul Frontiero – fourth man unidentified
SOUGHT-AFTER SPECIES: shrimp and groundfish
FATE: Sank
FLEET SUB-CATEGORY: inshore
HULL MATERIAL: wood

BABY ROSE

BOAT: *Baby Rose*
HORSEPOWER: 220
GROSS: 107
NET: 73
DIMENSIONS: 85.3 x 20 x 10.3
WHEN BUILT: 1941
WHERE BUILT: Thomaston, Maine
OWNER: Mary Rose Ciarametaro
CREW: Captain Vincent Ciarametaro
and son Joseph, Cook Serafino Pallazola,
Nicholas Toben, James Shanahan, Engineer Robert Herrick and Jack Rallo
SOUGHT-AFTER SPECIES: groundfish
FATE: Sank
FLEET SUB-CATEGORY: offshore
HULL MATERIAL: wood

BEATRICE & IDA

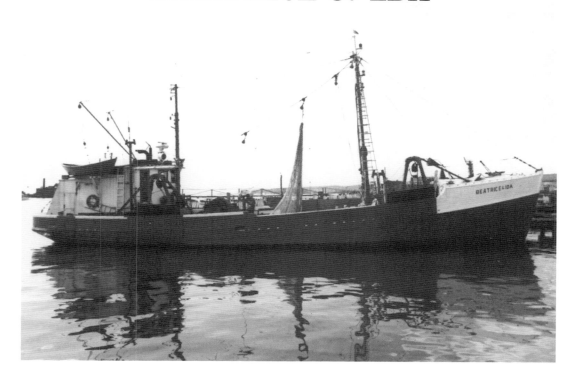

BOAT: *Beatrice & Ida*
HORSEPOWER: 400
GROSS: 109
NET: 74
DIMENSIONS: 88.3 x 20.6 x 10.7
WHEN BUILT: 1939
WHERE BUILT: Brooklyn, New York
OWNER: B. & I. Fishing Corp., New York
CREW: Captain Chris Cecilio, Don Pino, Willis Powers, James Tucker, Engineer Anthony Santos and Cook Antonio Lolivira
SOUGHT-AFTER SPECIES: lobster
FATE: Fished out of Rhode Island and later sank
FLEET SUB-CATEGORY: offshore
HULL MATERIAL: wood

BELINDA II

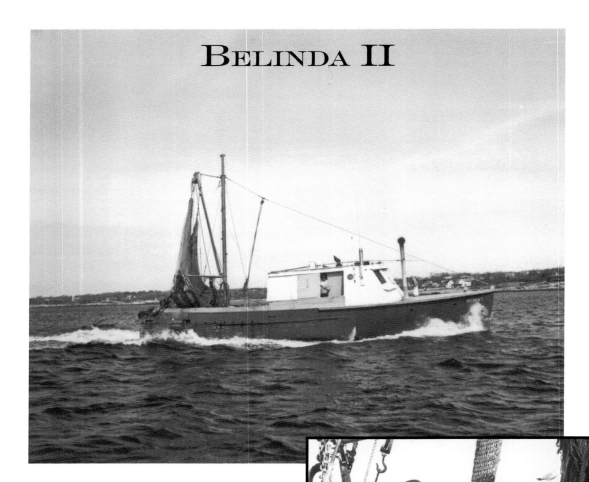

BOAT: *Belinda II*
HORSEPOWER: 100
GROSS: 28
NET: 25
DIMENSIONS: 47 x 13.4 x 6.1
WHEN BUILT: 1950
WHERE BUILT: East Boothbay Harbor, Maine
OWNER: Belinda Co. Inc., Massachusetts
CREW: Captain James Madruga and Walter Goyetche
SOUGHT-AFTER SPECIES: groundfish, whiting and shrimp
FATE: Vessel was sold to a Portsmouth, New Hampshire fisherman
FLEET SUB-CATEGORY: inshore
HULL MATERIAL: wood

BLUE SURF

BOAT: *Blue Surf*
HORSEPOWER: 400
GROSS: 178
NET: 121
DIMENSIONS: 95.9 x 23.1 x 12.8
WHEN BUILT: 1945
WHERE BUILT: Waldoboro, Maine
OWNER: Dingy Corp., Massachusetts
CREW: Captain Thomas "Obie" O'Brien (rest of crew unknown)
SOUGHT-AFTER SPECIES: groundfish
FATE: The former *Edith & Lillian*, went to New Bedford, Massachusetts, was converted to scalloping, present fate unknown
FLEET SUB-CATEGORY: offshore
HULL MATERIAL: wood

BLUE WATERS

BOAT: *Blue Waters*
HORSEPOWER: 400
GROSS: 130
NET: 56
DIMENSIONS: 89.2 x 21.3 x 9
WHEN BUILT: 1941
WHERE BUILT: Greenport, New York
OWNER: Silvario Gaspar
CREW: Captain Silvario Gaspar, Cook Jerry Scola, Vito LoGrasso, Filippo LoPiccolo, Antonio Margiotta, Joe Tarantino and Engineer Leo Ciaramitaro
SOUGHT-AFTER SPECIES: groundfish
FATE: Rammed a barge, split open bow and later sank
FLEET SUB-CATEGORY: offshore
HULL MATERIAL: wood

BONAVENTURE

BOAT: *Bonaventure*
HORSEPOWER: 765
GROSS: 119
NET: 81
DIMENSIONS: 90 x 21.5 x 10.5
WHEN BUILT: 1942
WHERE BUILT: Southwest Harbor, Maine
OWNER: Vessel Bonaventure Inc., Massachusetts
CREW: Captain Nicholas Novello and brother Sam (rest of crew unknown)
SOUGHT-AFTER SPECIES: groundfish
FATE: Sank
FLEET SUB-CATEGORY: offshore
HULL MATERIAL: wood

Photograph courtesy of Mrs. Nicolas Novello.

BONNIE LASS

BOAT: *Bonnie Lass*
HORSEPOWER: 165
GROSS: 18
NET: 6
DIMENSIONS: 39.6 x 13 x 6.7
WHEN BUILT: 1945
WHERE BUILT: Barnegat City, New Jersey
OWNER: Salvatore Montalbano
CREW: Captain John Giacalone and Matt Greany
SOUGHT-AFTER SPECIES: whiting and groundfish
FATE: Sold and sank
FLEET SUB-CATEGORY: inshore
HULL MATERIAL: wood

CAPE COD

BOAT: *Cape Cod*
HORSEPOWER: 165
GROSS: 34
NET: 14
DIMENSIONS: 56.4 x 15.3 x 7.5
WHEN BUILT: 1944
WHERE BUILT: Southwest Harbor, Maine
OWNER: Boat Eva II Inc., Massachusetts
CREW: (no crew photo) Captain Joe Sinagra
and son Joe Jr., Carlo and Carl Sinagra
Sought-after species: shrimp, whiting and groundfish
FATE: Sold, later sank at wharf where it was demolished and trucked to the dump
FLEET SUB-CATEGORY: inshore
HULL MATERIAL: wood

CAPE MAY

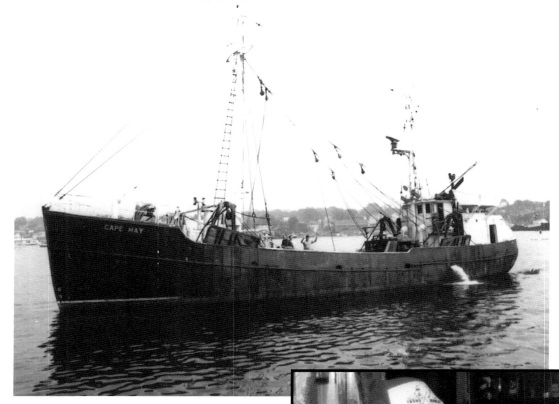

Photograph courtesy of Glenn Sutherland.

BOAT: *Cape May*
HORSEPOWER: 765
GROSS: 163
NET: 111
DIMENSIONS: 85.5 x 21.4 x 13
WHEN BUILT: 1946
WHERE BUILT: Groton, Connecticut
OWNER: Heroic Inc., Massachusetts
CREW: Captain Don Sutherland, Mate Thomas "Obie" O'Brien, Engineer Manuel Enos, Jim Tucker, Ray Bouchie, and Cook James Reed
SOUGHT-AFTER SPECIES: lobster
FATE: Sold to New Bedford, converted over to scalloping, presently fishing under same name
FLEET SUB-CATEGORY: offshore
HULL MATERIAL: steel

CAPT. SCROD

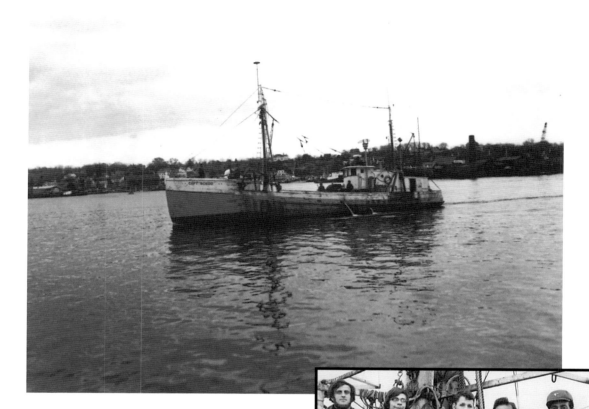

BOAT: *Capt. Scrod*
HORSEPOWER: 450
GROSS: 80
NET: 55
DIMENSIONS: 77.8 x 18.2 x 9.2
WHEN BUILT: 1944
WHERE BUILT: Waldoboro, Maine
OWNER: Boat Captain Scrod Inc., Massachusetts
CREW: Captain Dominic, Joe and Jimmy Novello, Peter Favazza, Cook Joe Rat and Sal Russo
SOUGHT-AFTER SPECIES: herring and groundfish
FATE: Sank
FLEET SUB-CATEGORY: offshore
HULL MATERIAL: wood

CARLO & VINCE

BOAT: *Carlo & Vince*
HORSEPOWER: 150
GROSS: 61
NET: 41
DIMENSIONS: 75.1 x 18.3 x 8.8
WHEN BUILT: 1932
WHERE BUILT: Essex, Massachusetts
OWNER: Carlo & Vince Inc., Massachusetts
CREW: Acting Captain John "Red" Parisi, Robert "Stubby" Taylor, Salvatore "Tally" Nicastro and Jimmy Parisi. The regular captain is Donnie Favazza.
SOUGHT-AFTER SPECIES: shrimp and whiting
FATE: Sank at wharf, later towed out to sea and sunk
FLEET SUB-CATEGORY: inshore
HULL MATERIAL: wood

Carole & Gary

BOAT: *Carole & Gary*
HORSEPOWER: 425
GROSS: 144
NET: 98
DIMENSIONS: 90.1 x 21.5 x 11.7
WHEN BUILT: 1945
WHERE BUILT: Boothbay Harbor, Maine
OWNER: Carole & Gary Inc., Massachusetts
CREW: Captain Salvatore and son Nicholas Curcuru, "Tito" Segas, Thomas Cavanaugh, John Parisi, Bobby Miller, Arthur Carter, and Elmer "Butchy" Maddix.
SOUGHT-AFTER SPECIES: groundfish
FATE: Sold to New Bedford, converted to scalloping, present fate unknown
FLEET SUB-CATEGORY: offshore
HULL MATERIAL: wood

CAROLYN RENE

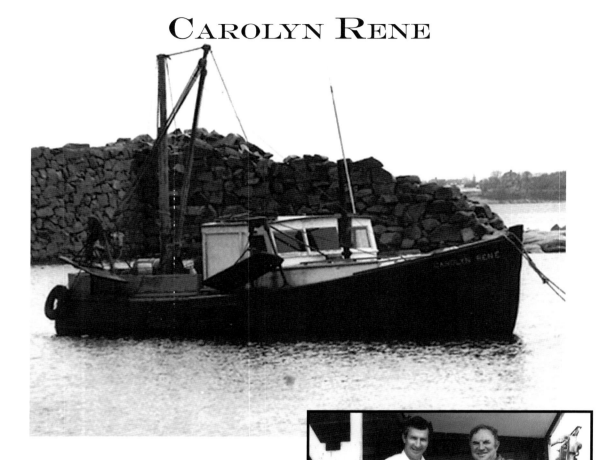

BOAT: *Carolyn Rene*
HORSEPOWER: 81
GROSS: 12
NET: 10
DIMENSIONS: 31.1 x 11.7 x 4.9
WHEN BUILT: 1957
WHERE BUILT: Gloucester, Massachusetts
OWNER: Winthrop A. Davis
CREW: Captain Winthrop "Bunt" Davis and Frank Muise
SOUGHT-AFTER SPECIES: shrimp and groundfish
FATE: Vessel is still afloat but not actively fishing
FLEET SUB-CATEGORY: inshore
HULL MATERIAL: wood

CIGAR JOE II

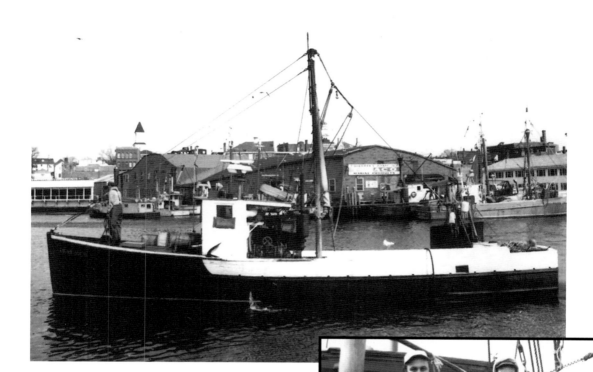

BOAT: *Cigar Joe II*
HORSEPOWER: 165
GROSS: 16
NET: 10
DIMENSIONS: 45 x 12.8 x 5.9
WHEN BUILT: 1947
WHERE BUILT: Port Clyde, Maine
OWNER: Boat Cigar Joe Inc., Massachusetts
CREW: Captain Sebastian "Busty" and brother Salvatore Frontiero
SOUGHT-AFTER SPECIES: shrimp, whiting and groundfish
FATE: Sank
FLEET SUB-CATEGORY: inshore
HULL MATERIAL: wood

CLINTON

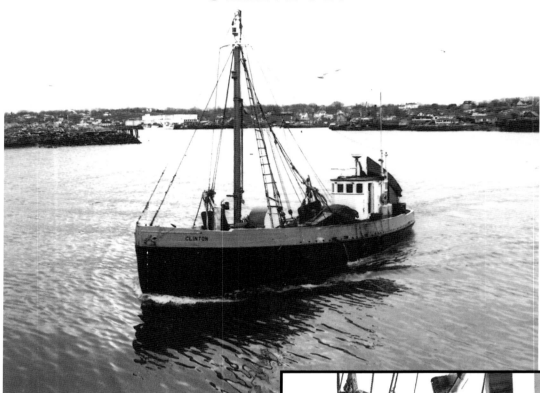

BOAT: *Clinton*
HORSEPOWER: 160
GROSS: 40
NET: 15
DIMENSIONS: 61.5 x 16.3 x 8.1
WHEN BUILT: 1925
WHERE BUILT: Thomaston, Maine
OWNER: Boat Clinton Inc., Massachusetts
CREW: Captain James "Spaba" and
William Bertolino
SOUGHT-AFTER SPECIES: whiting and groundfish
FATE: Sank
FLEET SUB-CATEGORY: inshore
HULL MATERIAL: wood

CURLEW

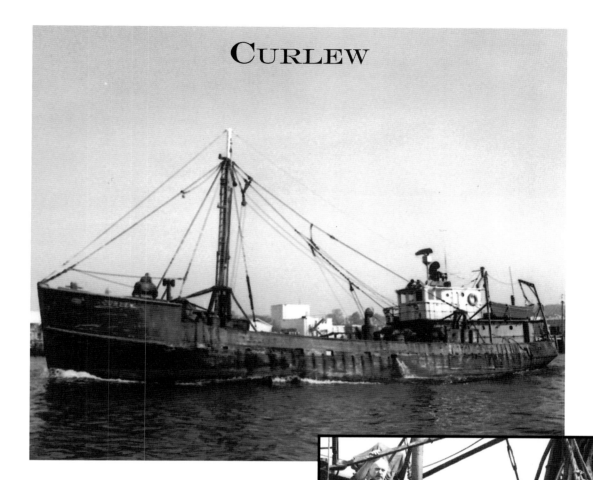

BOAT: *Curlew*
HORSEPOWER: 400
GROSS: 156
NET: 106
DIMENSIONS: 100 x 21.4 x 12.3
WHEN BUILT: 1942
WHERE BUILT: East Providence, Rhode Island
OWNER: Curlew Fishing Corp., Massachusetts
CREW: Ray Morash, Capt. Dominic Montagnino, Sven Sharch, Zeak Enos, Roy Amero, Cook Paul Hollaran, and Engineer Sam Amero
SOUGHT-AFTER SPECIES: groundfish
FATE: Sold to Lakeman family, later sank off of Maine coast as a dragger
FLEET SUB-CATEGORY: offshore
HULL MATERIAL: wood

DEBBIE ROSE

BOAT: *Debbie Rose*
HORSEPOWER: 495
GROSS: 67
NET: 33
DIMENSIONS: 66.1 x 17.4 x 9.2
WHEN BUILT: 1941
WHERE BUILT: South Bristol, Maine
OWNER: Boat Debbie Rose, Inc.
CREW: Captain John, Sal Jr. and Sal Randazza, Sr., Larry Joyce and J.J. Ciarametaro
SOUGHT-AFTER SPECIES: shrimp and whiting
FATE: Sold to New Bedford, converted over to scalloping, presently fishing
FLEET SUB-CATEGORY: middle
HULL MATERIAL: wood

DOLPHIN

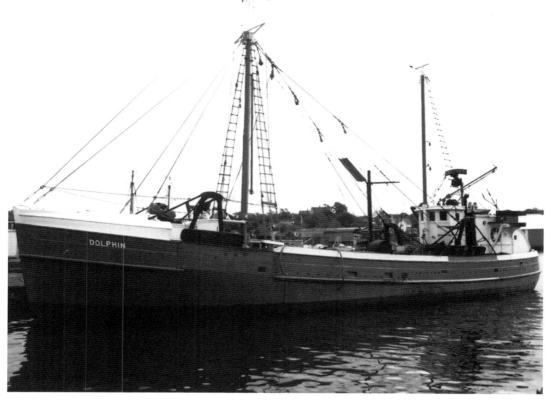

BOAT: *Dolphin*
HORSEPOWER: 250
GROSS: 115
NET: 78
DIMENSIONS: 78.4 x 21.1 x 11
WHEN BUILT: 1946
WHERE BUILT: Thomaston, Maine
OWNER: Boat Dolphin Inc., Massachusetts
CREW: (no crew photo) Captain Murray "Bud" and Leslie Williams, Engineer
Clinton E. Flygare, Dave White and Cook Larry Oliver
SOUGHT-AFTER SPECIES: lobster
FATE: Sold, became a pogie carrier and later sank
FLEET SUB-CATEGORY: offshore
HULL MATERIAL: wood

EMILY BROWN

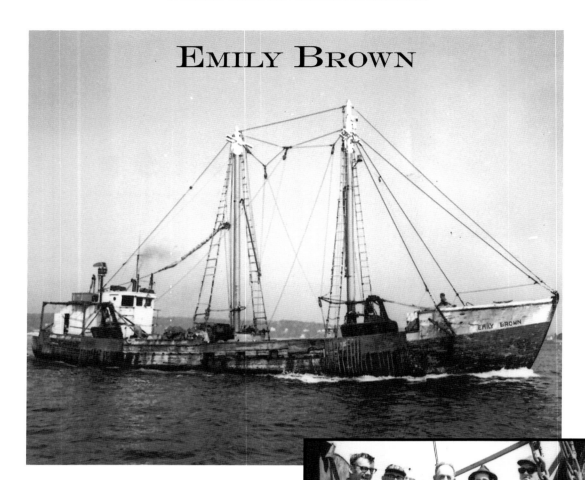

BOAT: *Emily Brown*
HORSEPOWER: 400
GROSS: 153
NET: 67
DIMENSIONS: 95.8 x 24 x 11.6
WHEN BUILT: 1944
WHERE BUILT: Ipswich, Massachusetts
OWNER: B&B Trawling Co.
CREW: Lou Blue, Captain Joe Pallazola, Engineer Lester Gray, Cook Maxie Joyce, Guerrino Cavallarin and Arthur Carter
SOUGHT-AFTER SPECIES: groundfish
FATE: Sank
FLEET SUB-CATEGORY: offshore
HULL MATERIAL: wood

FALCON

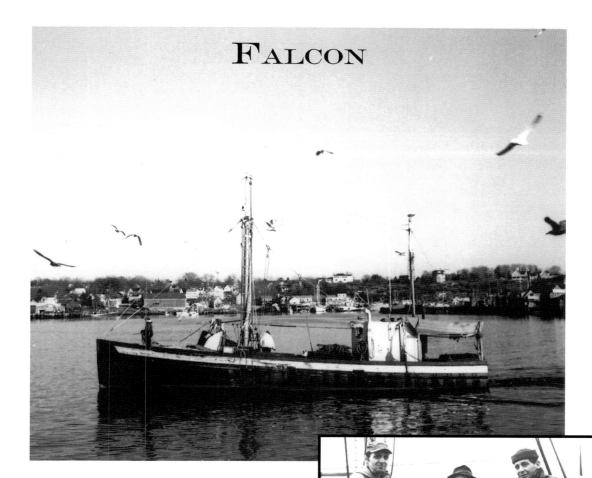

BOAT: *Falcon*
HORSEPOWER: 165
GROSS: 29
NET: 12
DIMENSIONS: 58.8 x 14.8 x 7
WHEN BUILT: 1932
WHERE BUILT: Thomaston, Maine
OWNER: Falcon Inc., Massachusetts
CREW: Frank, Captain Serafino and Anthony Favalora
SOUGHT-AFTER SPECIES: shrimp, whiting and groundfish
FATE: Sank
FLEET SUB-CATEGORY: inshore
HULL MATERIAL: wood

FRANCES M.

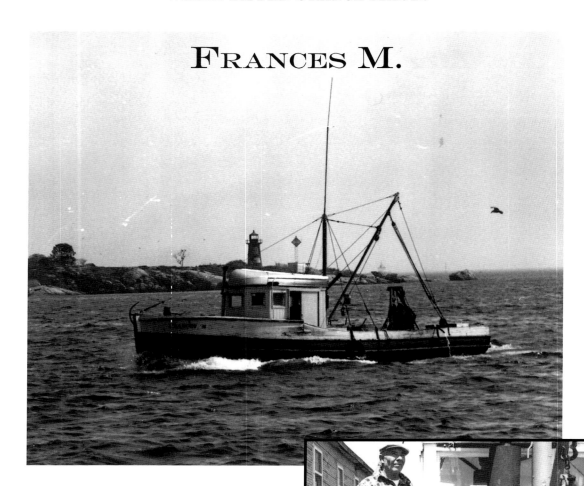

BOAT: *Frances M.*
HORSEPOWER: 110
GROSS: 24
NET: 19
DIMENSIONS: 49.9 x 13 x 5
WHEN BUILT: 1943
WHERE BUILT: Portsmouth, Virginia
OWNER: Rose M. Inc., Massachusetts
CREW: Captain Ignazio Maltese
SOUGHT-AFTER SPECIES: groundfish
FATE: Sold to Boston fisherman, later sank
FLEET SUB-CATEGORY: inshore
HULL MATERIAL: wood

FRANCES R.

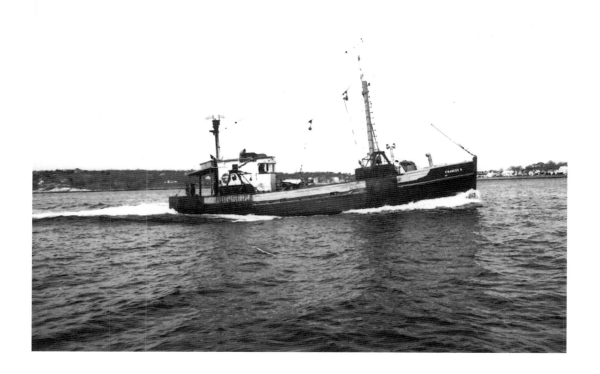

BOAT: *Frances R.*
HORSEPOWER: 250
GROSS: not available
NET: not available
DIMENSIONS: 60.6 x 17.7 x 9.3
WHEN BUILT: 1945
WHERE BUILT: Gloucester, Massachusetts
OWNER: William E. Ragusa
CREW: (no crew photo) Captain William and brothers Carl and Frank Ragusa, John Tarantino and Frank Ragusa Jr.
SOUGHT-AFTER SPECIES: shrimp, whiting and groundfish
FATE: Sank
FLEET SUB-CATEGORY: inshore
HULL MATERIAL: wood

GAETANO S.

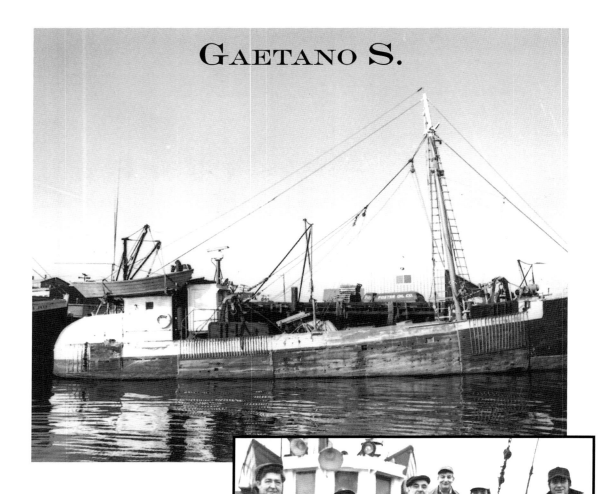

BOAT: *Gaetano S.*
HORSEPOWER: 350
GROSS: 111
NET: 76
DIMENSIONS: 85.1 x 20.1 x 11.1
WHEN BUILT: 1944
WHERE BUILT: Essex, Massachusetts
OWNER: Boat Gaetano S Inc., Massachusetts
CREW: Captain Joseph Parisi, Engineer Salvatore Parisi, Cook John Polizzia, John Buntrow, Sam Scola, and Mate "Spikey" Scola
SOUGHT-AFTER SPECIES: groundfish
FATE: Sank
FLEET SUB-CATEGORY: offshore
HULL MATERIAL: wood

GRACE & SALVATORE

BOAT: *Grace & Salvatore*
HORSEPOWER: 450
GROSS: 112
NET: 82
DIMENSIONS: 75.8 x 20 x 10
WHEN BUILT: 1958
WHERE BUILT: South Bristol, Maine
OWNER: Boat St. Anthony Inc., Massachusetts
CREW: Captain Sam "Boogie" Frontierro, Tony "Small Man" Frontierro, Vince Frontierro, Engineer Bruce Leavitt, Tony Cilufo, Carlo Lovasco and John Brooks
SOUGHT-AFTER SPECIES: groundfish
FATE: Sank
FLEET SUB-CATEGORY: offshore
HULL MATERIAL: wood

HAZEL B.

BOAT: *Hazel B.*
HORSEPOWER: 320
GROSS: 119
NET: 60
DIMENSIONS: 80 x 21.4 x 10.9
WHEN BUILT: 1945
WHERE BUILT: Winthrop, Massachusetts
OWNER: Trawler Emil C. Inc.
CREW: Captain Mickey Parisi, Jerry Nicastro, Paul Taro, Cook Anthony Aiello, Joe Mooter, and Engineer Sam Demetri
SOUGHT-AFTER SPECIES: groundfish
FATE: Sank
FLEET SUB-CATEGORY: offshore
HULL MATERIAL: wood

HOLY CROSS

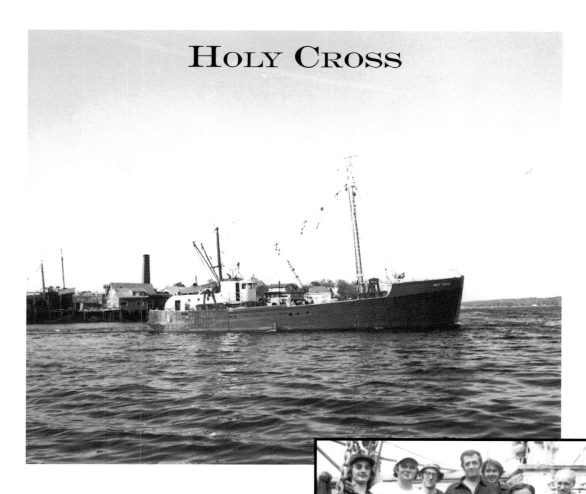

BOAT: *Holy Cross*
HORSEPOWER: 900
GROSS: 179
NET: 121
DIMENSIONS: 86 x 23.6 x 12.4
WHEN BUILT: 1942
WHERE BUILT: Rockland, Maine
OWNER: Holy Cross Vessel Inc., Massachusetts
CREW: Mike Randazza, Engineer Jerry, Amby and Captain Salvatore Lovasco, Cook Santo Farina, Phil Parisi and Sammy Loiacano
SOUGHT-AFTER SPECIES: groundfish
FATE: Sank off Maine coast
FLEET SUB-CATEGORY: offshore
HULL MATERIAL: wood

HOLY FAMILY

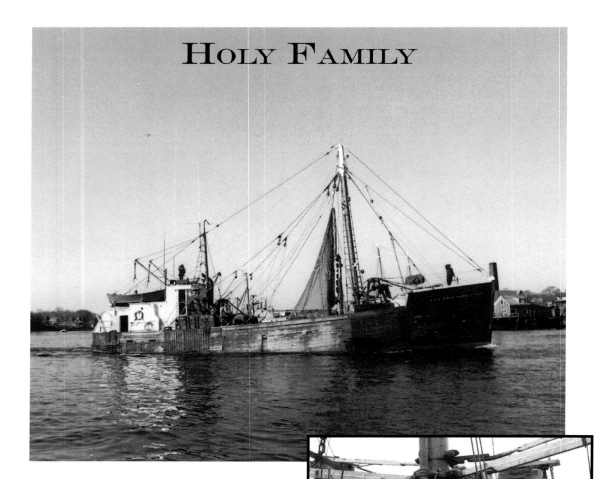

BOAT: *Holy Family*
HORSEPOWER: 480
GROSS: 124
NET: 64
DIMENSIONS: 87.9 x 21.2 x 11.1
WHEN BUILT: 1944
WHERE BUILT: Essex, Massachusetts
OWNER: Trawler Holy Family Inc., Massachusetts
CREW: Captain Carlo and Engineer Sebastian Moceri, Salvatore P. Curcuru, Cook Gaspar Lucido, Anthony Lafata, and Samuel Pallazola
SOUGHT-AFTER SPECIES: groundfish
FATE: Sank
FLEET SUB-CATEGORY: offshore
HULL MATERIAL: wood

HUNTER

BOAT: *Hunter*
HORSEPOWER: 240
GROSS: 26
NET: 18
DIMENSIONS: 50 x 16.4 x 6
WHEN BUILT: 1960
WHERE BUILT: Bena, Virginia
OWNER: Vessel Hunter, Inc., Massachusetts
CREW: Captain Sam and Vito LoGrasso, Salvatore DiMercurio and Anthony Noto
SOUGHT-AFTER SPECIES: shrimp, whiting and groundfish
FATE: Sold to another Gloucester fisherman, recently destroyed by U.S. Government fishing vessel buy-back program
FLEET SUB-CATEGORY: inshore
HULL MATERIAL: wood

HUNTRESS

BOAT: *Huntress*
HORSEPOWER: 165
GROSS: 14
NET: 9
DIMENSIONS: 35.5 x 13 x 5.1
WHEN BUILT: 1956
WHERE BUILT: South Bristol, Maine
OWNER: Cynthia Loiacano
CREW: Captain John "Chubby" Loiacano,
Ralph Loiacano and Kevin Curley
SOUGHT-AFTER SPECIES: groundfish
FATE: Sold back to Boothbay Harbor, Maine, fisherman, later fate unknown
FLEET SUB-CATEGORY: inshore
HULL MATERIAL: wood

IDA & JOSEPH

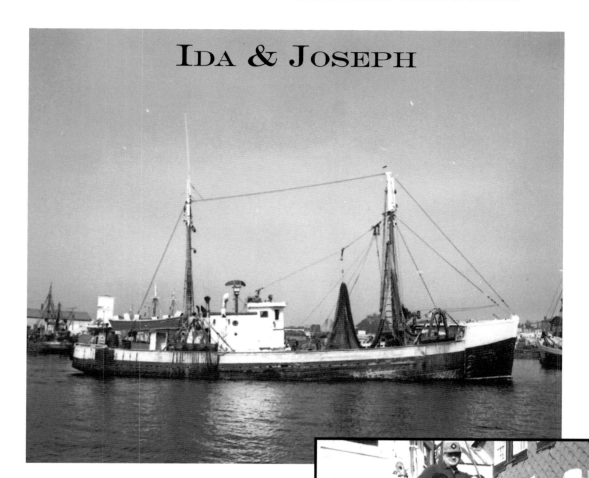

BOAT: *Ida & Joseph*
HORSEPOWER: 380
GROSS: 75
NET: 51
DIMENSIONS: 78.5 x 19.6 x 8.8
WHEN BUILT: 1941
WHERE BUILT: Kennebunkport, Maine
OWNER: Boat Ida & Joseph Inc.
CREW: Engineer William Parisi, James Orlando, Dominic Parisi, Cook Joseph Loiacano, Mate Joseph and Steve D'Amico, and Captain Joseph Calomo
SOUGHT-AFTER SPECIES: pogies during summer, whiting, shrimp, herring and groundfish during fall, winter and spring
FATE: Sank
FLEET SUB-CATEGORY: middle
HULL MATERIAL: wood

ISAAC FASS

BOAT: *Isaac Fass*
HORSEPOWER: 215
GROSS: 53
NET: 25
DIMENSIONS: 59.8 x 18.9 x 7.6
WHEN BUILT: 1917
WHERE BUILT: West Norfolk, Virginia
OWNER: Dory John Inc., Massachusetts
CREW: (no crew photo) Captain Robert Bruce, Eugene "Bud" Young and Einar Erlensson
SOUGHT-AFTER SPECIES: shrimp, whiting and groundfish
FATE: Vessel went ashore along outer Gloucester Harbor west shore and later broke apart
FLEET SUB-CATEGORY: inshore
HULL MATERIAL: wood

JEANNE D'ARC

BOAT: *Jeanne D'Arc*
HORSEPOWER: 510
GROSS: 117
NET: 83
DIMENSIONS: 85.4 x 20 x 10
WHEN BUILT: 1942
WHERE BUILT: South Portland, Maine
OWNER: Ocean Trawling Inc., Massachusetts
CREW: Salvatore LoPiccolo, Mate Frank Lucido, Carlo Ciolino, Pasquale Cottone, Cook Nino Bruno and acting Captain Joseph Parco. The regular captain is Serafino "Sophie" Favazza.
SOUGHT-AFTER SPECIES: groundfish
FATE: Sank
FLEET SUB-CATEGORY: offshore
HULL MATERIAL: wood

Photograph courtesy of Mary Favazza.

JO-ANN

BOAT: *Jo-Ann*
HORSEPOWER: 165
GROSS: 34
NET: 14
DIMENSIONS: 50.7 x 16.8 x 6
WHEN BUILT: 1948
WHERE BUILT: St. Augustine, Florida
OWNER: Boat Jo-Ann Inc., Massachusetts
CREW: (no crew photo) Captain Sam "Red" and sons Sam Jr. and Anthony Favaloro, and Joe Zappa
SOUGHT-AFTER SPECIES: shrimp, whiting and groundfish
FATE: Sold to Newport, Rhode Island fisherman, later went aground and sank
FLEET SUB-CATEGORY: inshore
HULL MATERIAL: wood

JOSEPH & LUCIA II

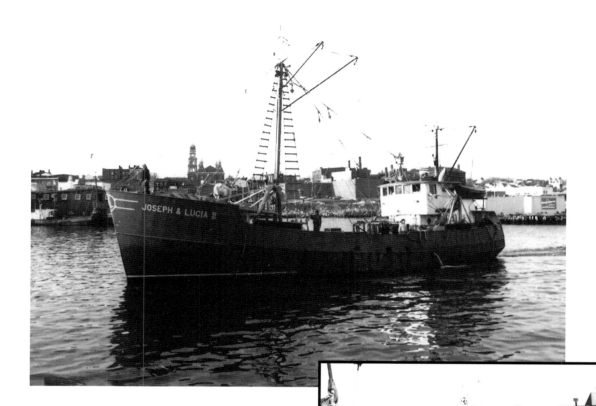

BOAT: *Joseph & Lucia II*
HORSEPOWER: 680
GROSS: 179
NET: 122
DIMENSIONS: 88.1 x 22.6 x 12.5
WHEN BUILT: 1964
WHERE BUILT: Somerset, Massachusetts
OWNER: Boat St. Victoria Inc., Massachusetts
CREW: Engineer Gaetano "Tommy" G. and
Captain Nino Brancaleone, John Baptiste
Novello, Jackie Favazza, Carlo Randazza,
Anibal Senos and John Sanfilippo
SOUGHT-AFTER SPECIES: groundfish, whiting and lobster
FATE: Sold to a New Bedford scallop fisherman, currently scalloping there
FLEET SUB-CATEGORY: offshore
HULL MATERIAL: steel

JOSEPH & LUCIA III

BOAT: *Joseph & Lucia III*
HORSEPOWER: 900
GROSS: 192
NET: 109
DIMENSIONS: 90.6 x 24.2 x 13.3
WHEN BUILT: 1968
WHERE BUILT: Dorchester, New Jersey
OWNER: Joseph & Lucia Inc., Massachusetts
CREW: Chief Tony, Joe "Charlie" and Captain Gaetano "Tommy" G. Brancaleone, Cook Gil Roderick, Gaspar Pallazola, Santo Aloi and Frank D'Amico
SOUGHT-AFTER SPECIES: groundfish, whiting and lobster
FATE: Sold to a New Bedford scallop fisherman; vessel currently scalloping there
FLEET SUB-CATEGORY: offshore
HULL MATERIAL: steel

JUDITH LEE ROSE

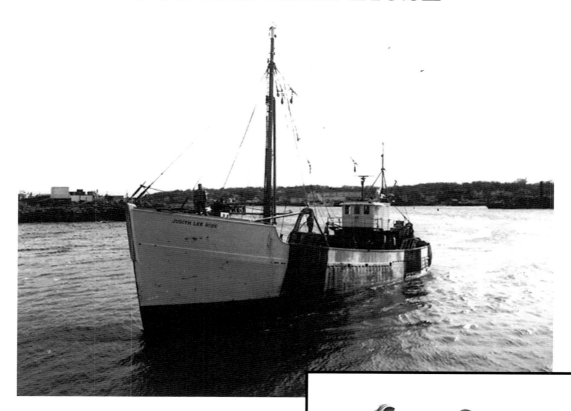

BOAT: *Judith Lee Rose*
HORSEPOWER: 613
GROSS: 198
NET: 100
DIMENSIONS: 103.9 x 24.2 x 12.2
WHEN BUILT: 1952
WHERE BUILT: Southwest Harbor, Maine
OWNER: Rose Fisheries Inc., Massachusetts
CREW: Frank Domingos, Cook Peter Manning, Captain Frank Rose Jr., Engineer Alan Murray, Gus Doyle, Mate Mike Maher and Dick Tucker
SOUGHT-AFTER SPECIES: lobster
FATE: Sank
FLEET SUB-CATEGORY: offshore
HULL MATERIAL: wood

KATIE D.

BOAT: *Katie D.*
HORSEPOWER: 515
GROSS: 114
NET: 77
DIMENSIONS: 87.2 x 20 x 10.8
WHEN BUILT: 1943
WHERE BUILT: Thomaston, Maine
OWNER: Vito C. Corp., Massachusetts
CREW: Salvatore DiGaetano, Joe Alba,
Tony Tocco, Peter Taormina, Captain
Vito Ciaramitaro, Sam Margiotta and Salvatore Cracchiolo
SOUGHT-AFTER SPECIES: groundfish
FATE: Vessel sank bow first while out fishing—pulling heavy load of fish aboard
caused mast to go through deck and bottom
FLEET SUB-CATEGORY: offshore
HULL MATERIAL: wood

LADY IN BLUE

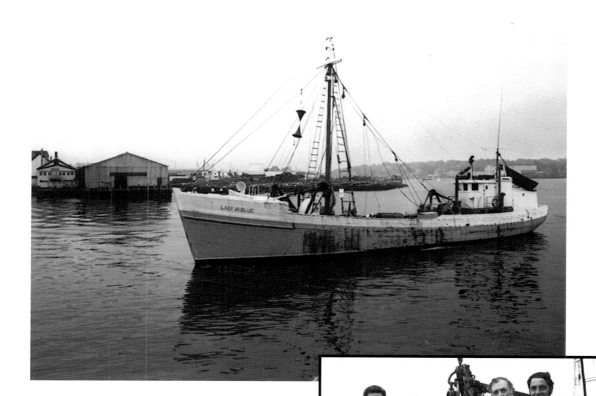

BOAT: *Lady in Blue*
HORSEPOWER: 500
GROSS: 199
NET: 135
DIMENSIONS: 92.1 x 20.8 x 10.2
WHEN BUILT: 1941
WHERE BUILT: Brooklyn, New York
OWNER: Lady in Blue Inc., Massachusetts
CREW: Captain Sam Frontierro, Engineer Andrew Corrao, Cook Joe Parisi and Gaspar and Jerry Pallozola
SOUGHT-AFTER SPECIES: shrimp, whiting and groundfish
FATE: Vessel was sold, refurbished as a windjammer on the West Coast
FLEET SUB-CATEGORY: offshore
HULL MATERIAL: wood

LADY OF GOOD VOYAGE

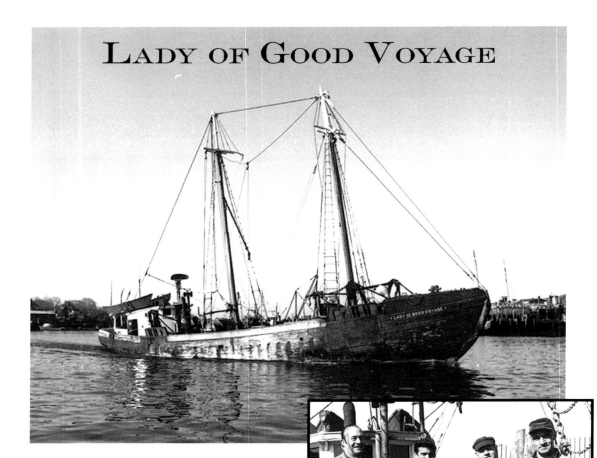

BOAT: *Lady of Good Voyage*
HORSEPOWER: 260
GROSS: 80
NET: 54
DIMENSIONS: 83 x 21 x 9.2
WHEN BUILT: 1941
WHERE BUILT: Ipswich, Massachusetts
OWNER: Lady of Good Voyage Inc., Massachusetts
CREW: Captain Manuel Rocha, Cook Marcalo Vagos, Joseph Bom, Hugh Amero and Baptiste Pallazolo
SOUGHT-AFTER SPECIES: lobster
FATE: Vessel sold to a Fulton Fish Market dealer who had Gloucester fisherman and Captain Joe Novello sail the ship down to the British Honduras where vessel was to fish for red snapper and grouper. A hurricane later washed the vessel ashore and smashed it to pieces.
FLEET SUB-CATEGORY: offshore
HULL MATERIAL: wood

LADY OF THE ROSARY

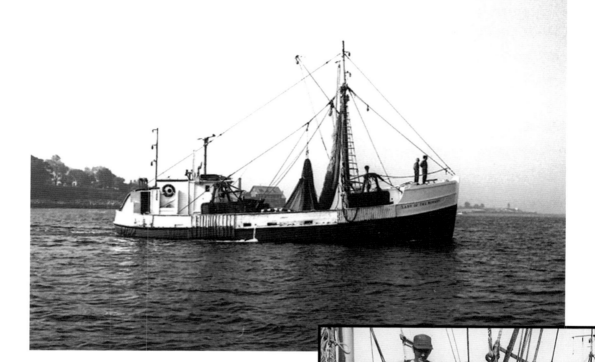

BOAT: *Lady of the Rosary*
HORSEPOWER: 270
GROSS: 47
NET: 19
DIMENSIONS: 57 x 17.8 x 9.8
WHEN BUILT: 1952
WHERE BUILT: McKinley, Maine
OWNER: Lady of the Rosary Inc., Massachusetts
CREW: Captain Gaspare and Tom Trupiano, Cook Mike Genovese, Anthony Frontiero, Dominic Orlando and Salvatore Cracchiolo
SOUGHT-AFTER SPECIES: whiting, shrimp and groundfish
FATE: Sank
FLEET SUB-CATEGORY: middle
HULL MATERIAL: wood

LAST CHANCE

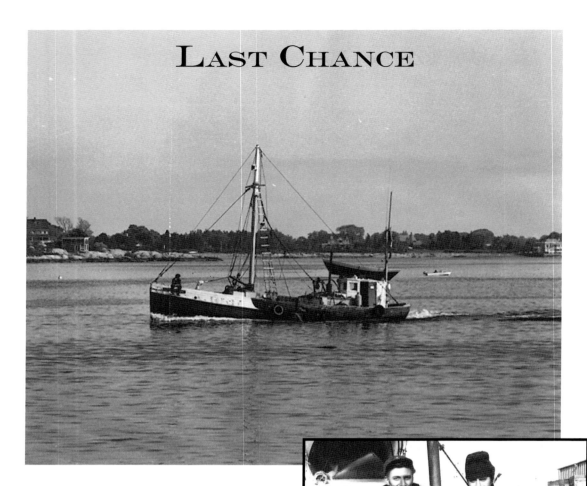

BOAT: *Last Chance*
HORSEPOWER: 81
GROSS: 20
NET: 14
DIMENSIONS: 45.7 x 13.8 x 5.5
WHEN BUILT: 1925
WHERE BUILT: Newcastle, Maine
OWNER: Last Chance Inc., Massachusetts
CREW: Captain Anino "Andy" Frontiero and son Samuel Frontiero
SOUGHT-AFTER SPECIES: whiting, shrimp and groundfish
FATE: Sold to New Jersey fisherman, fate unknown
FLEET SUB-CATEGORY: inshore
HULL MATERIAL: wood

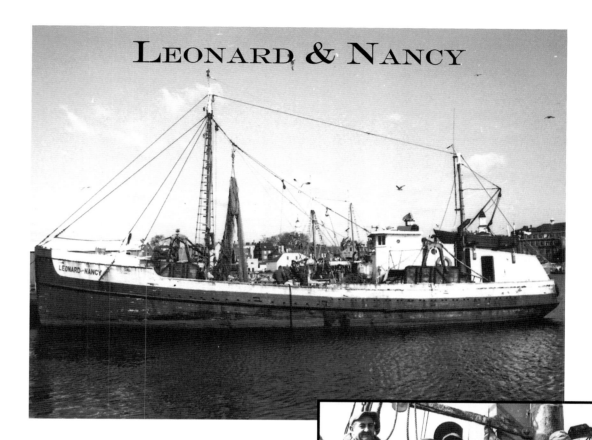

LEONARD & NANCY

BOAT: *Leonard & Nancy*
HORSEPOWER: 250
GROSS: 90
NET: 61
DIMENSIONS: 74.6 x 19.2 x 11
WHEN BUILT: 1946
WHERE BUILT: Waldoboro, Maine
OWNER: Ferrigno, Sylvester J.
CREW: Captain Thomas, Sebastian "Busty"
and Amby Scola, Joe Catania, Cook Vito
Pallazola and Engineer Sal Ferrigno
SOUGHT-AFTER SPECIES: groundfish and shrimp
FATE: Sank
FLEET SUB-CATEGORY: offshore
HULL MATERIAL: wood

LINDA B.

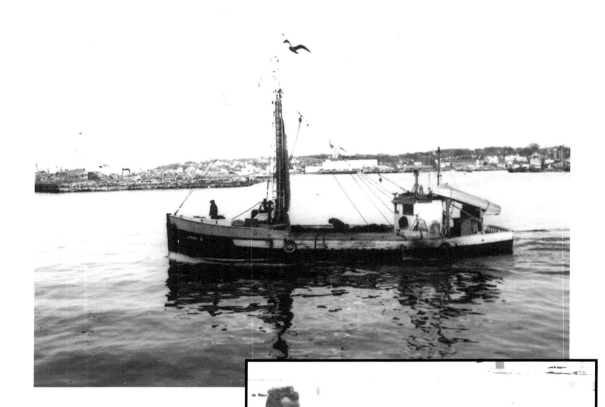

BOAT: *Linda B.*
HORSEPOWER: 145
GROSS: 33
NET: 23
DIMENSIONS: 48.2 x 14.3 x 6.2
WHEN BUILT: 1949
WHERE BUILT: Quincy,
Massachusetts
OWNER: Boat Linda B. Inc.,
Massachusetts
CREW: Captain Rosario "Salvi" and sons John and Joseph Testaverde, and Thomas
Frontiero
SOUGHT-AFTER SPECIES: whiting, shrimp, herring and groundfish
FATE: Vessel is still afloat tied to Fishermen's Wharf and currently not fishing
FLEET SUB-CATEGORY: inshore
HULL MATERIAL: wood

Little Flower

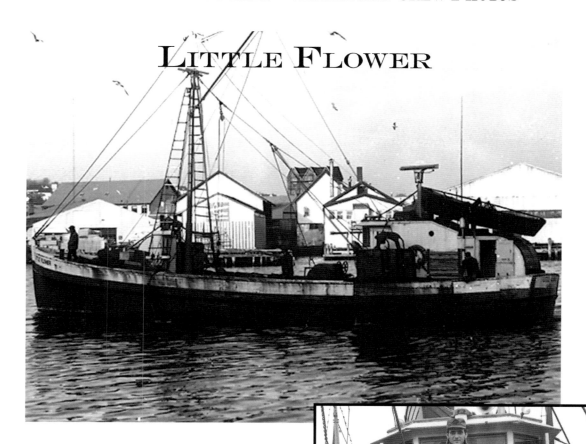

BOAT: *Little Flower*
HORSEPOWER: 171
GROSS: 43
NET: 29
DIMENSIONS: 61.1 x 15.2 x 7.0
WHEN BUILT: 1949
WHERE BUILT: South Bristol, Maine
OWNER: Boat Little Flower Inc., Massachusetts
CREW: Peter Taormina, Filippo Bono, Giacomo & Captain Vito Ferrara, and Salvatore Cracchiolo
SOUGHT-AFTER SPECIES: shrimp, whiting and groundfish
FATE: Sank
FLEET SUB-CATEGORY: inshore
HULL MATERIAL: wood

MARIA G.S.

BOAT: *Maria G.S.*
HORSEPOWER: 165
GROSS: 25
NET: 11
DIMENSIONS: 45 x 16.2 x 5.0
WHEN BUILT: 1940
WHERE BUILT: St. Augustine, Florida
OWNER: Boat Maria G.S. Inc., Massachusetts
CREW: Captain Joseph Sanfilippo and sons Antonino "Tony," Ignazio "Naz" and Salvatore "Sal-Sans" Sanfilippo
SOUGHT-AFTER SPECIES: shrimp, whiting and groundfish
FATE: Sold to Newburyport fisherman, refurbished into a gillnetter, presently fishing as *Sea Mistress*
FLEET SUB-CATEGORY: inshore
HULL MATERIAL: wood

MARY ANN

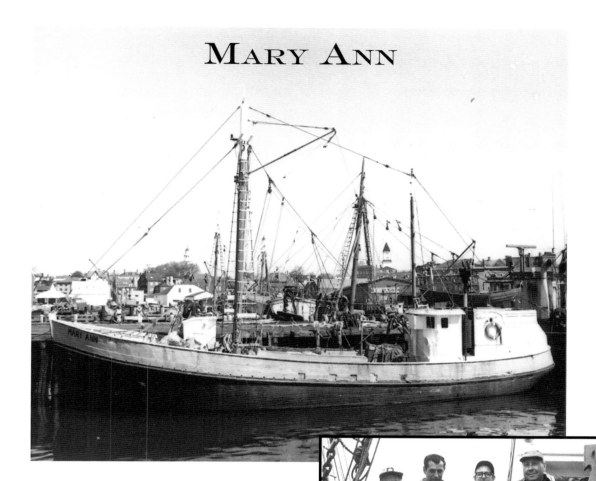

BOAT: *Mary Ann*
HORSEPOWER: 260
GROSS: 70
NET: 57
DIMENSIONS: 64.4 x 17.8 x 9.4
WHEN BUILT: 1954
WHERE BUILT: South Bristol, Maine
OWNER: Dragger Mary Ann Inc., Massachusetts
CREW: Captain Frank Consiglio, Joseph LoGrasso, Gerome Palazola, Joe Scola and Mike Linquata
SOUGHT-AFTER SPECIES: shrimp, whiting and groundfish
FATE: Sold to Gloucester fisherman, later became the *Carmella* and then sank
FLEET SUB-CATEGORY: inshore
HULL MATERIAL: wood

MARY ROSE

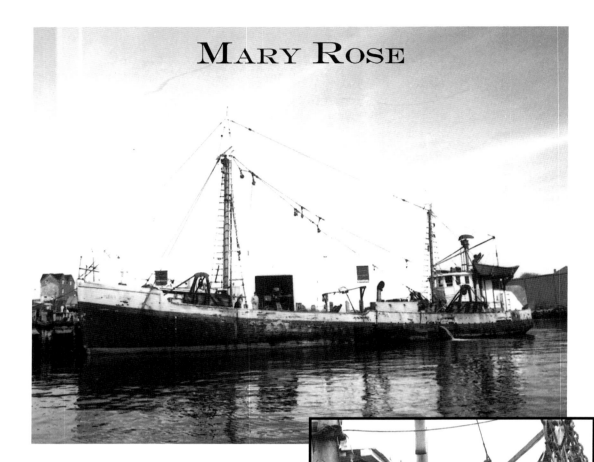

BOAT: *Mary Rose*
HORSEPOWER: 675
GROSS: 134
NET: 91
DIMENSIONS: 96.8 x 21.5 x 11.2
WHEN BUILT: 1943
WHERE BUILT: Southwest Harbor, Maine
OWNER: Boat M. & C. Inc., Massachusetts
CREW: Mike Dimercurio, Captain Alfonzo & Nino Millefoglie, Nino Ciaramitaro, Stephano Adelfio, Anthony Capone and Benny Favazza
SOUGHT-AFTER SPECIES: groundfish
FATE: Vessel sank shortly after this crew photo was taken. Captain Alphonse Millefoglie went on to buy the 101.4-foot *Little Al* (the former *Wawenock* from Maine) and Nino Ciaramitaro purchased the 88-foot *Mary Grace* (the former *Francis J. O'Hara* from Rockland, Maine)
FLEET SUB-CATEGORY: offshore
HULL MATERIAL: wood

MAUREEN

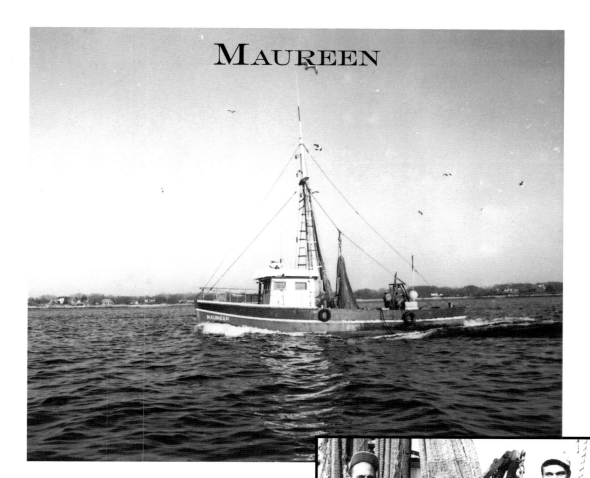

BOAT: *Maureen*
HORSEPOWER: 165
GROSS: 28
NET: 21
DIMENSIONS: 45.9 x 14.3 x 7.8
WHEN BUILT: 1946
WHERE BUILT: Newport, Rhode Island
OWNER: Boat Maureen Inc., Massachusetts
CREW: Captain Santo Militello, Matteo Groppo and Michael LoGrande
Sought-after species: shrimp, whiting and groundfish
FATE: Vessel was sold to a Boston fisherman
FLEET SUB-CATEGORY: inshore
HULL MATERIAL: wood

MOTHER & GRACE

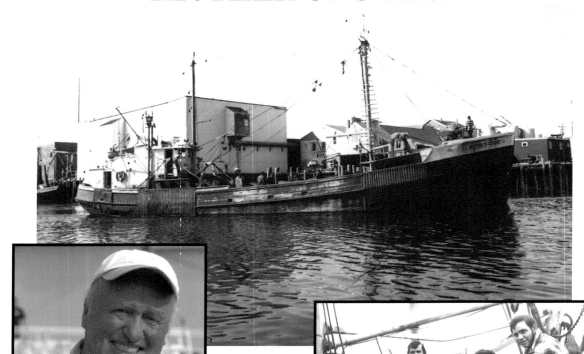

BOAT: *Mother & Grace*
HORSEPOWER: 480
GROSS: 117
NET: 82
DIMENSIONS: 82.6 x 20.3 x 9.3
WHEN BUILT: 1957
WHERE BUILT: South Bristol, Maine
OWNER: Moceri Family Inc., Massachusetts
CREW: Captain Sebastian "Busty," Joseph, Peter and Engineer Carlo (missing in photo) Moceri, Salvatore Pallazola, Cook Frank Aloi, Salvatore Curcuru, Matteo Loiacano and Peter Noto
SOUGHT-AFTER SPECIES: groundfish
FATE: Sank
FLEET SUB-CATEGORY: offshore
HULL MATERIAL: wood

NATALIE III

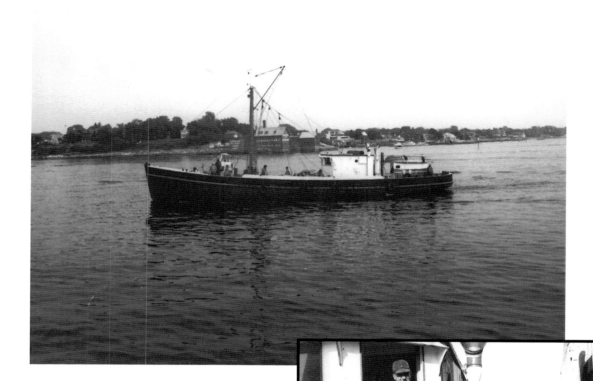

BOAT: *Natalie III*
HORSEPOWER: 380
GROSS: 79
NET: 53
DIMENSIONS: 84.2 x 20 x 8.6
WHEN BUILT: 1940
WHERE BUILT: Kennebunkport, Maine
OWNER: Uncle Sam of 76 Inc., Massachusetts
CREW: Cook Peter Ciolino, Captain Anthony Linquata, Engineer Joe Curcuru, Ambrose Verga, Anthony Bertolino and Salvatore Aiello
SOUGHT-AFTER SPECIES: shrimp, herring, whiting and groundfish
FATE: Sank
FLEET SUB-CATEGORY: middle
HULL MATERIAL: wood

NJORTH

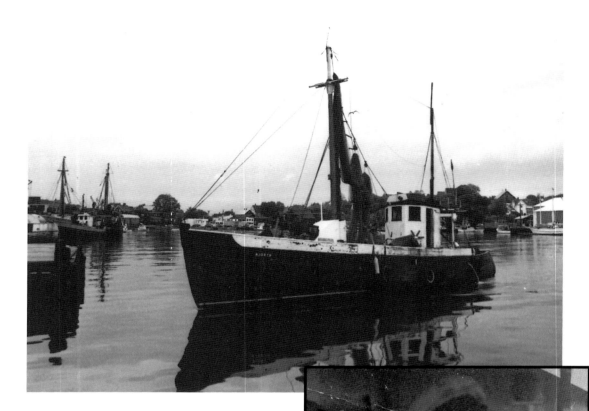

BOAT: *Njorth*
HORSEPOWER: 90
GROSS: 22
NET: 10
DIMENSIONS: 50 x 14.2 x 6.2
WHEN BUILT: 1926
WHERE BUILT: Thomaston, Maine
OWNER: Boat Njorth Inc., Massachusetts
CREW: Captain Charles Frontiero and Carlo Orlando
SOUGHT-AFTER SPECIES: groundfish and whiting
FATE: Sank
FLEET SUB-CATEGORY: inshore
HULL MATERIAL: wood

Photograph courtesy of Charles "Chuck" Frontiero.

OUR LADY OF FATIMA

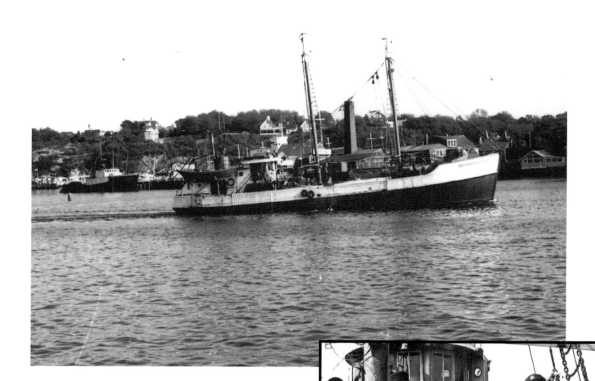

BOAT: *Our Lady of Fatima*
HORSEPOWER: 400
GROSS: 192
NET: 131
DIMENSIONS: 92.5 x 23.7 x 12.5
WHEN BUILT: 1952
WHERE BUILT: Brooklyn, New York, and Newport, Rhode Island
OWNER: Our Lady of Fatima, Inc., Massachusetts
CREW: Ray Richards, Captain Cecilio J. Cecilio, Cook E. J. Dare, William Russell, Albino Bola and Joe Fradola
SOUGHT-AFTER SPECIES: lobster and flatfish
FATE: Hit Provincetown Breakwater, vessel later totaled by insurance company
FLEET SUB-CATEGORY: offshore
HULL MATERIAL: wood

PATRIOT

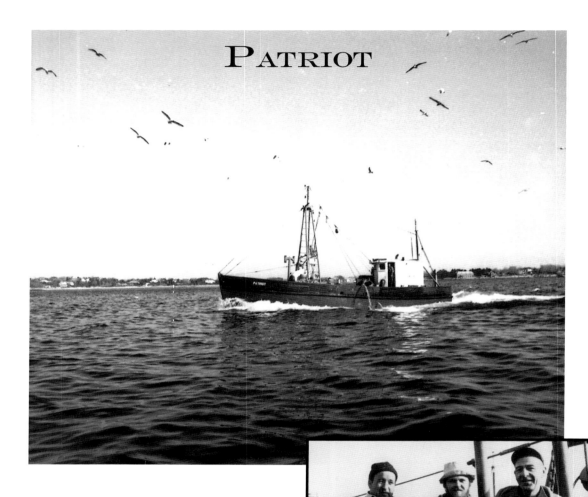

BOAT: *Patriot*
HORSEPOWER: 250
GROSS: 28
NET: 12
DIMENSIONS: 47.3 x 12. 9 x 6.9
WHEN BUILT: 1946
WHERE BUILT: Gloucester, Massachusetts
OWNER: Prosperity of Gloucester Inc.,
Massachusetts
CREW: Captain Bill and son Peter Muise,
and George Cabral
SOUGHT-AFTER SPECIES: shrimp, whiting and groundfish
FATE: Sank
FLEET SUB-CATEGORY: inshore
HULL MATERIAL: wood

PEGGYBELL

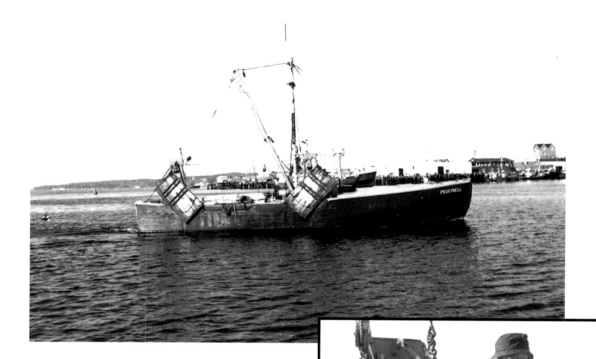

BOAT: *Peggybell*
HORSEPOWER: 81
GROSS: 20
NET: 12
DIMENSIONS: 40 x 12 x 4
WHEN BUILT: 1927
WHERE BUILT: Friendship, Maine
OWNER: Charles Sibley
CREW: Captain Charles Sibley
SOUGHT-AFTER SPECIES: groundfish
FATE: Sold, later sank at wharf in Gloucester where vessel was finally demolished
FLEET SUB-CATEGORY: inshore
HULL MATERIAL: wood

PEPPY

BOAT: *Peppy*
HORSEPOWER: 190
GROSS: 65
NET: 31
DIMENSIONS: 61.6 x 18.4 x 8.5
WHEN BUILT: 1954
WHERE BUILT: St. Augustine, Florida
OWNER: Peppy Corp., Massachusetts
CREW: Captain Thomas, Peppy and Lario Randazza, and Jerry Nicastro
SOUGHT-AFTER SPECIES: herring, whiting, shrimp and groundfish
FATE: Sank
FLEET SUB-CATEGORY: inshore
HULL MATERIAL: wood

PETER & JOSEPHINE

BOAT: *Peter & Josephine*
HORSEPOWER: 380
GROSS: 48
NET: 33
DIMENSIONS: 56.9 x 17.8 x 8.2
WHEN BUILT: 1945
WHERE BUILT: Solomons, Maryland
OWNER: Peter & Josephine Inc., Massachusetts
CREW: Captain Frank Cottone, Giovanni Sanfilippo, Guiseppe Baldassano, and Giochinno Cusumano
SOUGHT-AFTER SPECIES: shrimp and whiting
FATE: Sank
FLEET SUB-CATEGORY: inshore
HULL MATERIAL: wood

PROVIDENZA

BOAT: *Providenza*
HORSEPOWER: 150
GROSS: 19
NET: 13
DIMENSIONS: 41.7 x 13.3 x 5.5
WHEN BUILT: 1928
WHERE BUILT: Winthrop, Massachusetts
OWNER: Boat Providenza Inc., Massachusetts
CREW: Captain Paul and Peter Conti
SOUGHT-AFTER SPECIES: groundfish
FATE: Sold and later sank
FLEET SUB-CATEGORY: inshore
HULL MATERIAL: wood

RHODE ISLAND

BOAT: *Rhode Island*
HORSEPOWER: 300
GROSS: 58
NET: 45
DIMENSIONS: 64.7 x 18.1 x 9.1
WHEN BUILT: 1946
WHERE BUILT: Waldoboro, Maine
OWNER: Boat Rhode Island Inc., Massachusetts
CREW: Captain Anthony Trupiano, Busty Serio, Engineer Sam, Ambrose and Joseph Parisi, and Cook Gus Sutera
SOUGHT-AFTER SPECIES: whiting, shrimp and groundfish
FATE: Hit Gloucester Breakwater and later sank
FLEET SUB-CATEGORY: middle
HULL MATERIAL: wood

ROSALIE L.

BOAT: *Rosalie L.*
HORSEPOWER: 81
GROSS: not available
NET: not available
DIMENSIONS: 45 x 13
WHEN BUILT: 1954
WHERE BUILT: Nova Scotia
OWNER: Joseph Loiacano
CREW: Captain Joseph Loiacano and Anthony Pizzimenti
SOUGHT-AFTER SPECIES: whiting and groundfish
FATE: Later sold and became a seine boat, vessel was later dry-docked where it remains today
FLEET SUB-CATEGORY: inshore
HULL MATERIAL: wood

ROSANNE MARIA

BOAT: *Rosanne Maria*
HORSEPOWER: 155
GROSS: 63
NET: 24
DIMENSIONS: 70 x 17.8 x 9.1
WHEN BUILT: 1941
WHERE BUILT: Winthrop, Massachusetts
OWNER: Roseanne Maria Corp., Massachusetts
CREW: Captain Stephen and Engineer Louis Biondo, Cook Baptiste Lafata and James Interrante
SOUGHT-AFTER SPECIES: shrimp, whiting and groundfish
FATE: Rammed by an East German side trawler, vessel later sank on June 4, 1972, about 23 miles northeast of Gloucester.
FLEET SUB-CATEGORY: middle
HULL MATERIAL: wood

Photograph (top) courtesy of Mrs. Stephen Biondo.
Photograph (bottom) courtesy of Louis Biondo.

Photograph courtesy of Paul Scola.

BOAT: *Rose Marie*
HORSEPOWER: 180
GROSS: 62
NET: 31
DIMENSIONS: 80x18x9
WHEN BUILT: 1930
WHERE BUILT: Damariscotta, Maine
OWNER: The Rose Marie, Inc.
CREW: Captain Paul and brothers Joseph & Peter Scola, Andrew Orlando and Anthony Bertolino
SOUGHT-AFTER SPECIES: shrimp, whiting and groundfish
FATE: Vessel sank on January 18, 1971, about 30 miles SE of Gloucester
FLEET SUB-CATEGORY: middle
HULL MATERIAL: wood

SAINT JOSEPH

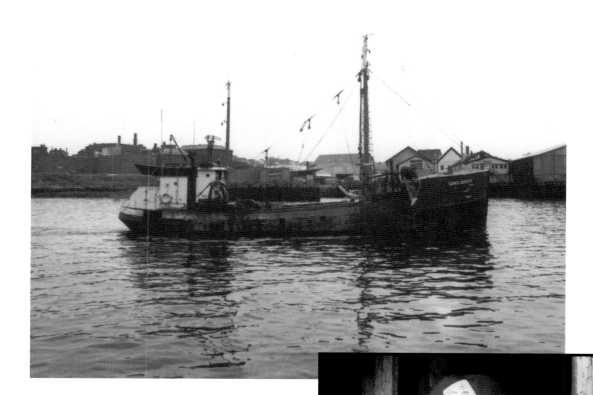

BOAT: *Saint Joseph*
HORSEPOWER: 240
GROSS: 77
NET: 62
DIMENSIONS: 72.2 x 17.8 x 9.4
WHEN BUILT: 1953
WHERE BUILT: South Bristol, Maine
OWNER: Saint Joseph Vessel Inc., Massachusetts
CREW: Captain Peter, Ambrose and Salvatore "Sam" Lovasco, Kenny Taylor, Robert York, Walter Wilkins and "Georgie" Palazola
SOUGHT-AFTER SPECIES: groundfish
FATE: Sank
FLEET SUB-CATEGORY: offshore
HULL MATERIAL: wood

Photograph courtesy of Geri "Mimi" Lovasco.

SALVATORE P.

BOAT: *Salvatore P.*
HORSEPOWER: 260
GROSS: 66
NET: 45
DIMENSIONS: 81.1 x 18 x 8.2
WHEN BUILT: 1932
WHERE BUILT: Essex, Massachusetts
OWNER: Salvatore P. Inc., Massachusetts
CREW: Captain Mike and Engineer James Parisi, Serafino Pallazola, Tony Riberio and Paul DiMaria
SOUGHT-AFTER SPECIES: shrimp, whiting and groundfish
FATE: Sold to Maine fisherman, renamed *Side Winder*, later sank
FLEET SUB-CATEGORY: middle
HULL MATERIAL: wood

SANDRA JANE

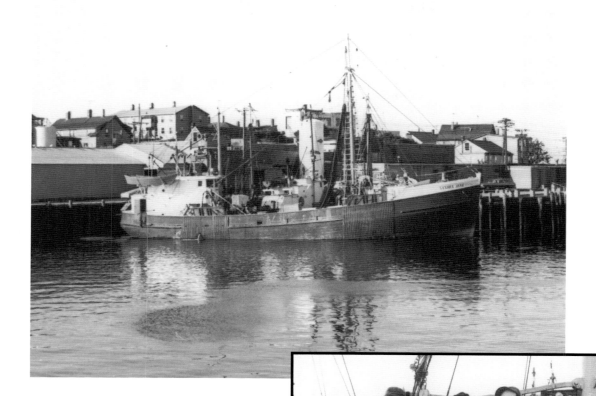

BOAT: *Sandra Jane*
HORSEPOWER: 480
GROSS: 137
NET: 95
DIMENSIONS: 83 x 21.1 x 10.7
WHEN BUILT: 1958
WHERE BUILT: South Bristol, Maine
OWNER: Ann & Grace Inc., Massachusetts
CREW: Engineer Anthony Barbara, Captain Salvatore "Sam" and Mate Matt Militello, Frank and Joseph Groppo, Joseph Ciolino and Gus Larocca
SOUGHT-AFTER SPECIES: groundfish
FATE: Sank
FLEET SUB-CATEGORY: offshore
HULL MATERIAL: wood

SANDRA JEAN

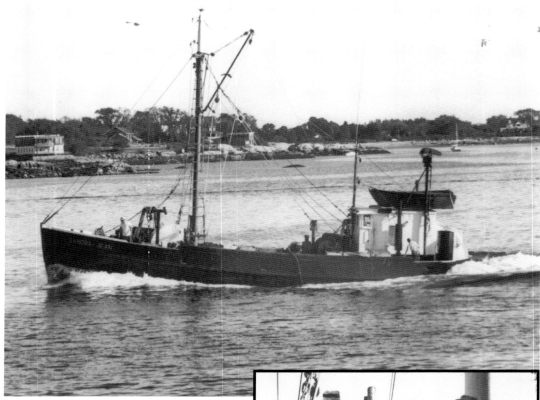

BOAT: *Sandra Jean*
HORSEPOWER: 220
GROSS: 39
NET: 26
DIMENSIONS: 62.6 x 16.7 x 7.4
WHEN BUILT: 1945
WHERE BUILT: Southwest Harbor, Maine
OWNER: Boat Sandra & Jean Inc., Massachusetts
CREW: Philip Parisi, Jim Nicastro, Captain Augustus Demetri and Cook Francesco LoGrasso
SOUGHT-AFTER SPECIES: shrimp, whiting and groundfish
FATE: Sank
FLEET SUB-CATEGORY: inshore
HULL MATERIAL: wood

SANTA LUCIA

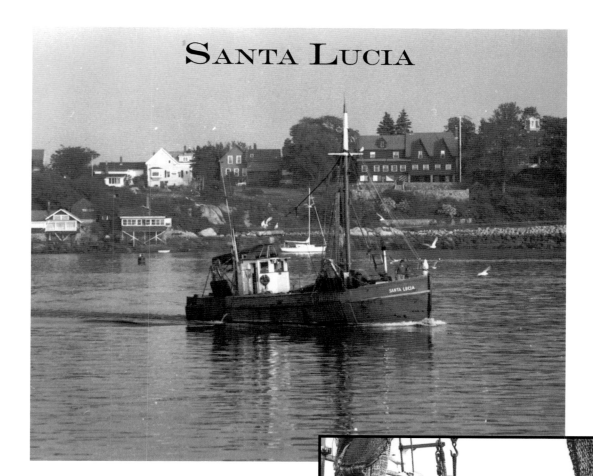

BOAT: *Santa Lucia*
HORSEPOWER: 200
GROSS: 40
NET: 27
DIMENSIONS: 56.9 x 15.2 x 8.1
WHEN BUILT: 1940
WHERE BUILT: Gloucester, Massachusetts
OWNER: Boat Santa Lucia Inc., Massachusetts
CREW: Captain Frank P and Gaetano Brancaleone, Jack Lombardo and Tony Ciluffo
SOUGHT-AFTER SPECIES: shrimp, whiting and groundfish
FATE: Sank off Maine coast
FLEET SUB-CATEGORY: inshore
HULL MATERIAL: wood

SANTA MARIA

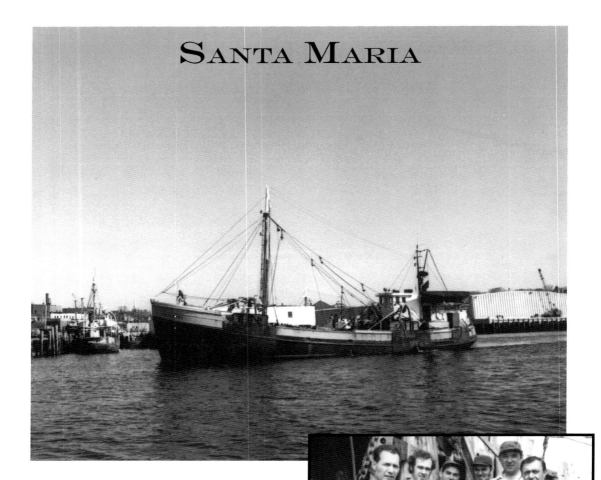

BOAT: *Santa Maria*
HORSEPOWER: 595
GROSS: 121
NET: 82
DIMENSIONS: 76.2 x 21.2 x 10
WHEN BUILT: 1965
WHERE BUILT: South Bristol, Maine
OWNER: Gloucester Santa Maria Inc.,
Massachusetts
CREW: Captain Antonino "Tony" and
Engineer Peter Genovese, Mate Joe
Marino, Leo Bertolino, Cook Anthony Ballarin, Mike Fontana and Dominic Bologna
SOUGHT-AFTER SPECIES: groundfish
FATE: Sank
FLEET SUB-CATEGORY: offshore
HULL MATERIAL: wood

SEA BREEZE

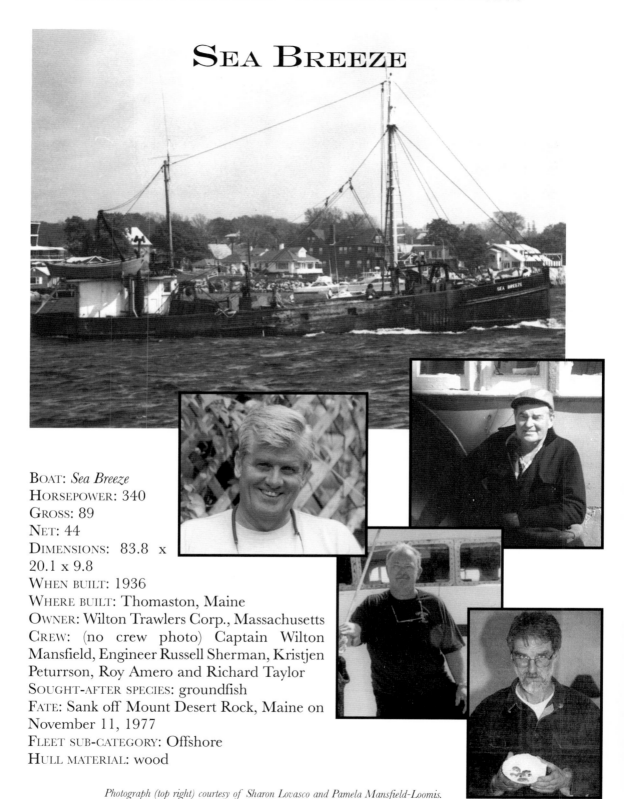

BOAT: *Sea Breeze*
HORSEPOWER: 340
GROSS: 89
NET: 44
DIMENSIONS: 83.8 x 20.1 x 9.8
WHEN BUILT: 1936
WHERE BUILT: Thomaston, Maine
OWNER: Wilton Trawlers Corp., Massachusetts
CREW: (no crew photo) Captain Wilton Mansfield, Engineer Russell Sherman, Kristjen Peturrson, Roy Amero and Richard Taylor
SOUGHT-AFTER SPECIES: groundfish
FATE: Sank off Mount Desert Rock, Maine on November 11, 1977
FLEET SUB-CATEGORY: Offshore
HULL MATERIAL: wood

Photograph (top right) courtesy of Sharon Lovasco and Pamela Mansfield-Loomis.

SEA BUDDY

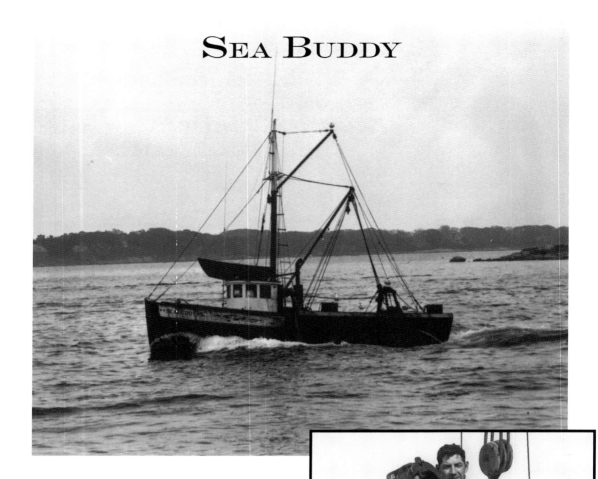

BOAT: *Sea Buddy*
HORSEPOWER: 165
GROSS: 12
NET: 8
DIMENSIONS: 34.8 x 11.5 x 5.6
WHEN BUILT: 1929
WHERE BUILT: Fairhaven, Massachusetts
OWNER: Sea Buddy Inc., Massachusetts
CREW: Captain Anthony "Ollie" Pallazola
SOUGHT-AFTER SPECIES: whiting and groundfish
FATE: Sank
FLEET SUB-CATEGORY: inshore
HULL MATERIAL: wood

SERAFINA N.

BOAT: *Serafina N.*
HORSEPOWER: 160
GROSS: 80
NET: 62
DIMENSIONS: 104.1 x 14.9 x 8.1
WHEN BUILT: 1917
WHERE BUILT: Port Clinton, Ohio
OWNER: Philip and Salvatore "Sam" Nicastro
CREW: Captain Phil Nicastro and brothers Baptiste, Joseph and John Nicastro
SOUGHT-AFTER SPECIES: shrimp, whiting and groundfish
FATE: Vessel beached at Pavillion Beach, demolished there, trucked to dump
FLEET SUB-CATEGORY: inshore
HULL MATERIAL: wood

SERAFINA II

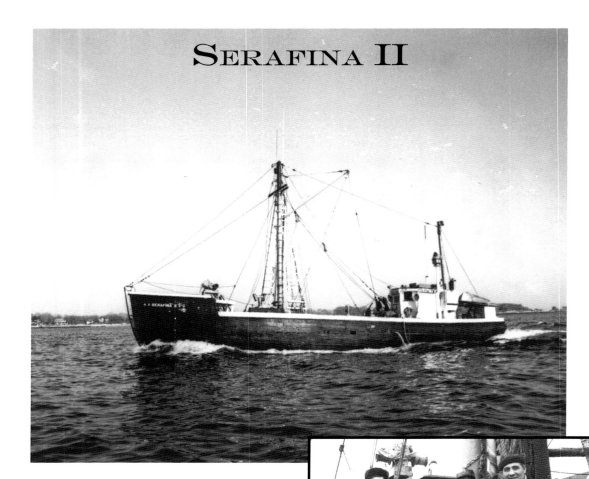

BOAT: *Serafina II*
HORSEPOWER: 315
GROSS: 49
NET: 23
DIMENSIONS: 69.7 x 17.5 x 7.6
WHEN BUILT: 1926
WHERE BUILT: Rockport, Massachusetts
OWNER: Boat Serafina II Inc., Massachusetts
CREW: Captain Ben Chianciola and Engineer Ben Chianciola, Cook Vito Ferrante and Mate Vincent Salafia
SOUGHT-AFTER SPECIES: shrimp, whiting, herring and groundfish
FATE: Sank
FLEET SUB-CATEGORY: middle
HULL MATERIAL: wood

SPRAY

BOAT: *Spray*
HORSEPOWER: 82
GROSS: 35
NET: 7
DIMENSIONS: 49.5 x 15.5 x 6.3
WHEN BUILT: 1957
WHERE BUILT: Fernadina Beach, Florida
OWNER: Fishing vessel Spray Inc., Massachusetts
CREW: Captain Joseph "Spray" Saputo and Otavio Saputo and Joe Orlando
SOUGHT-AFTER SPECIES: shrimp, whiting and groundfish
FATE: Vessel later changed hands in Gloucester. That owner later sold the vessel to someone out of state. It's unknown if vessel is still afloat.
FLEET SUB-CATEGORY: inshore
HULL MATERIAL: wood

ST. BERNADETTE

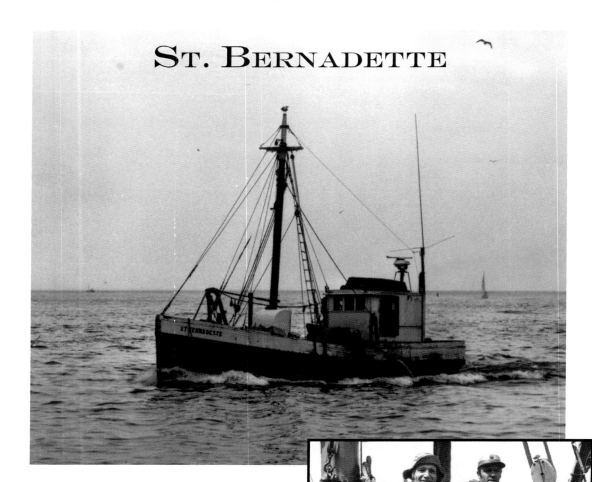

BOAT: *St. Bernadette*
HORSEPOWER: 165
GROSS: 31
NET: 21
DIMENSIONS: 56.7 x 14.8 x 7.1
WHEN BUILT: 1930
WHERE BUILT: Plymouth, Massachusetts
OWNER: St. Bernadette Inc., Massachusetts
CREW: Captain Sam Orlando and Vincent "Jimmy" Saputo
SOUGHT-AFTER SPECIES: whiting and groundfish
FATE: Sold to Boston man, vessel ended up on Lynn Marshes across from General Electric plant
FLEET SUB-CATEGORY: inshore
HULL MATERIAL: wood

ST. GEORGE

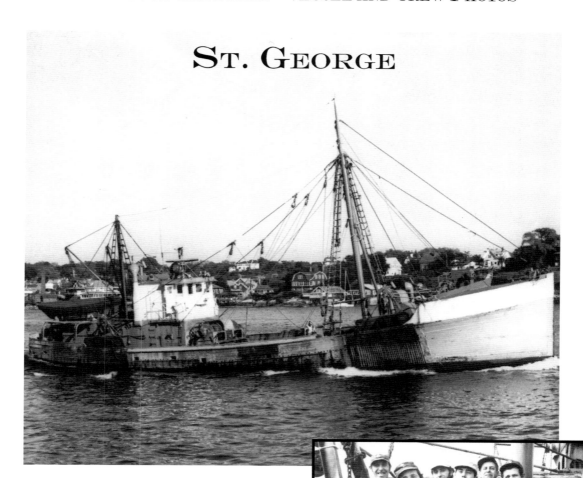

BOAT: *St. George*
HORSEPOWER: 550
GROSS: 176
NET: 99
DIMENSIONS: 105.5 x 23.6 x 11.8
WHEN BUILT: 1940
WHERE BUILT: Rockland, Maine
OWNER: Boat St. George Inc., Massachusetts
CREW: Captain Antonino "Tony," Cook Frank and Engineer Simone Sanfilippo, Dominic Taormina, Salvatore Noto, and Joseph Orlando. Missing is Thomas Ciulla.
SOUGHT-AFTER SPECIES: groundfish
FATE: Sank
FLEET SUB-CATEGORY: offshore
HULL MATERIAL: wood

St. John II

BOAT: *St. John II*
HORSEPOWER: 160
GROSS: 18
NET: 12
DIMENSIONS: 41.5 x 12.9 x 7.1
WHEN BUILT: 1950
WHERE BUILT: Gloucester, Massachusetts
OWNER: Elite Inc., Massachusetts
CREW: Captain Russell and Todd Wonson
SOUGHT-AFTER SPECIES: whiting and groundfish
FATE: Sank at dock and was later demolished
FLEET SUB-CATEGORY: inshore
HULL MATERIAL: wood

ST. JUDE

BOAT: *St. Jude*
HORSEPOWER: 200
GROSS: 42
NET: 15
DIMENSIONS: 66 x 16.8 x 8.0
WHEN BUILT: 1930
WHERE BUILT: Damariscotta, Maine
OWNER: Sebastiana C. Inc., Massachusetts
CREW: Captain Mike, Sebastian, Sr. and Sebastian Jr. Lovasco, and Cook Anthony Parisi
SOUGHT-AFTER SPECIES: shrimp, whiting and groundfish
FATE: Sank
FLEET SUB-CATEGORY: inshore
HULL MATERIAL: wood

ST. MARY

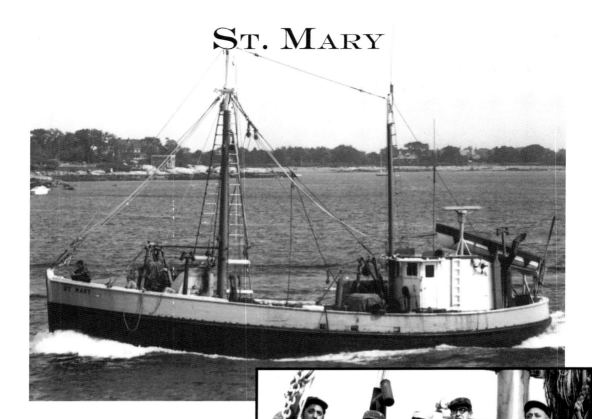

BOAT: *St. Mary*
HORSEPOWER: 380
GROSS: 50
NET: 34
DIMENSIONS: 56.1 x 17.1 x 9.2
WHEN BUILT: 1951
WHERE BUILT: South Bristol, Maine
OWNER: Boat St. Mary Inc., Massachusetts
CREW: Captain Dominic, Emilio and Michael Spinola, and Sam Scola
SOUGHT-AFTER SPECIES: herring, whiting, shrimp and groundfish
FATE: Vessel stopped fishing out of Gloucester in the 1990s and was later sold to a Boston fisherman.
FLEET SUB-CATEGORY: inshore
HULL MATERIAL: wood

ST. NICHOLAS

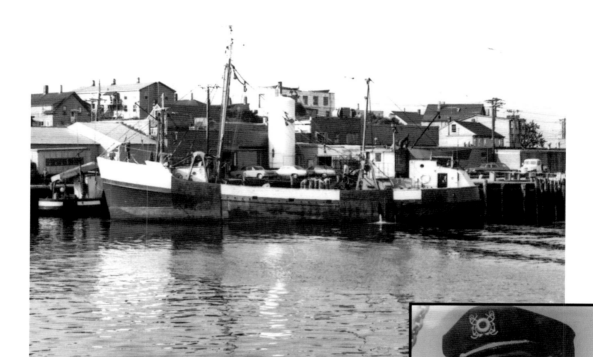

BOAT: *St. Nicholas*
HORSEPOWER: 760
GROSS: 137
NET: 93
DIMENSIONS: 84.2 x 22.6 x 11.6
WHEN BUILT: 1965
WHERE BUILT: Boothbay Harbor, Maine
OWNER: St. Nicholas Inc., Massachusetts
CREW: (no crew photo) Captain Thomas, Paul, Nicholas and Cosmo Parisi, Cook Marino Orlando, Engineer Frank Pallazola and Thomas Linquata
SOUGHT-AFTER SPECIES: groundfish
FATE: Sank
FLEET SUB-CATEGORY: offshore
HULL MATERIAL: wood

Photograph (top) courtesy of Charles Nicastro.
Photograph (bottom) courtesy of family.

ST. PETER

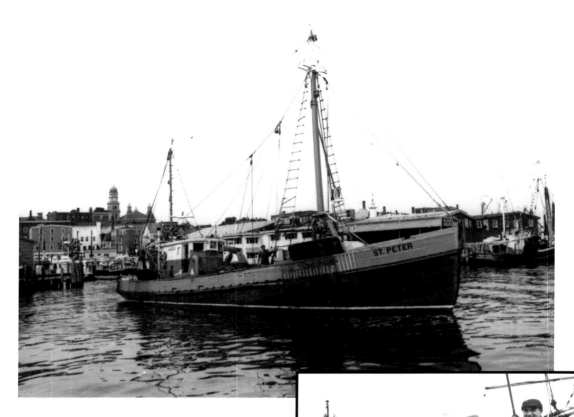

BOAT: *St. Peter*
HORSEPOWER: 340
GROSS: 62
NET: 50
DIMENSIONS: 74.5 x 19.2 x 8.9
WHEN BUILT: 1927
WHERE BUILT: Essex, Massachusetts
OWNER: Boat St. Peter Inc., Massachusetts
CREW: Captain Sebastian "Busty" Sr., Sebastian "Busty" Jr., and Sammy Scola, Cook Frank Marino and Thomas Lupo
SOUGHT-AFTER SPECIES: herring, whiting, shrimp and groundfish
FATE: Sank
FLEET SUB-CATEGORY: middle
HULL MATERIAL: wood

ST. PETER III

BOAT: *St. Peter III*
HORSEPOWER: 220
GROSS: 46
NET: 31
DIMENSIONS: 62.6 x 18.3 x 7.2
WHEN BUILT: 1956
WHERE BUILT: Cape May, New Jersey
OWNER: Boat St. Peter III Inc., Massachusetts
CREW: (no crew photo) Captain Thomas and Cook Peter Favazza, Engineer Tony Gallo and Joe Frontiero
SOUGHT-AFTER SPECIES: herring, whiting, shrimp and groundfish
FATE: Sold to Boston man to serve as a fish carrier, present fate unknown
FLEET SUB-CATEGORY: middle
HULL MATERIAL: wood

Photograph (top) courtesy of Sara Favazza.
Photograph (bottom) courtesy of Donna Kyrouz.

ST. PROVIDENZA

BOAT: *St. Providenza*
HORSEPOWER: 150
GROSS: 24
NET: 10
DIMENSIONS: 49.4 x 15 x 5.7
WHEN BUILT: 1924
WHERE BUILT: Amesbury, Massachusetts
OWNER: Boat St. Providenza Inc., Massachusetts
CREW: Captain Thomas and Anthony Aiello
SOUGHT-AFTER SPECIES: groundfish and whiting
FATE: Sank
FLEET SUB-CATEGORY: inshore
HULL MATERIAL: wood

ST. ROSALIE

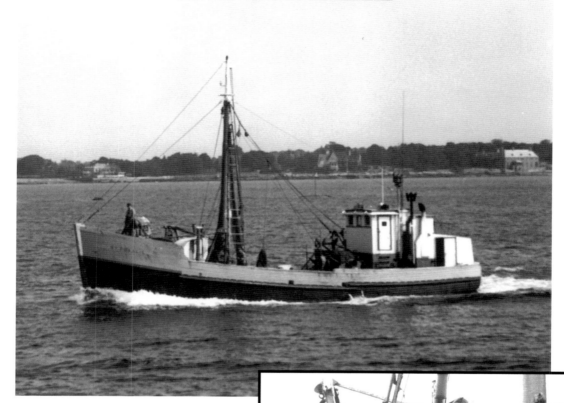

BOAT: *St. Rosalie*
HORSEPOWER: 230
GROSS: 65
NET: 25
DIMENSIONS: 65.8 x 17.5 x 9.6
WHEN BUILT: 1947
WHERE BUILT: Essex, Massachusetts
OWNER: Boat Maria Immaculata Inc., Massachusetts
CREW: Captain Acursio "Gus" and Ignazio Sanfilippo, John Aiello, Paul Moceri and Tony DiMercurio
SOUGHT-AFTER SPECIES: herring, whiting, shrimp and groundfish
FATE: Vessel was sold and later beached and demolished here before being trucked to the dump
FLEET SUB-CATEGORY: inshore
HULL MATERIAL: wood

SWEET SUE

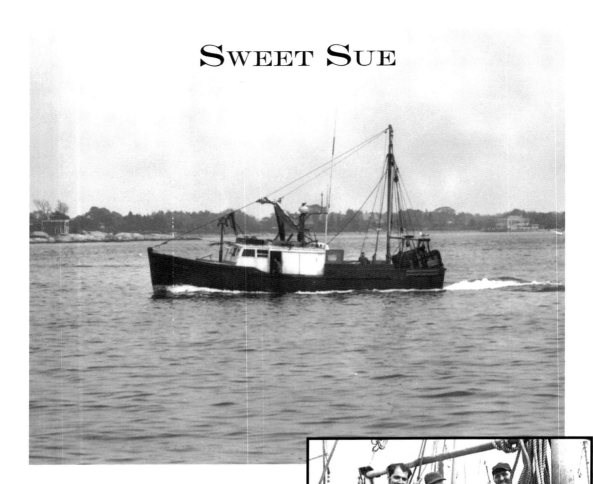

BOAT: *Sweet Sue*
HORSEPOWER: 165
GROSS: 35
NET: 19
DIMENSIONS: 46.6 x 14.7 x 6.6
WHEN BUILT: 1957
WHERE BUILT: East Boston, Massachusetts
OWNER: Elliot Marchant
CREW: Captain Joseph Mitchell Jr., and Herb and Edward Gleason
SOUGHT-AFTER SPECIES: groundfish and whiting
FATE: Unknown
FLEET SUB-CATEGORY: inshore
HULL MATERIAL: wood

TEXAS

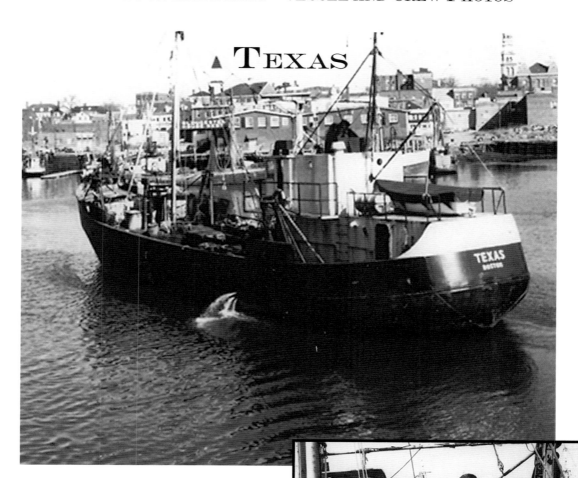

BOAT: *Texas*
HORSEPOWER: 680
GROSS: 159
NET: 82
DIMENSIONS: 89.3 x 22.7 x 11.9
WHEN BUILT: 1945
WHERE BUILT: Somerset, Massachusetts
OWNER: Texas Inc., Massachusetts
CREW: Captain Larry Scola, Vito Misuraca, Engineer Sam Frontiero, Mike Calomo, James Interrante, and Cook Pete Favazza
SOUGHT-AFTER SPECIES: groundfish
FATE: Sold to New Bedford fisherman, converted over to scalloping, currently fishing
FLEET SUB-CATEGORY: offshore
HULL MATERIAL: steel

THERESA R.

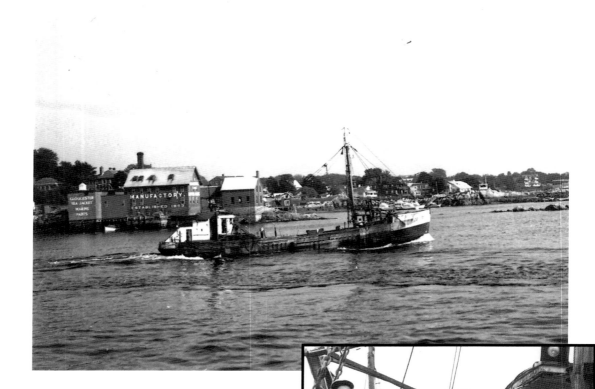

BOAT: *Theresa R.*
HORSEPOWER: 260
GROSS: 125
NET: 85
DIMENSIONS: 89.2 x 20.6 x 11.4
WHEN BUILT: 1944
WHERE BUILT: Ipswich, Massachusetts
OWNER: Rosa Inc., Massachusetts
CREW: Captain Gus, Nicholas, Engineer
Anthony and Joseph Sanfilippo, Harry
Bammarito, and Benedetto D'Amico
SOUGHT-AFTER SPECIES: whiting, shrimp and groundfish
FATE: Sank
FLEET SUB-CATEGORY: offshore
HULL MATERIAL: wood

TINA MARIE

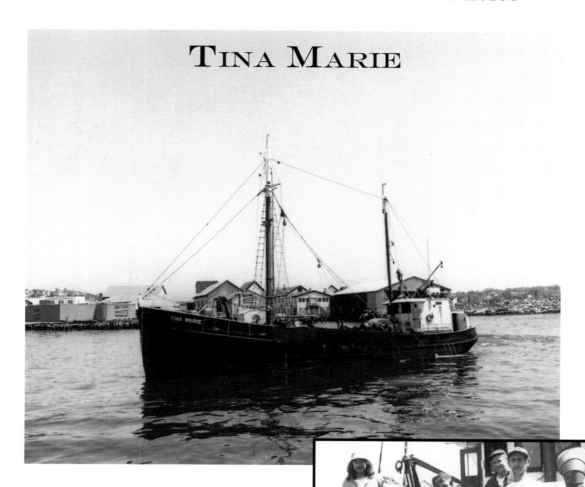

BOAT: *Tina Marie*
HORSEPOWER: 240
GROSS: 77
NET: 62
DIMENSIONS: 72.2 x 17.8 x 9.4
WHEN BUILT: 1952
WHERE BUILT: South Bristol, Maine
OWNER: Tina Marie Corp., Massachusetts
CREW: Captain John Quince, William and Engineer Curtis Dagley, Phil Verga, Ambrose Orlando and Cook Joe Pallazola
SOUGHT-AFTER SPECIES: groundfish, redfish and whiting
FATE: Sank
FLEET SUB-CATEGORY: offshore
HULL MATERIAL: wood

TRINEA LEA

Photograph courtesy of Grace McKay.

BOAT: *Trinea Lea*
HORSEPOWER: 165
GROSS: 15
NET: 10
DIMENSIONS: 34.8 x 12.7 x 6.1
WHEN BUILT: 1949
WHERE BUILT: Gloucester, Massachusetts
OWNER: Pal Fish Corp., Massachusetts
CREW: (No crew photo) Captain Sam Nicastro
SOUGHT-AFTER SPECIES: groundfish and whiting
FATE: Unknown
FLEET SUB-CATEGORY: inshore
HULL MATERIAL: wood

VINCIE & JOSEPHINE

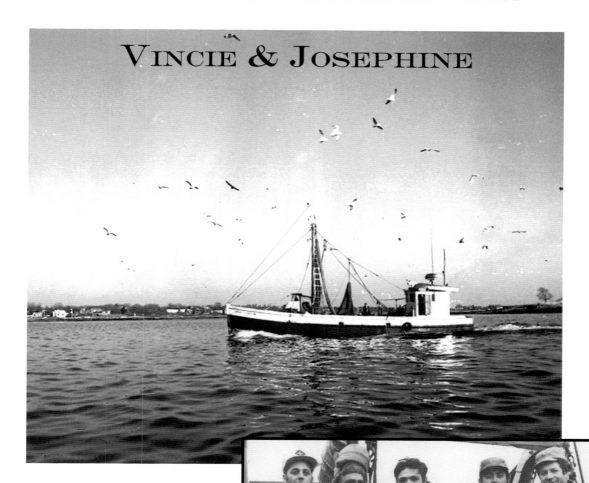

BOAT: *Vincie & Josephine*
HORSEPOWER: 270
GROSS: 46
NET: 21
DIMENSIONS: 60 x 15.2 x 8.4
WHEN BUILT: 1944
WHERE BUILT: Winthrop, Massachusetts
OWNER: Vincie & Josephine Inc., Massachusetts
CREW: Engineer Salvatore Costanzo, Peter Frontiero, Giochinno "Jackie" and Captain Salvatore "Sam" Ferrara, and Anthony Cracchiolo
SOUGHT-AFTER SPECIES: shrimp, whiting and groundfish
FATE: Sank
FLEET SUB-CATEGORY: inshore
HULL MATERIAL: wood

VINCIE N.

BOAT: *Vincie N.*
HORSEPOWER: 315
GROSS: 69
NET: 36
DIMENSIONS: 78.8 x 18.4 x 9.4
WHEN BUILT: 1936
WHERE BUILT: Rockland, Maine
OWNER: Vincie N Inc.
Massachusetts
CREW: Captain Joe, Sam and
Tony Novello, Gus Balbo, Louis Benson and Joe Orlando
SOUGHT-AFTER SPECIES: herring, whiting, shrimp and groundfish
FATE: Vessel stopped fishing around 2000. Its tired hull was later rebuilt as a replica
of the three-masted cargo vessel *Eleanor.*
FLEET SUB-CATEGORY: middle
HULL MATERIAL: wood

Chapter 6

The Crews—The Lifestyle—
Family Worries

Some 430 fishermen—about 348 Italian, 50 Irish, Yankee and Canadian, 30 Portuguese, and 2 Icelandic—worked the early 1970s dragger fleet. In 1972 the average age of a fisherman was forty-five; *Judith Lee Rose* cook Peter Manning was the fleet's oldest fisherman at seventy-nine. Early on many fishermen followed their fathers' footsteps by going to sea when just eight or nine years old, but the fishermen between 1970 and 1972 did not want their sons to go fishing.

Some of the 348 Italian fishermen first immigrated to the United States during the 1920s. Then, "my father [Dominic Spinola] left Milazzo, Sicily, aboard a French iron freighter and came to this country, arriving in Philadelphia. During his mid-teens he moved to Gloucester in 1926 and fished here aboard the *Natalie III* and later the *Frances R.* In 1951 he had his own boat built, the *St. Mary*, which he skippered for many years before his death," said Mike Spinola, one of three sons still actively fishing the *St. Mary*.

The next Italian wave of future Gloucester fishermen immigrated mainly from Terrasini, Sicily, between World War II and the mid-1970s. A few also came from Trapetto and Sciacca, Sicily. Gaetano "Tommy" G. Brancaleone was one of those immigrants. In 1956, at the age of thirteen, he arrived in Gloucester with his five sisters and mother. His father had already arrived in America. "We came here for a better life; living conditions were tough in Italy, especially after the second world war. But by the mid-1970s, things improved in Italy. A lot of the Sicilians who came to Gloucester were bricklayers and mechanics; they learned fishing here," said Brancaleone.

Also, numerous boat owners called over relatives from Italy to fish on their vessels. Captain Cecilio J. Cecilio said,

> The 1963 to 1964 union fishermen strike over redfish prices, caused in part by dealers refusing to pay more than 3.75 cents per pound for redfish, drove away most of the Portuguese fishermen in Gloucester. The strike took two months to settle. During that time many exasperated Portuguese left for New Bedford to fish for yellowtail flounders. Also, a lot of the old-timers went back to Portugal and other Gloucester boys left for Texas and Louisiana to go shrimping.

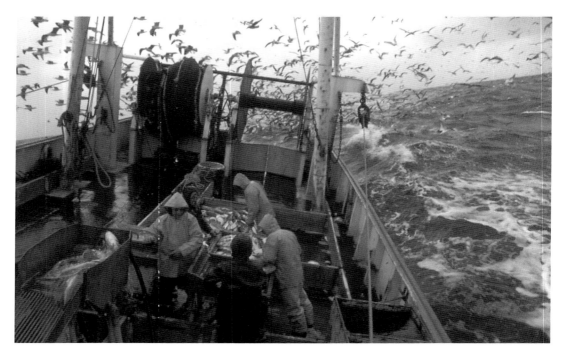

The crew of the *Vincie & Josephine* clears the last set's catch off of the deck as the vessel continues to fish with its net and doors under tow on the bottom of Georges Bank in January.

Gus Alba, owner and operator of the *Alba*, talks and gestures to his crew on deck. He is one of the many Italian-American fishermen who manned the Gloucester fleet of the early 1970s.

166

Gil Roderick further explains, "By 1970 many of the Portuguese had already either died off or gone back to Portugal after retiring. The majority didn't send their sons out fishing then." During the 1930s, 1940s and 1950s, Cecilio said,

> *The Portuguese fleet in Gloucester was larger than the Italian fleet. Most of the vessels swordfished during the summers and redfished during the rest of the year. The Portuguese fleet used to tie up side-by-side at the State Fish Pier. From the State Fish Pier you could cross the harbor over to the United Fisheries Wharf [now Rose's] by jumping from one boat to the other.*

During that same period the Italian fleet specialized in mackerel seining and dragging. By the early 1970s none of that fleet seined for mackerel anymore.

The typical Gloucester fishing vessel had a crew of between one and eight, depending upon its size. The one-man crews—including Captain Bill Sibley of the *Peggybell*, Anthony "Ollie" Pallazola of the *Sea Buddy*, Ignazio Maltese of the *Frances M.* and Sam Nicastro of the *Trinea Lea*—either used a second set of steering and control stations on the deck or ran back and forth from the wheelhouse to control the vessel while working their fishing gear.

Crew positions carried these specific responsibilities:

CAPTAIN—Often the owner, the captain was in charge of the entire fishing operation, boat and crew, mainly at sea, but also while ashore. A good captain was a key component in any vessel's success. Not only did he have to navigate and choose the best grounds, he had to decide when to stop fishing—either because of storminess or when the catch was sufficient and the market best for selling. A captain also had to keep his crew in order. Captains realized that they were only as good as their crews. Some skippers rarely left the wheelhouse except during mealtime, but others might even help their crews mend torn nets on deck. As crews worked on the deck, captains often watched like hawks. If a crewman wasn't doing his job or was working recklessly, he was sure to hear some choice captain's words. While not on watch, many of the skippers slept with one eye open. They knew the sounds and the feel of their vessels. Anything out of the ordinary would quickly bring them to their feet. The skippers also stayed behind the wheel of their ship for hours on end during bad storms. Most of the crews had great respect for their captains, which often included some fear. In the crews' minds it was "him versus us." The crew, working on deck and experiencing the elements, often saw things differently from the captain, and vice versa. The captain gave the all-important trip-ending command, "Store the gear; let's go home."

MATE—He was not only in charge of making sure the vessel's fishing gear was maintained and in good supply, but also had the authority to order new gear, ranging from spare net parts to mending twines to deck blocks to new doors. The mate also worked the deck.

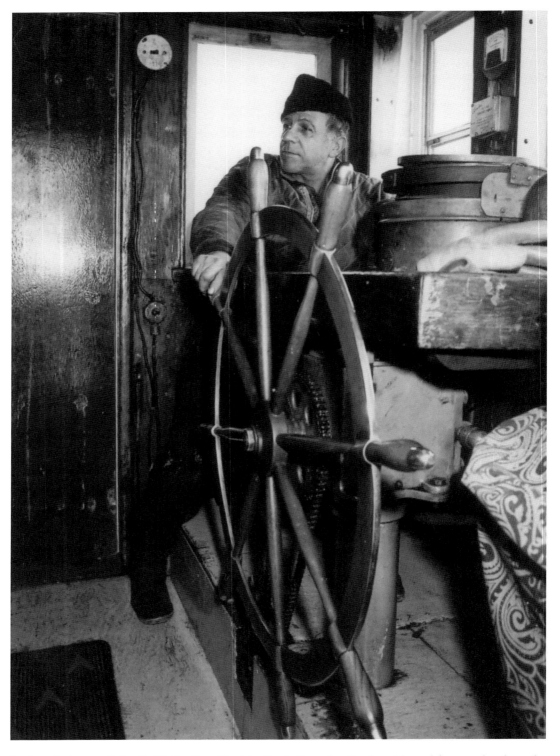

In the pilothouse of the *Judith Lee Rose*, Captain Frank Rose, Jr. sits alongside and keeps a hand on the brass-spoked helm. Notice the large magnetic compass in front of the wheel.

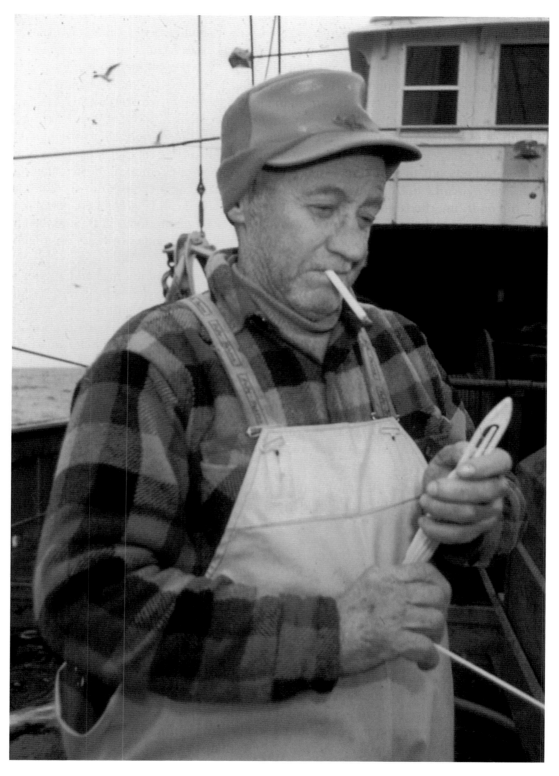

Mike Maher, the mate on the *Judith Lee Rose*, fills a knitting needle with mending twine.

Judith Lee Rose cook, Peter Manning, wets down the tablecloth in the fo'c'stle during rough weather to prevent it from sliding off. At age 79, Manning was one of the oldest fishermen of the early 1970s fleet.

COOK—Besides working on the deck, the cook also took care of the fo'c'stle, where he customarily prepared three meals daily for the hungry crew. "For just one meal, I used to cook up about ten pounds of pork chops for my seven-man gang," said Roderick, who prepared literally tons of food during his thirty-seven years in fishing. "I had to order the grub, including meats, vegetables by the basket, and fruits by the boxes, also stock the fo'c'stle food shelves and refrigerator and lastly, keep the food bills down, too," said Roderick. For safety reasons, during stormy weather the cook prepared cold meals for the gang. Up to the 1970s most Gloucester boats shopped for groceries at small markets like Charlie Ellis' Friend Street Market, Joe Ciaramitaro's Washington Street Market or Joe Kyrouz's Railroad Avenue Market, which also had delivery service right to the boat. Later, vessels bought at local supermarkets.

ENGINEER—Like the cook and mate, he also had to do deck work. But the engineer's other big job at sea was to care for all mechanical equipment—ranging from the main

engine to the deck and gallous frame blocks—while also making many impromptu at-sea repairs, including replacing the seals of pumps. "A good engineer would keep the engine room spotless, too," said Roderick. "You could eat off my engine room floor," said Gaetano "Tommy" G. Brancaleone, the engineer aboard the *Joseph & Lucia II*. For their extra duties, "The cook, mate and engineer received thirty-five dollar bonuses every trip," said Roderick. Among his dockside duties, the engineer had to change the main engine's oil (often 110 gallons) every 1,000 hours, and replace the fuel and oil filters. In addition, the Gloucester draggers powered by heavy-duty, clutch-free, air-start diesels required their engineers to spend extra time in the engine room to shift and throttle the engine. Former *Judith Lee Rose* engineer Alan Murray remembers having to repeatedly shut off the engine, hand crank the camshaft, and then air-start the engine. The captain signaled the engineer with different bell codes: "One bell meant go forward, while two bells meant reverse," recalled Murray.

CREW—The remainder of the crew were deckhands who helped with setting out and hauling back the net, as well as dressing and storing the catch. In addition, while fishing or steaming, all crew members had to take two- to three-hour turns at watch. A good crew—another crucial component of any vessel's success—not only knew their business but worked well together. The *St. Mary* and the *Serafina N.*, like many other vessels, had brother crews, who worked well together for years. Other boats also had long-time crews, but less desirable boats often had rapid crew turnovers.

"During my thirty-seven years of fishing, I fished on twenty-two different boats. You had to start somewhere. Out of those boats I refused to go out on one because of its unseaworthiness, while others got sold off. I always tried to get a better site. Once I got on with the Brancaleones [the *Joseph & Lucia II and III*]; I never moved any more," said Roderick.

A crewman always had the option to skip a trip, and a "transient" fisherman would fill his spot. A fisherman with a good reputation could often get year-round work "trenching." Eventually he could work his way into a permanent site on a good boat this way.

"Friendship and camaraderie existed among the fishermen then [in the early 1970s]," explained Tom Aiello, captain of the *St. Providenza*. "One hand washes the other," was a common saying and philosophy within the Italian fleet.

Friendly rivalries ran among many fishermen and their vessels. One classic rivalry existed between the crews of the pogie seiners *Ida & Joseph* and *Rockaway*. I witnessed an example of that rivalry one fishing day while a guest aboard the *Ida & Joseph*.

Both vessels had left Gloucester Harbor early in the morning that summer day to seine pogies in Boston Harbor. By the time both vessels arrived in Boston Harbor, the wind already blew hard out of the northeast and the ocean was rough. Neither of the crews wanted to fish, and to save face, neither wanted to be the first to throw in the towel and head home. Finally, the skipper of the Rockaway, Joe "Tarzan" Nicastro—a stocky man with a round face that gave off a warm glow and, sometimes, a mischievous grin—had enough. Surrounded by his crew in the pilothouse, Nicastro radioed Captain Sandy Calomo, "I'll promise to go right in

if you promise to go right in." Both captains and crews could barely contain their laughter, and off they went.

But unfriendly rivalries existed, too. Some captains fished alongside each other practically their whole lives and for one reason or another never spoke to each other ashore or at sea. What would have happened if one was sinking, and the only other vessel around was the rival's?

Prejudices among segments of the fleet were still apparent in the early 1970s. Many Italian and Portuguese fishermen continued to share a dislike for each other. Long-established Italian fishermen often made known their ill feelings for the new wave of Italian fishermen who arrived in Gloucester during the 1960s and 1970s and worked exceptionally hard to get ahead. "You greasers aren't going to take over the fishing fleet," the older group told the new immigrants.

Most of these newcomers worked their way up from the deck to the pilothouse and to vessel ownership. They often bought second-hand vessels—first making sure they had good engines and winches—and fished these hard to earn money for a better used vessel or even a new one. These fishermen worked under the philosophy, "The boat buys the house." Most did buy their own homes away from the city. Many also sponsored other families from Italy to come to America and work on their vessels.

There were many ways to split a vessel's gross stock, which could run between ten and twenty thousand dollars a trip in those days and up to one hundred thousand dollars much later on. Special settlement houses in Gloucester earned their livings divvying up fishing trips for the vessels. The law firm of Sandler and Laramee did most of the settlement work for the early 1970s fleet. Earlier on, Captain Cecilio J. Cecilio remembers using the 60/40 settlement split where 40 percent went to the owners and 60 percent went to the crews. "The grub and ice was the gang's part to pay for, while the fuel and combined expenses including five percent union fee and lumpers' costs were taken right off the top before the split. Later on many went to the 'Italian Lay'," said Cecilio.

With the "Italian Lay" system, "The trip's expenses for fuel, ice and gear were taken right off the top; 60 percent then went for the crew, which had to pay for the food separately, while the remaining 40 percent went to the boat and skipper. Often the captain also got 10 percent of the crew's split," explained Roderick.

Besides the official settlement, the crews were often treated to "shack money." This included the sales of incidental small catches such as halibut and lobster caught during a groundfishing trip. In the case of lobster draggers, any side catch such as hake, cusk, redfish and flounder, was cashed into "shack money" for the crews.

Just about every fisherman has experienced a "broker" trip during his career. Gil Roderick recalls one such trip.

> *I spent three weeks out redfishing aboard the Gloucester. When the trip was finally over, I had to pay the boat twenty-five dollars to help pay for the expenses. Besides catching not much fish because of having to ride out a lot of stormy weather at sea, and the fish being cheap then, we didn't even make enough to cover expenses.*

The settlement sheet.

Courtesy of Capt. Cecilio J. Cecilio

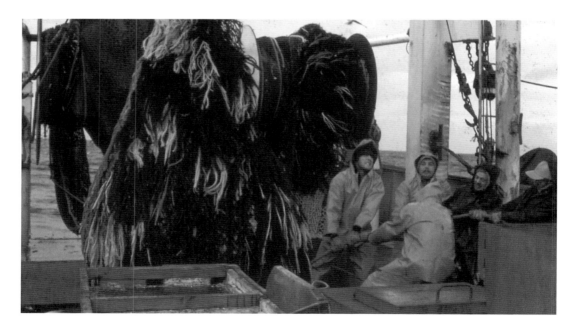

The *Vincie & Josephine* crew undoes the cod end chain knot to release the catch.

What was the fisherman's lifestyle like? Writers have often romanticized this. Landlubbers have idealized it as being one of independence, having the freedom of the vast seas, working close to nature, often under healthy conditions, and earning a living with your hands. Many fishermen have other thoughts.

"Three quarters of a fisherman's life is fishing; half of that time is spent at sea, while the other quarter is spent ashore maintaining the boat, the engine and the gear," said Sal Ferrigno, on the *Leonard & Nancy*.

Phil Nicastro on the *Serafina N.* further described being a fisherman. "You go, go, go so often when the weather is good that you hardly have time to catch your breath then." Gil Roderick believed the fisherman "was married to the boat. Christmas, New Year's Day and St. Peter's Fiesta were the only times you could count on being home."

"No effort, no paycheck" was the fisherman's main law of economics. Besides making hay while the sun shone, these sea harvesters also had to do it when the sun didn't shine. Although the inshore and offshore fishermen's lifestyles differed to some degree, they shared the common denominator of having to put in their long sea and shore-side times and also having to make tremendous personal and family sacrifices, including being away during most holidays and missing much of their children's growing up and rites of passage. But to most, fishing was a proud way of life—albeit full of uncertainty and potential dangers, including constant weather challenges, fires, rammings, explosions and sinkings, as well as personal, physical and mental demands. Overcoming or working with these as well as possible while still earning a living produced tremendous inner pride and satisfaction. Besides, many fishermen were carrying on the family tradition, and moreso, many firmly believed this was the only work they could do.

Typically, the inshore fisherman "would rise daily often six days a week, Saturday through Thursday at 2:30 a.m. and would return home around 5:30 p.m., always taking Fridays off for settling up," said "day boat" (inshore) fisherman Mike Spinola of the *St. Mary*—a vessel famous for being the first to leave and the last to return in the afternoon, believing "the early bird gets the worm." "We also fueled up and got ice at the Cape Pond Ice Company on Fridays. By mid-morning then, barring any net repairs or mechanical repairs, the rest of the day would be mine to spend some time with my family, and we'd start all over again Saturday morning," he said. "But, at least he's home every night," said Spinola's wife Doreen. At the end of their long working day, most fishermen just wanted to come home, have supper and go to bed.

But sometimes, stormy stretches temporarily broke this "go, go" routine and actually afforded the inshore fisherman the treat of sleeping late. Quite often during questionable weather, the inshore fisherman was still on call awaiting final orders. Frequently a crew ended up just going out for a boat ride and burning up fuel because they were driven back by heavy seas.

If the weather was good, the inshore fisherman would go. "Two hundred and twenty-five were the most days we ever fished during a year," recalled Spinola. A typical inshore vessel seasonally fished for groundfish, shrimp, whiting and sometimes herring.

On the other hand, the offshore fisherman, like the middle fleet fisherman, wasn't home every night, often being away seven to fourteen days at a time hundreds of miles from shore. The mid fleet fisherman often made two- to three-day-long trips. "Most offshore draggers planned to make twenty-six to thirty trips per year. One year we [the Paul & Domenic crew] made thirty-two trips. One week when we got into the large cod and pollock off of Cape Cod, we completed three offshore trips," said Gaetano "Tommy" G. Brancaleone.

But the offshore fisherman was given three-day-long layovers between trips. Often these layovers turned out not to be completely free of fishing-related activities, as crews frequently had to make net repairs and get ice and water for the next trip, the cook had to restock the galley and the engineer had to maintain the engine.

Gil Roderick (as well as, I assume, the rest of the crew) will never forget one so-called layover while crewing aboard the *Joseph & Lucia II*. Home after a long trip, Gil and his wife Priscilla were just about out their door to have dinner when the telephone rang. His skipper, Captain Nino Brancaleone, called and told the crew to report back to the boat as soon as possible to go right out fishing. The *Joseph & Lucia III*, skippered by Nino's brother "Tommy" had gotten on some fish, and Nino wanted to get some of the action.

During the days off—shore time—offshore and inshore fishermen would socialize together. The Italians often socialized at the St. Peter's Club along Rogers Street with their best friends, or "gumbas," where they would have a few drinks, play cards and talk "fish," telling sea stories, and comparing fish prices and catches. The

Both active and retired fishermen socialize at the St. Peter's Club on Rogers Street in Gloucester. Here, a gang talks fish and plays cards.

Portuguese fishermen often congregated at the Gloucester Fraternity Club along Sadler Street and the D.E.S. Hall on Prospect Street.

Once at sea the offshore fisherman was virtually on-call twenty-four hours a day for up to two weeks, which included setting out and hauling back the net every two to three hours and taking his two-hour pilothouse watch turns.

"You were done when the fish were done. I worked thirty-six straight hours on the *Joseph & Lucia III's* deck," said Roderick. "We were on the fish, and we kept fishing even though we were waist-deep in fish on the deck. Fresh peaches were the only thing the gang had to eat then."

But, Gaetano "Tommy" G. Brancaleone topped that duration by "working straight out on deck for forty-one hours aboard the *Joseph & Lucia II*," he said.

In between watches and steady fishing, the offshore fisherman somehow found time to eat three big daily meals, snack and also catnap with his work clothes on. While their vessel either steamed to more fertile grounds or rode out bad storms at sea, the crews could catch up on badly needed sleep.

Fatigue has always been the fishermen's enemy, especially for the offshore men, because it slows their reflexes and thinking. Banging trawl doors and working deck blocks and drum winches have broken or amputated the limbs of many weary fishermen, while swinging bags of fish have crushed others' ribs or even worse, knocked them overboard. A man standing on a net part on a lurching vessel could easily be yanked overboard. Darkness, cold water and choppiness drastically reduced the chances of retrieving a man who had fallen overboard. And collisions have resulted from fishermen falling asleep behind the wheel.

The fisherman at sea was tested by on-board personal challenges, but also faced many outside dangers. While fishing close to other vessels, the man behind the wheel had to worry about towing his fishing gear too close to another vessel's and getting their nets and doors crossed. Undoing this damage often required hauling back and unfastening one of the towing cables. The possibility of getting the net wrapped in the propeller when setting out or hauling back always posed a potential problem for the man behind the wheel. Frequently, the Coast Guard would have to tow such a disabled vessel back to port where it might have to be hauled out unless a diver would clear the propeller. Crews sometimes freed a propeller at sea by manually reversing the shaft with a huge monkey wrench and pulling the net off. The fisherman on watch, especially late at night or early in the morning, often had to fight to stay awake. Fishing vessels have collided with freighters or other fishing vessels when men on watch lost the battle to stay awake. In some cases, a boat sank and fishermen died.

Nature constantly challenged all fishermen with heat, cold, wind, waves and fog. Summer heat could easily spoil a catch on deck unless the fish were quickly dressed, washed and iced down in the hold. Even iced-down redfish and flounder would quickly spoil in the hold if the vessel stayed out too long when the sea was warm. Yellowtail flounders were notorious for spoiling after seven days; their autolysis began in the bellies of the fish and then worked outward into the fillet.

And oh, what cold fishermen have had to contend with. "The air was so cold one winter day that the catch and also the net immediately froze on deck after hauling

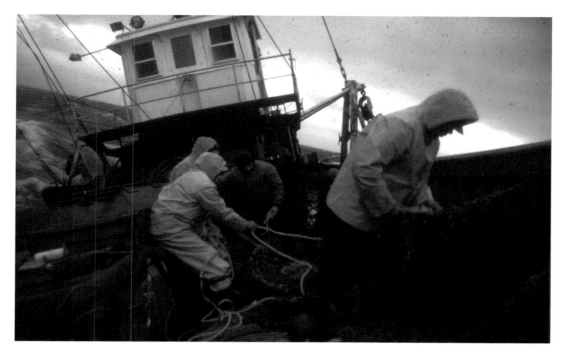

The *Judith Lee Rose* crew repairs a torn net despite their rolling vessel.

back. We had to use the jilson and block and tackle to rip the frozen net off the deck and get it back overboard," said Roderick.

The cold often created dangerous instability when freezing spray "iced up" on rigging, decks, sides and wheelhouses, often while the vessel was pounding into the ferocious waves of a northwesterly gale. To guard against top-heaviness and the possibility of rolling over "we would either slow down or 'lay to' while part of the crew smashed the ice off with wooden mallets while others shoveled it overboard," remembered *Judith Lee Rose* crewman Frank Domingos. In winter the *Judith Lee Rose* frequently iced up with over three hundred and thirty thousand pounds of redfish aboard while making the thousand-mile return trip from the Grand Bank.

On deck, the cold—often exacerbated by wind—frequently chilled a fisherman to the bone and even turned his hands white. Luckily, the warm fo'c'stle was only a few steps away.

Despite the presence of wheelhouse radars, fog challenged fishermen, especially during the spring and early summers. Fog always increased the chance of being rammed by another fishing boat. Even worse was the danger of being run down by a 600-foot freighter steaming along at 20 to 30 knots. The men on the freighter might not even notice if they struck a fishing boat, and there would go your chance of rescue. Many of the major shipping lanes transect traditional fishing grounds.

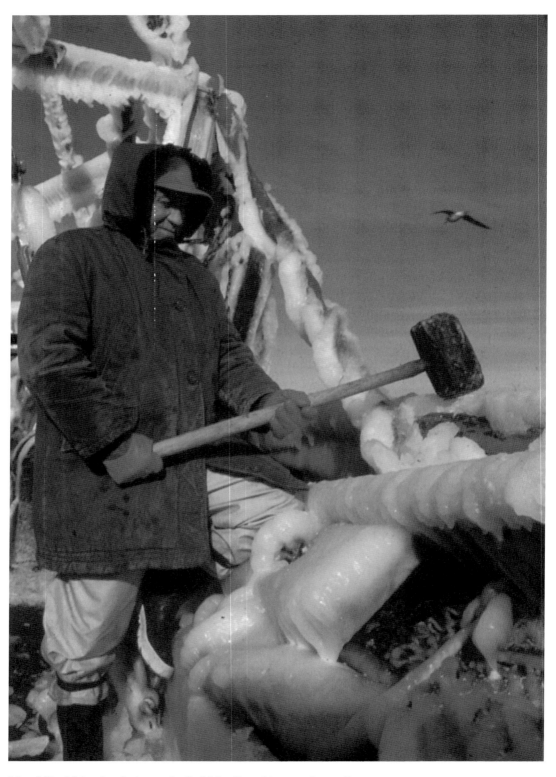

Mate Mike Maher breaks ice on the *Judith Lee Rose* with a wooden mallet.

Gus Doyle pauses to warm his hands on the deck of the *Judith Lee Rose* during a January night 250 miles offshore.

The *Judith Lee Rose* gang remembers all too well one foggy incident when a freighter passed by them so close astern that its hull scraped their towing wires.

The fishermen, especially those offshore, had to be ever vigilant for signs of storms, especially dangerous northeasters. Again and again, captains were forced to decide whether to head home or remain at sea and ride out a storm. Commonly, if a vessel was far offshore, had just begun a trip and had very little fish aboard, then it would remain at sea. On the other hand, if a storm threatened to be prolonged and severe, then most vessels would steam home or to the nearest port, such as Newport, Rhode Island or Yarmouth, Nova Scotia. During some bad storms, draggers would alternately "jog" (head slowly into the wind and waves) and "lay to" (drift sideways to the wind and waves, often with the main engine shut off) for up to three days, usually in deeper water where the long-period waves don't break as often as in shallower water.

Still, weather-related tragedies were sometimes unfortunately just part of the fisherman's life. "Eighty-six-foot *Capt. Cosmo* out of Gloucester lost with six men in Georges gale." The *National Fisherman* headlined my November 1978 article on that tragedy. The *Capt. Cosmo* and its six-man crew: Captain Cosmo Marcantonio, Salvatore Grover, Vito Misuraca, Jerome Pallazola, John Burnham, and Benjamin Interrante disappeared without a trace on or near Georges Bank then.

The previous year the *National Fisherman* had published another tragic Gloucester story of mine titled, "Two men are lost when dragger sinks." In this case the 83-foot *Sea Breeze* sank on November 11, 1977, ten miles south southwest of Mt. Desert Rock, Maine, during a strong southwester. Crewmen Forrest Dare and Roy Amero drowned. Captain Wilton Mansfield, Victor Simpson and Russell Sherman were rescued.

Weather was not the only danger. Collisions, fires and explosions also took their toll. The next four paragraphs contain excerpts from articles which describe such accidents.

"Dragger sinks but crewmen safe—East German trawler rams ship at anchor," read the June 5, 1972 *Gloucester Daily Times* headline. These *Gloucester Daily Times* excerpts further describe the incident. "The steel-hulled 214-foot side trawler *Brandenburg* hit the 70-foot *Rosanne Maria* a glancing blow in the bow, within four feet of where two crew members were sleeping. The accident happened shortly after 1 a.m. Sunday 23 miles northeast of Gloucester, just beyond the 12-mile-limit near the Isles of Shoals." Captain Stephen J. and Louis "Gino" Biondo, Baptiste Lafata, and James Interrante crewed the ill-fated dragger.

"Gloucestermen Come to Rescue of Neighbors," is the title of my *National Fisherman* article describing how the 115-foot eastern-rig dragger *Little Al* caught fire eighty-three miles southeast of Gloucester and later sank before Captain Alfonzo and brother Anthony Millefoglie, engineer Salvatore Bologna, John B. Orlando, cook Benedetto Favazza, Matteo Loiacano and mate Salvatore Curcuru were saved by 95-foot Gloucester dragger *Sandra Jane*.

"Gloucester Dragger Sinks after Door Punctures Hull," a 1979 *National Fisherman* article I authored, described how the 86-foot *Holy Cross*, then skippered by Salvatore

Lovasco, sank while fishing 60 miles off Portland, Maine, after its rear door punctured the hull while the net was being hauled back on September 12, 1979, at 8:45 a.m.

In my June 12, 1977 *National Fisherman* article entitled "One Killed, Three Survive Dragger Explosion," I describe how on March 31, 1977, tragedy struck the 60-foot Gloucester dragger *North Star* and its four-man crew of Captain Sebastian, Anthony and Peter Noto and Frank Balestreri. A powerful engine room blast killed twenty-five-year-old Anthony Noto and seriously injured the skipper, while its other two crewmen suffered from shock and minor burns.

The time between Christmas and New Year's Day and the St. Peter's Fiesta—usually held during the last weekend in June—were the two important holiday breaks when fishermen could get fishing off their minds, unwind, celebrate and spend quality time with their families and friends. The St. Peter's Fiesta was not all fun, though. During the days preceding it, many of the crews hauled out, painted and maintained their boats in preparation for the Fiesta. "We always first stripped off the fishing gear two weeks before the Fiesta and then hauled up the *St. Mary* and painted her inside and out as well as replaced a lot of her mechanical equipment," said the vessel's engineer, Mike Spinola.

For *Joseph & Lucia III* cook Gil Roderick and former *Joseph & Lucia II* engineer Gaetano "Tommy" G. Brancaleone, Fiesta time meant spending days painting the vessels as well as replacing and sometimes rebuilding equipment aboard their vessels. Their main engines were usually rebuilt on board every other year.

In 1997 his Eminence Cardinal Bernard Law blesses the Gloucester fleet aboard the *Padre Pio* during the St. Peter's Fiesta.

St. Peter's Fiesta celebrated its seventy-first year in June of 1998. According to the St. Peter's Fiesta Committee booklet, "This Fiesta, sponsored by the Italian-American fishing colony of Gloucester, takes place on the weekend closest to the Feast Day of St. Peter, June 29. Sicilians immigrating to Gloucester brought the custom of paying homage to St. Peter, the patron saint of fishermen, who has protected the fishermen against the many storms encountered at sea." Also, in 1926 Salvatore Favazza, known by many as the "Father of the Fiesta," "had a life-size statue of St. Peter enshrined in the heart of the Italian district." Years later the Fiesta evolved into a festive event, but remained deeply religious. Some of the 1998 events, held Thursday through Sunday, many of them relatively unchanged since the early 1970s, included: the formal candlelight opening, the procession bringing the St. Peter statue to the Fiesta altar, music and dancing, seine boat races and greasy pole contests at Pavilion Beach, children's games and rides, and on Sunday, a solemn Pontifical Mass followed by a religious procession and the blessing of the fleet.

Winners of the greasy pole contest and seine boat race earn the respect of their peers and the community, and all-important bragging rights. They also earn their place in the St. Peter's Fiesta history. Many contestants are second-generation competitors. The all-time greasy pole winner—winning about fourteen times—is Salvi Benson, followed by eight-time winner Peter "Black" Frontiero. The 1998 champ was Nino Sanfilippo. Also in 1998, two years in a row, the "Staying Alive" seine boat team rowing the *Santa Maria* beat out champion team "Die Hards," rowing the *Pinta*.

The St. Peter's Fiesta Committee in 1998, consisting of officers Tom Brancaleone (President), Joseph Novello (Vice President), Leonard Vitale (Chairman), Anthony Giacalone (Treasurer), and Michael Linquata (Clerk), along with other members of the Board of Directors Frank Cottone, Anthony Cusumano, Salvatore Ferrara, Reverend Frederick Guthrie, Santo Militello, Alfonzo Millefoglie, Anthony Parisi, Rose Aiello, and Lucia Sheehan work extremely hard to keep this wonderful tradition alive.

The once-large Gloucester Portuguese fleet had its own fleet blessing, Our Lady of Good Voyage, which included a parade that passed by Our Lady of Good Voyage church. "The first fleet blessing occurred during the mid-1940s when the bishop came down to the State Fish Pier and blessed all of the Portuguese boats which were tied alongside one another here. This ended around 1960 after the redfish strike had driven most of the Portuguese fishermen from Gloucester," said Captain Cecilio J. Cecilio, the former 1957 to 1958 president of the Blessing of the Fleet Committee. He continued,

> *For the first couple of years the Portuguese carried the very heavy either six hundred or eight hundred pound Lady of Good Voyage statue made from African rosewood* [ironwood], *before returning this to the Lady of Good Voyage Church. They later carried the much lighter Our Lady of Fatima statue. I remember when the Portuguese hospital ship,* Gil E. Annas, *which cared for the Grand Banks dory fishermen, transported this solid wood statue to Gloucester Harbor.*

182

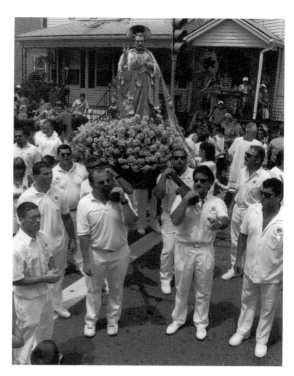

Italian-American fishermen carry the statue of St. Peter through the Gloucester streets in 1997.

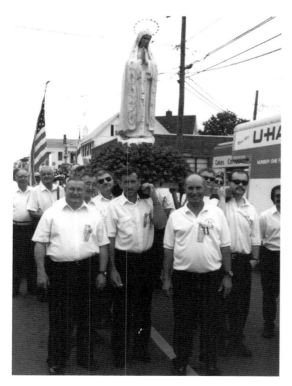

Portuguese-American fishermen carry the Our Lady of Fatima statue through the streets during the 1998 St. Peter's Fiesta.

After 1960 the Portuguese joined their fleet blessing with the Italians' St. Peter's Fiesta and later both Portuguese and Italian fishermen carried their patron saints through the streets.

While fishing, not only did the fisherman worry about his family, his wife and children worried about him. "I was always concerned that the family was all right. I couldn't have a family life; I had to be married to the boat. Work was scarce; I had no choice, but I considered myself lucky to have a site on the highline *Joseph & Lucias*," said Roderick, a husband and father of three now-grown children. Gaetano "Tommy" G. Brancaleone was also torn between having to earn a living at sea and wanting to spend time with his family. He had just gotten married in 1967 and shortly afterwards started a family, while he also began offshore fishing on the *Joseph & Lucia II*. "Fishing was very hard then, I missed my family terribly, I wanted all of us to be together. While I was fishing, we could never plan anything together," said this father of three now-grown sons.

Mike Spinola also regrets that he couldn't have done more with his family, especially when his daughters were young: "I wish I could have taken the kids on more day trips, especially to Canobie Lake, and also gone camping more with them. It's a shame that I had to spend so much time at sea; I even missed out on many special events such as their First Communions. For us [the *St. Mary* crew] fishing was a daily thing," said Spinola.

Since this interview, Mike has left fishing and taken a shore job.

While the fishermen were responsible for bringing home the money, their wives played the critical role of caring for house and children. "I had big responsibilities: I had to be both mother and father; I had to do it all including running the house," said Priscilla Roderick, Gil's wife of fifty-five years.

One of Gloucester's most famous fishermen's wives, Lena Novello, echoed those sentiments.

> *You're the mother—you're the father—when he* [late husband, Joe Novello] *was out. Besides running the household and kids, I was also the shore agent for the* Vincie N. [the family fishing boat]. *If Joe had either engine or radar trouble, he would call me on the radio, and consequently I would call a repairman and have him waiting at the dock when the boat arrived.*

The fishermen's wives often worried about their husbands at sea. Without hesitation Priscilla Roderick said, "My biggest concern was the weather: while lying in bed at night and feeling strong winds shake the house, I often said to myself, 'it must be terrible out there.'"

Priscilla will also never forget the long night she once spent talking to her mother over the telephone while both her husband, Gil, and her father, Frank Perry, were on the vessels *Edith & Lillian* and *Joseph Mattos*, heading home alongside each other and taking a pounding in a hurricane. "We could hear them

talking over the radio; we constantly wondered if they would make it back to Gloucester safely," she said. They did.

What was it like for a child to have a fisherman father? Lena Novello knows this all too well:

> *My father was a fisherman. As a little girl, this could be often petrifying when he was away during bad weather. My mother would be so worried sometimes she wouldn't even cook. It was hard not knowing where he was. In those days there was no way to get in touch with him at sea. You could only find out when one boat of the fleet went into a port such as Shelbourne, Nova Scotia, and would call home and spread the word.*

But Lena also had good memories of him as a fisherman. "My father would always come home with a bucket filled with tasty little things from the ocean like shrimp and conchs. We would put these on the coal stove and cook them. Instead of either candy or sweets, this was my treat from him. I couldn't wait to look and see what was in the bucket."

Lena grew up during Gloucester's mackerel seining days. "Often the men didn't even have time to come home and eat if they were busy mending a torn seine along the waterfront; they felt they had to get right back out fishing," she said. Lena remembers often accompanying her mother and other women "bringing pans of hot spaghetti down to the men."

"Having come from a fishing family with nine children—six boys and three girls—I said that I would never marry a fisherman, but I did," added Lena.

I believe that up to a certain age, children really need their fathers. One offshore fisherman's son sometimes felt, "I didn't even have a father at all." Boys go through a developmental stage when they enjoy doing things with their fathers. Later on many older children just accepted the fact that their fathers were fishermen and would be away from home for long periods of time. Some were even glad that their fathers were away, so they could get away with more.

CHAPTER 7
THE INSHORE AND
THE OFFSHORE FISHERMAN AT WORK

W hat was going to sea like during the winter, first for the day boat shrimp dragger *Serafina N.*, and then the offshore deep-sea lobster trip boat *Judith Lee Rose?*

A Northern Shrimp Day Trip Aboard the *Serafina N.*

At 3:30 a.m. on this January day in 1970, the American Legion flag hung limp—a good sign for Gloucester's thirty-eight-boat inshore fishing fleet, which had been kept in port for days by northwest gales. Fishermen always checked on that flag near the waterfront to see how hard the wind was blowing. All along the looped waterfront from Commercial Street to Rocky Neck, anxious fishermen walked or drove to their vessels. Soon diesels hummed in the twenty-degree air; deck lights chased away darkness, and white, red and green running lights glowed in the black sky.

The 104-foot-long *Serafina N.*—a tired, former World War I sub chaser that needed three pumps going to keep her afloat—soon joined that string of white mast lights leaving Gloucester Harbor. The wooden dragger's twelve- to fourteen-hour-long day would consist of steaming to and from fishing grounds within twenty-five miles of Gloucester, making three two-and-a-half-hour-long tows with its small-meshed shrimp net, and lastly unloading its boxed catch. Friday was settlement day, the only guaranteed day off from this often-exhausting routine.

Once past Eastern Point, *Serafina N.*, whose gray and green hull and white and red-trimmed wheelhouse colors had been dulled by salt and sun, sped due north at ten knots for Scantum Basin, a popular three hundred and fifty-foot-deep mud bottom shrimp ground between Rockport and New Hampshire less than twenty miles away. Captain/co-owner Phil Nicastro, a stocky man with a round face and good nature, steered *Serafina N.*'s big, brass, spoked wheel.

No longer needed for deck watch, Phil's brothers Joe "Tarzan," John "Chubby," and Baptiste "Thidda" entered the warm fo'c'stle and climbed into their bunks. An

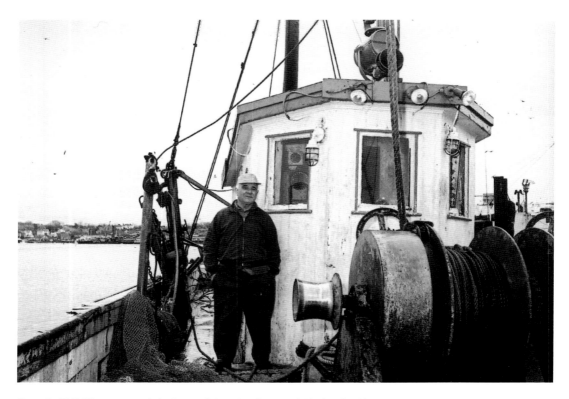

Captain Phil Nicastro stands in front of the wheelhouse of his *Serafina N.*

oil stove heated the temperature to seventy degrees. Lulled by that warmth, the hum of the main engine, and the soft creak of timbers they quickly succumbed to sleep.

But, shortly before 6:00 a.m. the pilothouse horn blasted, shattering their dreams. It was time to set out. *Serafina N.* had just arrived north of the "half-way hump" and had cut her engine and was ready to get her fishing gear in the water. The "halfway hump" marked the southern edge of Scantum Basin. Scantum Basin looked like a floating lighted city as most of Gloucester's inshore fleet also chose to shrimp there. A white strip over the eastern horizon showed dawn was about to break. The Nicastros donned their black rubber boots and oilskins and arrived on deck to set out their hundred-foot-wide net off the starboard side. The ebbing tide carried the green polypropylene net, with orange head rope floats, away from the boat.

Next, Captain Phil began setting out—a tricky process on a side trawler—by first rapidly circling with the stretched-out, funnel-shaped net suspended alongside from the fore and aft gallous frames. Tarzan and Thidda manned the double drum winch just forward of the pilothouse. The skipper made a final net check from the wheelhouse looking for twists in the net before heading *Serafina N.* due north and shouting, "Let it go!" Instantly, the men released the winch brakes, and the net and its pair of trawl doors plunged into the ocean. Within minutes, 180 fathoms of 5/8-inch-thick cable had slowly passed out of each drum, and the winchmen

locked their brakes. Lastly, the crew hooked up the two lined-up towing cables, which ran from the winches and through deck and fore-and-aft gallous frame blocks to the fishing gear astern in the "hook up block." The cables are marked at regular intervals, including at 180 fathoms. The spreading apart of the two towing wires in the water off of the stern showed the net and doors had been properly set out. By 6:00 a.m., water gushed, gurgled and swirled astern of the *Serafina N.* as she chugged ahead at three knots, and her heavy fishing gear scooped up shrimp from over three hundred feet below.

Dawn brought a glassy ocean, a sub-freezing air temperature and a mostly clear sky, but a worrisome eastern horizon colored with an orange band and tinged with blackish gray. This omen concerned the crew. Soon that sun, mimicking a large fiery ball, rose from its eastern water bed and cast a path over the ocean surface.

Other Gloucester boats like the *St. Jude, Carlo & Vince, St. Mary, Anthony & Josephine* and *St. Rosalie* also set out their fishing gear at the same time and location as the *Serafina N.* Some of their exhausts belched out loud hums and crackles as everyone towed in the same general northward direction and kept safe distances to prevent their nets and doors from crossing.

Right away after setting out, Captain Phil set the plastic "haul back clock" on the wall for 8:30 a.m. The silver radiator in the pilothouse hissed welcome steam heat. The Captain kept constant vigilance with the compass, Loran A (Long Range Aid to Navigation), and the black-and-white depth sounder. The first tow of the day always seems to be the longest, since there is no catch yet on deck to work on. To help pass time, he sporadically chatted over the radio with his fishermen buddies, including Mike on the nearby *St. Jude.*

Meanwhile, Captain Phil's brothers returned to the fo'c'stle. Thidda soon fried bacon and eggs in a big iron pan atop the kerosene stove. The coffee was already heated up in a big pot on the stove. He served breakfast on the galley table and relieved the captain of pilothouse duty so that he could get a bite to eat down below. After breakfast, Phil took a cup of steaming coffee back to the wheelhouse as his brothers turned in for more sleep. The four brothers got along exceptionally well, not only this day but also for years as a crew. Another brother and a co-owner of the *Serafina N.*, Salvatore "Tally" Nicastro, fished on the Gloucester dragger *Carlo & Vince.*

Then, Captain Phil blasted that irksome wheelhouse horn again at 8:30 a.m.—"time to haul back"—as he idled down *Serafina N.*'s diesel and threw it out of gear. Chubby opened up the "hook-up block," and "bang," the two towing wires snapped out of it. Next the winch men released the brakes, and the incoming cables soon crackled while being rolled up on the drums. The hauling back operation heavily listed the long and narrow *Serafina N.* to the starboard. Surface water swirls simultaneously emanated off her port side.

In a few minutes the waterlogged doors with their shiny steel shoes broke the water and were slowly winched tight and hooked up to their gallous frames. The drum winch next yanked in the trawl's "scissor" and "ground" cables, and the net eventually surfaced. *Serafina N.* circled several times with the net alongside to clean

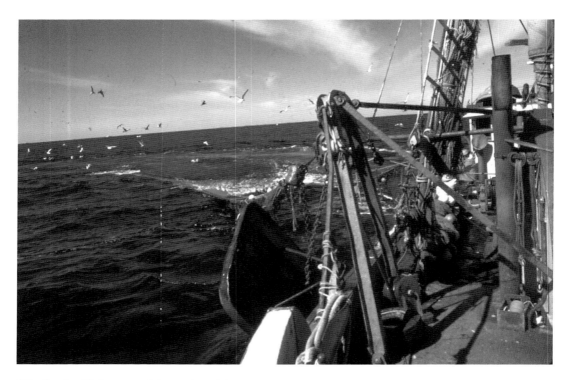

"Hauling back" the net and doors aboard the *Little Flower*.

the catch in the cod end. The brothers liked the looks of the amount of water the bulging cod end broke. Swooping gulls frantically picked out whiting and herring meshed in the top of the net.

After cleaning, Captain Phil throttled down the diesel and took it out of gear again. Aided by blocks and tackles, the crew first winched aboard the net's wide mouth and lastly its tapering cod end. After untying the cod end chain knot, nearly a ton of shrimp, groundfish and trash fish cascaded onto the deck. Following this, the crew quickly set back out, and *Serafina N.* started her second tow by 9:00 a.m.

By then a light southwest wind grayed up the ocean surface and the sun continued climbing the sky. The fleet of nearly thirty Gloucester boats was also scattered throughout Scantum Basin. Skippers compared their first tow catches over the airwaves.

Meanwhile, Joe, Thidda and Chubby began washing down, sorting and boxing most of the catch. They threw aside the marketable fish—flats (greysole and dabs) and codfish—into baskets before tackling the shrimp. This involved handpicking and scooping hundreds of creatures—mud stars, tiny herring and whiting, or "cigarettes," along with an occasional small octopus and an alligator fish—from the shrimp with a hand sieve before containing it in pine boxes that hold around one hundred and twenty pounds. The catch was stored on deck along the portside rail and covered with a tarp. Since the air was so cold, no ice was needed to keep the catch fresh today. *Serafina N.* also has a fish hold below deck to store the catch. Billowing clouds of hungry gulls followed astern and relished the discards.

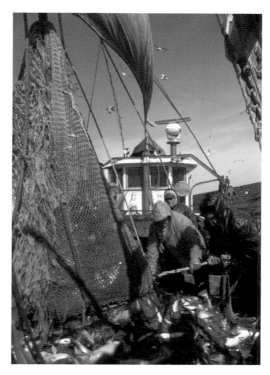

After the crew undoes the chain knot, shrimp, along with a few groundfish, cascade out of the cod end into a deck pen aboard the *Little Flower*.

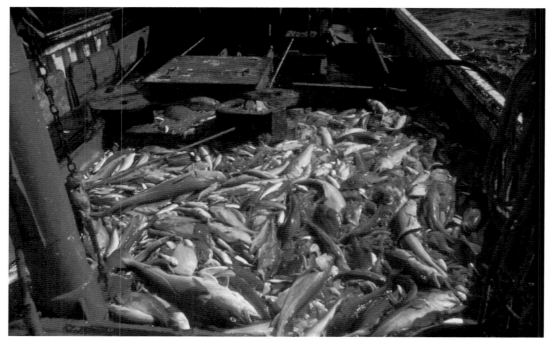

This is that catch on deck.

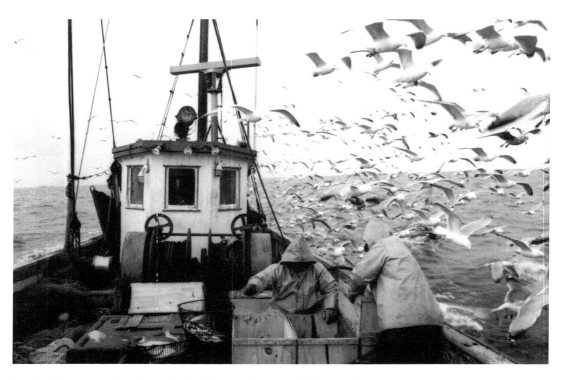

Serafina N. crewmen clear the deck of the last tow's mainly shrimp catch.

The encouraging first tow, which took approximately ninety minutes to clean and box, netted fifteen hundred pounds of big northern shrimp (thirty shrimp to the pound) and two hundred and fifty pounds of groundfish. The crew covered the catch on deck with a canvas and then went below for a mug up.

At 11:30 a.m. the Nicastros hauled back again, netting about one thousand pounds of shrimp and three hundred pounds of groundfish the second time around. The fishing pressure had apparently scattered the Scantum shrimp body. Quickly, *Serafina N.* set out for the third and final time today. By late morning the freshening southwest wind already created a two-foot chop. A milky sky then also dimmed the sun as the temperature hit the high thirties.

Around noontime, as Joe and Chubby worked on the second tow's catch, Thidda went below and cooked up a shrimp and pasta lunch. Consequently, the cook relieved Phil of pilothouse watch so that he and Joe and Chubby could chow down. Once back on deck, the Nicastros also dressed (cut heads off and pinched out the guts) some small whiting and herring and then fried them on the main engine's muffler back aft. The crew savored the sweet and tender fish. They even ate the herring—bones and all.

At 2:20 p.m. *Serafina N.* finished the last tow of the day, hugging the edge of half-way hump. A smoky sou'wester was in full force. The smoky sou'wester's winds gusted past twenty-five miles an hour and riled up three- to-six-foot-high waves. This is just what the fishermen feared would happen by either late morning

or early afternoon after seeing the dawn omen over the eastern horizon. The arrival of the backside of a high-pressure weather system usually produces gusty, warm winds out of the southwest. Earlier that day that system's clear, cold and calm conditions persisted when it was directly overhead.

Pressured by the weather, the crew quickly hauled back. Doing so, they noticed bubbles rising from the net as it neared the choppy surface. "Must have gotten into the codfish," said Captain Phil. Sure enough, the last set produced twenty-five hundred pounds of thirty- to forty-pound apiece large cod, but only a scant eight hundred pounds of shrimp. The codfish expel air from their swim bladders while ascending the water column.

The gang stored the fishing gear aboard the bobbing *Serafina N.* before Captain Phil started to steam her home to the south'ard. The old gal sliced through the chop. Meanwhile, the crew dressed, washed and boxed the big cod. Once done with the catch, Joe, Chubby and Thidda hosed down the deck area and their own oilskins. Captain Phil occasionally spat out chewing tobacco through the pilothouse door.

Much of the Scantum fleet headed home with *Serafina N.* off the backside of Cape Ann, while the smaller boats took a quicker and calmer route to Gloucester through the Annisquam River. *Serafina N.* quickly left her competition behind as she passed the Salvages buoy, and Thacher's Island off of Rockport and lastly rounded Eastern Point. By then, other draggers, gillnetters and tub trawlers converged into Gloucester Harbor by around 4:00 p.m. from Ipswich Bay, Scantum Basin, Jeffrey's Ledge and Middle Bank. Curcuru Brothers, Sonny DelTorchio's, Fishermen's Wharf and John B. Wright Fish Company already had vessels unloading catches at the dockside businesses.

Once in the inner harbor, *Serafina N.* idled past Cape Pond Ice Company and proceeded past Ocean Crest Seafoods and Felicia Oil Company Wharf to its dealership and berth at Frontierro Brothers, Inc. (FBI) Wharf. "What do you have?" owner Patsy Frontierro asked Captain Phil as he climbed onto the wharf to watch weighing out the catch. "About thirty-five hundred pounds of shrimp, three thousand pounds of cod and three hundred fifty pounds of flats," answered Phil. The shrimp and cod were worth about fifteen cents per pound and the flats were worth about fifty cents per pound, which all added up to a good stock for the day.

Following this, Frontierro's brothers Benny, Sam and Freddie quickly hoisted, weighed and then iced the catches before sticking them onto pallets. Then other wharf workers handed down replacement boxes for the next day's trip. Many retired fishermen gathered around the wharf, too, to get a fish to take home.

The crew docked *Serafina N.* at her berth at the end of the wharf before Chubby killed the main engine. The Nicastros locked all the doors, and while walking off the boat, Captain Phil told his brothers, "The weather looks good for tomorrow; same time tomorrow morning, boys."

The Log of the *Judith Lee Rose*

Trawling for lobsters two hundred miles offshore during mid-January 1971

Built in 1953 as a redfish dragger at Southwest Harbor, Maine, the approximately 104-foot-long *Judith Lee Rose* was named after owner, Captain Frank Rose Jr.'s daughter. Before lobstering offshore, the big white dragger targeted redfish on the Grand Banks off Newfoundland. The *Judith Lee Rose* could carry up to three hundred and fifty thousand pounds of these slow-growing fish that yielded the boats five cents per pound or less back in the 1950s. The redfish stock eventually crashed in the late 1960s, and the *Judith Lee Rose* became Gloucester's pioneer in the offshore lobster fishery.

On Tuesday, January 5, 1971, at 4:30 p.m., I embarked with the seven-man crew of the *Judith Lee Rose*—Captain Frank Rose Jr.; first mate Mike Maher; cook Peter Manning; deckhands Gus Doyle and Frank Domingos; first engineer Alan Murray; and second engineer Richard Tucker for a deep sea lobster dragging trip. Soon, sporadic vibrations were felt throughout the trawler at her Gloucester berth as the 625 horsepower Enterprise main diesel turned over and gray smoke billowed out from the smokestack. No ripples marred the harbor's surface, but the sky looked unsettled. Herring gulls funneled overhead; the bluish-black clouds highlighted their white plumage. The air felt cold.

Captain Rose hollered "okay" and then raised his right arm to the gang on deck to release and haul aboard the thick mooring lines. More intense vibrations were felt, and the engine's cylinders labored as an initial kick forward churned up a gush of bubbling water from the trawler's rounded stern and pushed her away from the dock. She was on her way to another nine- to eleven-day fishing trip. Keeping to tradition, Captain Rose blasted the horn three times while leaving the outer harbor. His family waved good-bye from the Stacey Boulevard with yellow kerchiefs.

Once past Eastern Point Dogbar Breakwater, the first engineer gave the big Enterprise diesel nearly full throttle, and the *Judith Lee Rose* steamed southeast toward open ocean at ten knots. The sky cleared and whitecaps appeared as a gusty twenty- to thirty-mile per hour northwest wind exercised its power on the sea's surface. The sun made one last appearance before descending out of sight in the west. The fiery ball extended its final rays as if they were gates clanging down from the heavens, trying to shut out the night. Pushing seas pounded against the vessel's high stern. The fishing boat began to nose-dive slightly and yaw, but at least she was going fair-wind.

Supper—fried pork chops, bread and butter, baked potatoes, squash, melon and coffee—was served in the forward fo'c'stle at 5:30 p.m. The grub was plentiful. Each fisherman had his regular spot at the dining table. Captain Rose sat at the head of the table. Here, he could get up and run out quickly if an emergency arose. Still wearing his white apron, the cook left the fo'c'stle once dinner had been served and then took control of the vessel from the pilothouse so the remainder of the crew could eat. Manning's departure from the fo'c'stle was the signal that dinner was ready and waiting.

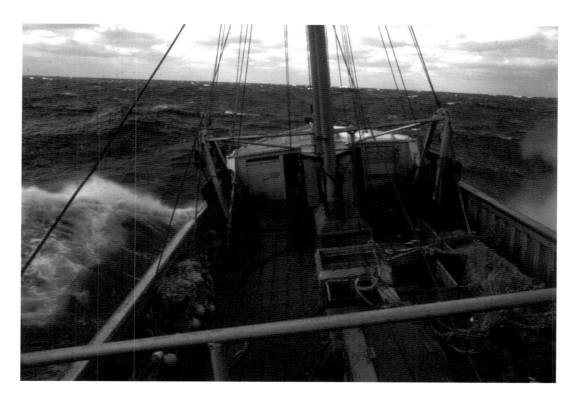

The *Judith Lee Rose* heads into some heavy seas.

The wind whistled around the wheelhouse and swayed the mast rigging. Boat timbers buckled and crackled in the fo'c'stle, and occasionally, the propeller would send out vibrations as it and the shaft spun in empty air. The ocean surface frothed with white caps. Soon, all of the crew members except the man who had pilothouse watch duty crawled into their soft bunks. Everyone aboard had a two-hour turn at watch. The men quickly succumbed to fatigue.

The gusty northwest wind continued into the next morning, turning the ocean's surface feather white with angry ten-foot-high waves. Shearwaters and kittiwakes glided over the boat's wake in the thirty-degree air. They followed along for miles, hoping for tossed-over food scraps. At 6:30 a.m., the cook yelled "breakfast," and orange juice, bacon and eggs, toast with butter and jam, and coffee awaited the crew on the galley table. Within a few minutes, everyone, except the cook, was in his seat. Morning conversation was sparse. The miserable weather and the fishing area were the only topics discussed. After breakfast, the men chatted a while longer before returning to their bunks. Some fell asleep, building up a sleep reserve, and others read. They knew what lay ahead.

At 12:30 p.m., the *Judith Lee Rose* reached her fishing ground—Oceanographer Canyon—some two hundred miles south-southeast of Cape Ann along the continental slope off of Georges Bank. The crew members instinctively jumped into their boots, put on their oilskins and gloves and gathered on deck after Captain

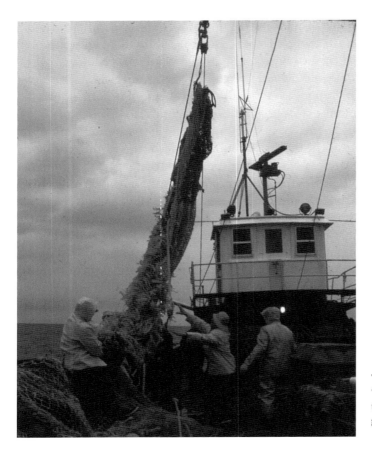

The *Judith Lee Rose* crew begins "setting out" the net by first hoisting the cod end with its wig-like chafing gear over the rail.

Rose rang a piercing signaling bell from the wheelhouse. The main engine was idled down, and the rolling vessel lay broadside to the angry seas and wind.

The crew next set out the one hundred-foot-wide, funnel-shaped nylon net which had a roller sweep. The rollers allowed the mouth of the net to pass over rough bottom. The crew first winched up the roller sweep over the starboard rail, followed by the cod end. The cod end had woven-in strands of wig-like chafing gear and cowhide on its underside to protect it while being towed on the bottom with fish inside. The rest of the twine was fed over the side and carried away from the boat by a strong tide, followed by the remainder of the roller sweep and the head-rope with its many plastic floats. Captain Rose looked about making sure the trawl was set out properly, then signaled the engineer down in the engine room to give the Enterprise low throttle forward. Diesel fuel burned and water churned as the boat made two wide circles with net alongside to make sure it had no twists or turns.

Winchmen Doyle and Maher took their positions, and another pilothouse bell rang once—the signal to release the drum winch brakes. Then, the fore and aft massive trawl "doors"—two thousand pounds each—splashed into the water. The paraplanes descended upright in opposite directions, spreading apart and taking the net down with

them. Fathoms and fathoms of two ⅞-inch cables were paid out till the 450-fathom double rope cable markers appeared. The two drums were braked tight, and the two towing cables were locked in the hook-up block astern. The otter trawl would scoop up lobsters twelve hundred feet below on a broken bottom (a mixture of sand and rock) during two and a half hour intervals at a speed of three knots.

While most of the men went below for a mug up, Captain Rose and Tucker remained in the pilothouse and steered the vessel, took continuous LORAN A readings and kept a tab on water depth and bottom topography with the sounding machine. They had to avoid towing over sharp peaks and drops which could rim-wrack, or tear, the net. No other boats were seen fishing in the area.

Two and a half hours passed; Captain Rose sounded off the haul-back alarm, and a chain of events followed. In no time, the crew appeared on deck. The main engine was slowed down, and a separate diesel started up to power the main trawl winch. The trawl's towing wires soon crackled as the winch's rotating drums wound them up. Within a few minutes, the trawl doors scraped against the boat's side and were winch-lifted up tight against their gallous frame blocks. Furious seas broke and frothed against the *Judith Lee Rose's* windward side. The crew, often pelted by flying spray, next used the jillson to haul aboard the mouth of the trawl, followed by its tapered sections. Black-backed gulls shrieked overhead, and kittiwakes glided atop the ocean surface nearby. Finally, the men used the double tackle to pull aboard the bulging cod end. They undid the cod end chain knot, and about fifteen hundred pounds of lobsters and fish flowed onto the partitioned deck. The net was immediately set out again, and the *Judith Lee Rose* resumed fishing. By now, floodlights were chasing away the darkness on deck.

The crew's next job, minus the captain, was to sort and store the catch—jobs made more difficult by the rough ocean and rolling boat. They washed down the entire catch with a high-pressure hose and then worked around the catch, picking out the lobster, banding their claws and placing them in plastic tubs according to size. Lobster weighing two pounds and under made one grade, while those weighing greater than two pounds made the other. Each tub could hold about one hundred pounds of lobster. Banding the claws prevents lobster from crushing one another. The fishermen used plier-like banding tools to spread apart the rubber bands and slide them over the claws. Out of approximately five hundred pounds of male and female lobster, the smallest one weighed about a pound while the largest weighed around eighteen pounds. Most of the lobster weighed over two pounds.

After the lobster, the men tackled the marketable fish. About five hundred pounds of white hake, cusk and greysole were culled from the catch, dressed, washed and separated into baskets. Greysole did not need to be gutted. Captain Rose carefully watched his crewmen's performance from the wheelhouse. Anyone not doing his job would hear about it.

Roughly five hundred pounds of trash fish (fish that was not saved, but returned to the ocean): long-finned hake, goosefish, batfish, redfish, black-bellied rosefish, eelpout, marlinspikes, long-nose grenadier, and abyssal grenadier, made up the

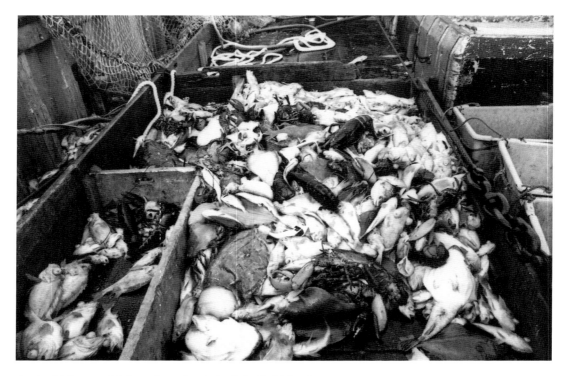

A mixed lobster and fish catch on the deck of the *Judith Lee Rose*

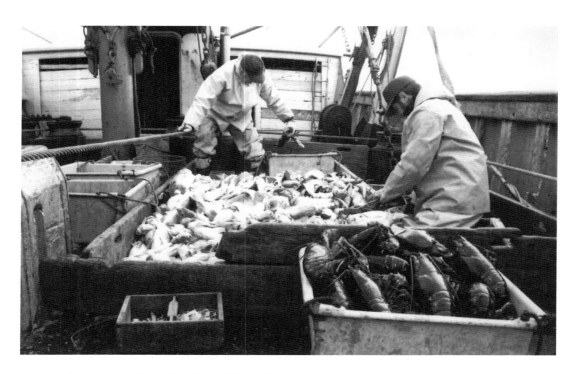

Judith Lee Rose crewmen Peter Manning and Dick Tucker sort out lobster from the catch.

remainder of the catch. Pieces of tree coral also came up with the net. Ironically, starting in the 1980s, domestic European and Asian markets opened up for whole monkfish, their tails and their livers. Monkfish then became a target species for draggers and gillnetters, often yielding over two dollars per pound.

The marketable catch was stored below deck in the fish hold. Crewmen Tucker and Doyle opened the hatchway on deck and climbed down about twenty-five feet of aluminum ladder to get there. First, the lobster containers were lowered down and emptied according to lobster size into a separate fish hold compartment. The greysole flounders, hake, and cusk were iced down in a forward fish stall. The *Judith Lee Rose* didn't save the redfish at the beginning of the trip, since these oily fish do not hold up well during long trips. All of the empty baskets and tubs were hoisted out of the fish hold. Once done, Doyle and Tucker came out of the fish hold and quickly closed the hatchway. The fish hold section housing the lobster was soon flooded. A motor-driven pump at the stern of the boat helped maintain a constant seawater level of two hundred and forty thousand gallons.

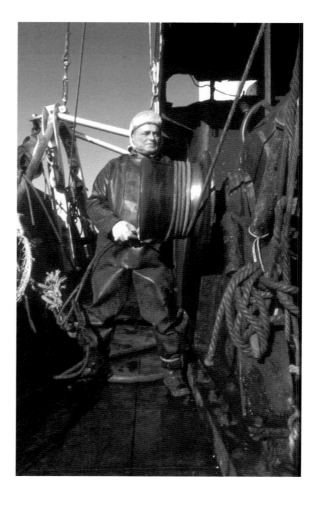

Frank Domingos operates the winch head.

Last, the crew washed down the deck and rid the area of fish viscera and trash fish. Hungry seabirds enjoyed the discards after they were washed out of the scuppers.

After all of the deck and below-deck work the men were hungry, too. A hearty supper of roast beef, pan-fried potatoes, boiled carrots, bread and butter and coffee sated their appetites.

No sooner did most of the men sack out and fall asleep, than it was time to haul back again. This pattern of eat, sleep, watch and fish around the clock continued for seven to eight days—or however long it took to get a trip. The second haul of the first fishing day brought in seven hundred and fifty pounds of large lobster and a few groundfish.

At 1:15 a.m., the third haul back of the first fishing day was made. The elements challenged the boat and the fishermen. The strong northerly wind blew across the floodlighted deck, which resembled an island surrounded by sheer walls of inky blackness. The cold air, a flat thirty degrees, burned the fishermen's bleary eyes as well as their exposed skin and even carved grimaces in their faces. Steam poured forth from their mouths as they talked. A crewman sometimes stopped work and hugged himself to build up body heat under his foul-weather gear.

If the cold and wind weren't bad enough, the *Judith Lee Rose* yawed frequently in the big seas, making it even harder for the fishermen to keep their balance on their hands and knees as they culled out and banded lobster. Every once in a while a deck man fell on his back, and the others asked if he was all right. Even the catch sloshed back and forth on the deck in unison with the boat's rolling. Nary a mast light could be seen yonder, but white caps were clearly visible in the darkness.

Strong twenty- to thirty-mile per hour winds continued on Thursday, January 7, and at least the early-morning hauls resulted in twelve hundred more pounds of lobster. The stubborn wind and choppy seas roared on, but remarkably, the trawler continued fishing. Captain Rose, like most other offshore skippers, fished until the conditions became too dangerous to do so. Haul backs and set outs continued to take place every two and a half hours.

By early afternoon, the northwest wind had increased in velocity to forty miles per hour. Black-backed gulls still soared overhead. The exasperated captain ordered the crew to haul back and store the gear on board till the wind died down. The heavy doors were hauled inside the rail and blocked tight against their gallous frames and the net was tucked alongside the railing. Seawater was drained from the fish hold to prevent the lobsters from sloshing about and crushing one another.

Towing in choppy weather increased the probability of damaging or losing the entire trawl, worth about three to four thousand dollars. Even worse, stormy weather not only upped the chances of strained blocks and tackles, cables and ropes snapping and hurting or killing a crewman, but also of waves breaking on deck and washing someone overboard. Fishermen have also been lost at sea after standing on a net partially hauled aboard and being uplifted when a roll of the vessel pulled the net down.

After everything was secure on deck and engineer Murray shut down the main engine, everyone but Captain Rose returned to the bunks to catch up on lost sleep, and the *Judith Lee Rose* lay adrift, cupped within the wind and seas.

Tired and weary, the *Judith Lee Rose* crew enjoys supper in the cozy fo'c'stle.

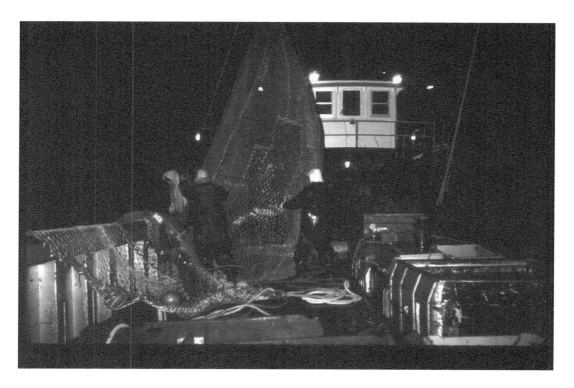

The *Judith Lee Rose* crew "sets out" more of the net during the wee morning hours.

Friday, January 8, brought a diminished wind along with a badly torn net. After blowing for four straight days, by late afternoon the prevailing winter wind out of the northwest finally diminished to twenty-five miles per hour. Captain Rose gave orders to set out, and once again the nylon net and heavy doors went back to work on the mysterious bottom, but this tow turned out to be a waste of time. The net, especially its belly section, came back rim-wracked, and most of the catch had escaped. The crew quickly stretched out the torn belly on deck, cut away badly torn sections with their pocketknives and got out the knitting needles and nylon and sisal mending twines. They had the net fishing again in twenty minutes. Even Captain Rose came down from the pilothouse to help with the mending. The *Judith Lee Rose* carried spare net parts. The vessel also had a spare net and set of doors on the port side and could use it if the starboard-side gear got lost or badly damaged. The crew didn't want to lose any fishing time unneccessarily.

Hard bottoms were ideal for tearing bottom trawls towed by heavy boats. Once a net snagged down on a bottom obstruction, like a sharp edge or rock, something had to give, and nine times out of ten, the twine ripped.

The obstinate winter wind finally died down by late afternoon, and the choppy ocean surface also flattened out. The Gloucester-based *Cape May*, another lobster dragger, briefly fished alongside of us. The *Cape May* was the first vessel spotted in days. Good lobster catches averaging around five hundred pounds a tow continued.

The sea's surface was flat calm, and neither timbers buckled nor dishes, pots, and pans slid in the fo'c'stle on Saturday, January 9. At 6:00 a.m. cook Manning served bacon and flapjacks. The day's temperature soared to forty-five degrees. Catnaps between tows were a poor substitute for eight hours of sleep, and mental and physical fatigue mounted amongst the crew. Whiskers lengthened on their faces, and loneliness and distant loved ones began to dominate the fishermen's thoughts. Most pondered how much longer this trip would last.

Sunday, January 10, delivered a bad omen at sunrise—a bright red sky in the east. The fishermen nodded their heads knowingly—"red skies in the morning, sailors take warning." The reading from the barometer in the pilothouse began to drop, and, just as bad, dense flocks of birds followed the *Judith Lee Rose*. Both men and birds knew a storm was imminent.

In the meantime, catches averaged six hundred pounds of large lobster. Two giant male lobsters—"horse lobster"—weighing twenty-five pounds apiece, were scooped up in one of the tows. The deck crew had to wrap electrical tape around their huge claws, since no bands were large enough to slip over them. By late afternoon, a gentle wind out of the northeast riled up capillary waves on the ocean surface.

The National Weather Service forecast raised storm warnings for offshore areas, including Oceanographer's Canyon, during a 5:20 p.m. radio broadcast. The forecast predicted the storm would strike by evening and would lash out with winds up to sixty miles per hour out of the northeast, heavy rain, and waves building to twenty-five feet high. Skippers of nearby New Bedford, Boston and Gloucester-based vessels and foreign skippers could be heard debating over the radio whether or not they should head for home. Those vessels with a good trip aboard steamed home; others continued fishing until the foul weather hit, and then they would ride it out at

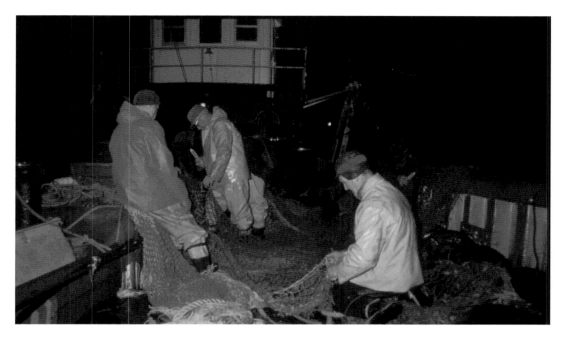

Crewmen of the *Judith Lee Rose* mend a badly torn net stretched out on the open deck.

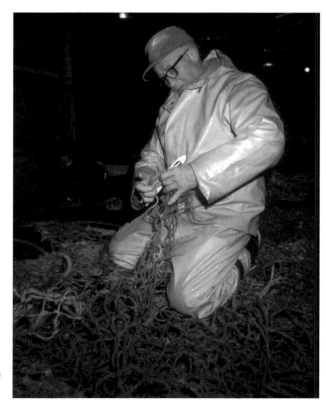

Mate Mike Maher begins mending the torn net.

sea. Many of the radio voices came from Gloucester skippers who sounded so near, yet were so far.

The storm hit at 9:00 p.m. The howling northeast wind and rain falling in vertical torrents were enough for Capt. Rose to signal the haul-back alarm. The fishermen appeared on deck in full foul-weather gear including sou'westers. The race to haul back and store gear in a hurry was on. The separate winch diesel roared and gave off a cloud of gray exhaust that rose like a pale shadow silhouetted against the raindrops and darkness. Most of the mast rigging also swayed from side to side as the seas built up, spat out white foam and bubbles and rocked and rolled the *Judith Lee Rose*. Finally, the doors surfaced, followed by the net. The net had gotten torn again. Bad luck came all at once. Like during the last breeze, the crew stored the gear, drained the fish hold, and this time covered the hatchway with a waterproof canvas. The northeast wind began to blow harder, driving the rain into blinding horizontal sheets. The *Judith Lee Rose* rode out the storm alternately jogging into the wind and seas at headway speed and laying to them and bobbing like a cork. Luckily, not only was she a big vessel with a high bow and plenty of freeboard, she was run by a crew that has ridden out even hurricanes.

Once the deck had been secured, Tucker had the watch, while most of the crew returned to the fo'c'stle where they couldn't get their dripping oilskins off fast enough. After wiping the precipitation from their faces, they enjoyed hot cups of coffee before hitting the sack. Captain Rose also got a respite from wheelhouse duty, lying down in his bunk there. He rested with one eye open.

At 2:30 a.m. everyone in the fo'c'stle was awakened and nearly thrown out of their bunks. A mammoth sea had lifted the dragger's bow out of the water for a split second and sent it crashing down. The timbers moaned continuously in the fo'c'stle, while dishes and silverware kept sliding back and forth in their storage compartments there. The main overhead light in the fo'c'stle flickered.

But, the *Judith Lee Rose* kept jogging slowly into the mountainous seas. Darkness made seeing what lay ahead very difficult. Every once in a while, one of the liquid mountains would crash over the twenty-five-foot-high bow and splash tons of water onto the open deck, sending rumbling vibrations throughout the trawler. Stored paper boxes and foul-weather gear even flew about in the fo'c'stle. The men had to either brace themselves in their bunks or get tossed out. No one knew what to expect next. The vessel jogged for another hour before the main engine was shut off, and she laid to the wind and seas. This option seemed much smoother than jogging. While laying to, or drifting sideways to the wind and waves, the vessel just slowly rose up and down with the waves. Fortunately, there was plenty of open ocean and deep water out at Oceanographer's Canyon.

At daybreak Manning served the gang a cold cereal breakfast. Cooking anything on the stove posed the danger of something spilling over and starting a fire or scalding someone. Everybody sat tight in their bunks until it was their time for their pilothouse watches.

Some of the long period waves had twenty-five-foot peaks. Occasionally, a big wave made its might known by crashing against the trawler broadside and tossing

aboard tons of water. The highly adapted oceanic birds flew low among the wave troughs to shield themselves against the turbulent air.

By late afternoon the rampaging northeast wind began to simmer down, and a patch of white sky appeared in the west. Fortunately, this low-pressure area moved rapidly. Huge ground swells lingered on as the wind died down to a few miles per hour. Captain Rose took a LORAN reading of the boat's whereabouts so he could return her to where she last fished.

A welcome reddish skyline glowed in the west. The fishermen smiled—"red skies at night are a sailor's delight." Before setting the fishing gear out, the torn net had to be repaired. The men began mending its torn belly and wing barehanded and often on their hands and knees. Despite occasionally stopping to cup their cold bare hands in front of their mouths and blow on them and getting up from their hands and knees and moving about to warm themselves in the thirty-degree air, they completed the cumbersome chore in about forty-five minutes. Mike Maher was one of the oldest crewmen at the time; he was in his late sixties. I remember his hands often turning white from the cold while mending.

The wind blew moderately—between fifteen and twenty-five miles per hour— on Tuesday, January 12, but the lobster catches were good, averaging about eight hundred pounds per tow. By now, the total lobster catch was well up in the thousands of pounds.

A 2½-foot-long electric skate, or torpedo ray, was towed out of the depths in an early afternoon set. This cartilaginous fish has electric organs composed of modified muscle tissue in its pectoral fins; they create electrical charges that can give a human being a nasty shock. The men picked up the flattened fish with rubber gloves and gave it the heave-ho. Besides lobster, the trawl also scooped up other interesting invertebrates, including squid, an octopus, red sea starfish, basket starfish, and Jonah crabs, along with many unidentified pen-like annelids and sea pens. Only the lobster was saved.

The ninth day of the fishing trip, Wednesday, January 13, brought along fair weather, a cramped-up feeling and a mishap. By now many of the crew, as well as myself, began to feel cramped up. No longer did the 104-foot-long boat feel or look this size; it felt as if we were living in a matchbox. Most wondered when the fishing trip would end.

A mishap occurred during a late afternoon tow. When hauled back, the net had not a single scale or shell within it; somehow the cod end chain knot had come undone while under tow, and the entire catch went right out of the net.

Northerly winds blew lightly, and seas were slight on Thursday, January 14. The day's lobster catches averaged four hundred pounds per tow. An old herring gull landed on the whaleback deck and began preening its primary wing feathers. Most likely, the seabird had swum into an oil slick that coated its feathers. The fishermen told me that an oceanic bird will usually only land and rest on a boat when sick or near death. Later, the bird died.

Winter's prevailing westerly wind lightly exercised its power the next day. The fishermen sported stiff whiskers, and their clothing had become grimy and itchy by

Friday, January 15. There were no shower facilities on fishing boats then. The men sensed the end of the trip was near. Lobster catches averaged five hundred pounds a tow.

Late Friday night, Captain Rose gave word to haul the gear aboard and store it. The crew knew what this meant, and elation showed on their faces. The *Judith Lee Rose* soon headed home to the northwest. Several dragger mast lights were seen in the distant darkness. Crew members didn't waste any time catching up on lost sleep. Now it would be uninterrupted—at least until their watches came up. Captain Rose knew he had a good trip of lobsters. He was also anxious for the trip to end, but captains always kept that to themselves.

A moderate northwest wind that tossed up a five-foot chop accompanied dawn. Darkness fled as the sun ascended in the east. The air temperature, in the low thirties, dropped as the vessel neared land. The *Judith Lee Rose's* big bow sliced through the waves; spray flew and coated her deck sides and lower mast rigging. Soon, the thin ice coating grew thicker as more spray blew aboard and froze, and what was dark became light because of the ice, and the rounded became jagged as layers of ice and icicles formed. The crew set up a lifeline that ran from the entrance of the fo'c'stle to the pilothouse. Such a lifeline is also set up during stormy weather. It has prevented fishermen from being washed overboard.

Fifty miles off Cape Cod, the skipper radioed a lobster dealer there. Rose asked him what he was paying for lobster. The dealer's prices were: $1.20/lb. for small, $.90/lb. for large, and $.60/lb. for weak lobsters. Captain Rose liked what he heard. He gave the dealer their estimated arrival time.

At 12:02 a.m., the *Judith Lee Rose* had docked at the Cape Cod lobster dealership along the Cape Cod Canal. Earlier, cook Manning had served up a delicious supper of fried chicken. He even specially made blueberry and apple pies for dessert. The sky was exceptionally clear; stars glittered above, and a full moon lit up the land and sea. The water was as calm as a millpond.

The lobster dealer soon walked out of his two-story building, said "Hello," and asked the captain what he had. His dockside building housed a number of lobster tanks. Captain Rose climbed onto the wharf alongside the dealer. The two weighed the lobsters—tub by tub—and jotted down the weights. The rest of the crewmen had the job of filling the tubs in the fish hold and then hoisting them out and onto the wharf. The small lobster, two pounds and under, were weighed first. Any weak lobsters among them were put aside and weighed later.

The off-loading took about two hours. The captain and the dealer then went into the building's office. Captain Rose soon came out with a check for 13,580 pounds of lobster.

The *Judith Lee Rose* left the dealership at 2:01 a.m. and reached Gloucester Harbor by 7:05 a.m. Before that, snowflakes fell at sea and visibility dropped to a few feet. A gentle northeast wind pushed the lifeless ice designs into frolicky motion. The dragger's radar helped the watchman safely navigate. In no time, the crew heard the echo of the foghorn at the tip of Dogbar Breakwater.

The big white boat docked alongside DelTorchio Brothers Wharf shortly afterwards to unload three thousand pounds of cusk, hake and greysole. Captain Rose would pick up the check for these fish later on.

At last the lobster dragger reached her berth in the inner harbor. The crew's families were waiting in cars to pick them up. Immediately, Doyle and Domingos jumped ashore, caught the bow and stern lines and placed the end loops over wharf cleats. Murray soon shut down the main diesel, and the pilothouse and fo'c'stle doors were locked shortly afterward. The seven-man crew and this guest climbed over the portside rail with their duffel bags and a few paper boxes full of filleted fresh fish onto a snow-covered wharf. The solid land felt good. Both the crew members and vessel could rest up for three days. The trip's proceeds would be settled up, and the crew would be paid during the three-day layover. Then, another nine- to eleven-day fishing trip would be in the making.

CHAPTER 8

FATE OF THE FLEET AND THE
FISHERMAN SINCE THE EARLY 1970s

Just what has happened to the Gloucester fleet since the early 1970s? After sinkings, sales and demolitions, only one of the original ninety-five draggers remains afloat in Gloucester in 2007. The *Little Sandra* (formerly *Anthony & Josephine*) still actively fishes, owned and operated by Captain Mike LoGrande and his sons Tom and Matt.

Those crews of character of the early 1970s fleet have since retired or passed away, while some of the younger ones have become boat owners or skippers, taken shore jobs or started other businesses, or have left fishing altogether. The early 1970s was truly the beginning of the end for the eastern rig side trawler in Gloucester, as well as the end of the fisherman's independent lifestyle and the freedom of the fishing grounds.

As tough as the early 1970s were, the fleet kept on plugging—fishing for this and for that as new markets opened for more underutilized species. The fleet, with the help of the Fishermen's Wives, kept pushing for the two hundred-mile-limit to rid the east coast of those damned "Russians."

Some brave fishermen actually invested in new vessels. In 1972 Captain John Cusumano added the new sixty-foot blue and white, red-trimmed wooden-hulled *Acme* to the fleet. His old *Acme*'s pilothouse was reused on the new Maine-built vessel. Two years later, Vito and Giochinno "Jackie" Ferrara took a gargantuan step by having Steiner Shipyard in Bayou LaBatrie, Alabama, build them the all-steel western rig 80 x 23 x 10-foot side trawler *Little Flower II* powered by a Cat D343 TA diesel. This handsome, beamy, pale blue and white vessel soon became the envy of the inshore fleet. More Gloucestermen bought second-hand gulf states wooden and steel western rigs with forward wheelhouses: Leo Vitale brought up the *Four Brothers*, while the Lakeman family purchased the *Silver Lining*, and Jackie Russo bought the *Dolores Louise* and Chubby Loiacano purchased the wooden-hulled eastern rig *Sailor's Choice*.

In 1976 the fishermen's dreams came true as Congress passed the Magnuson-Stevens Fishery Conservation and Management Act. The Gloucester boats, even though many were old and tired and underpowered, were poised for a boom. Soon, most of the foreign fishing fleet left Georges, and once again there were fish to be caught.

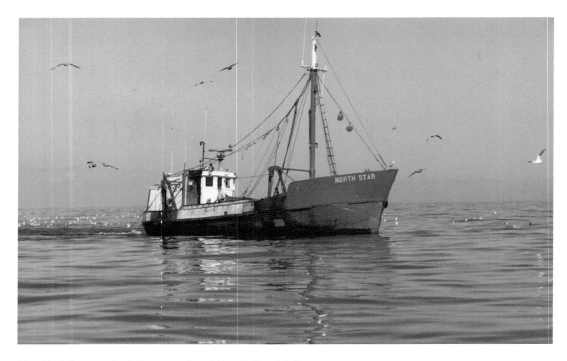

The *North Star* tows its fishing gear for whiting in Ipswich Bay.

Many seven- to ten-day-long offshore fishing trips yielded sixty to eighty thousand pounds of cod and haddock, and the prices rose steadily, too. Did the fish naturally rebound on their own, or were Gloucester boats just catching the fish that would have otherwise been caught by the foreign vessels?

According to "Fisheries Management for Fishermen: A Manual for Helping Fishermen Understand the Federal Management Process," a pamphlet by Richard Wallace, William Hosking and Stephen Szedlmayer:

> *The 1976 Magnuson-Stevens Fishery Conservation and Management Act empowered the federal government to regulate fishing from three miles offshore out to 200 miles. This Act created eight regional fishery management councils that are overseen by the Secretary of Commerce. Each council develops fishery management plans (FMPs) for the stocks in their geographical region. These regulations and other NOAA laws are enforced by NMFS law enforcement agents, the U.S. Coast Guard, cooperating state officers and other federal agents. Congress directs fishery management policy through amendments to the Magnuson Act.*

In 1996 Congress reauthorized this original Magnuson Act, which became the Sustainable Fisheries Act. "This new act incorporated national standards and addressed by-catch, safety, over-fishing, fish habitat and community impact issues," said Susan Murphy, Fishery Policy Analyst on Groundfish Plan for NMFS. This act was reauthorized in 2006.

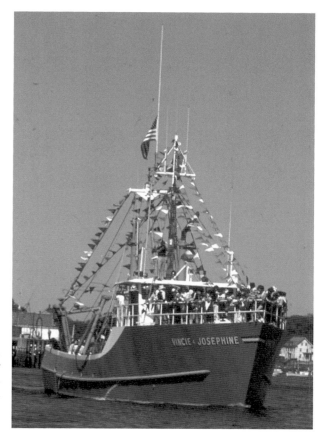

The new 83-foot-long *Vincie & Josephine*, festooned with flags, arrives in Gloucester Harbor in 1976 after a long steam from Alabama. This was Gloucester's first vessel funded under the Fishing Vessel Obligation Guarantee Program.

As a result of the fish and the two hundred-mile-limit, fishermen felt good about their industry again. The U.S. Government with its new 1976 Fishing Vessel Obligation Guarantee Program even promoted an East Coast fleet build-up to capitalize on the two hundred-mile-limit. Under this program, overseen by the National Marine Fisheries Service, the U.S. Government would guarantee 100 percent of banks' new vessel loans to commercial fishermen.

A gold rush mentality soon permeated the Gloucester waterfront. I especially remember the joyous late 1970 and early 1980 times, being a fisherman myself, and also a free-lance writer covering mainly new vessel arrivals for the *National Fisherman*, then located in Camden, Maine. The fishing industry was in high gear here; new boats soon arrived in port. One of my 1976 *National Fisherman* articles was headlined, "This Steiner built trawler is no shrimp boat" referring to Salvatore Costanzo's and Captain Sam Ferrara's sparkling new 83 x 23 x 12-foot steel-hulled stern-ramp trawler *Vincie & Josephine*, powered by a 565 HP Caterpillar diesel. *Vincie & Josephine* was safer, easier and faster to work and more efficient. It symbolized the future fishing vessel—the all-electric, raised fo'c'stle steel stern-ramp trawler powered by a big diesel and featuring hydraulic winches,

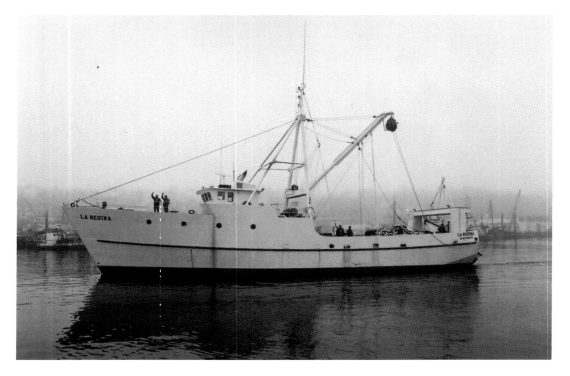

The combination dragger and seiner *La Regina*

net reels and wire spools and the very latest electronics, including LORAN C and color fish finders. This state-of-the-art trawler, whose fishing gear was now handled off the stern as the vessel moved forward, could fish on harder bottoms and in rougher weather than many of the former side trawlers could. Incidentally, this blue and white vessel was Gloucester's first boat funded under the Fishing Vessel Obligation Guarantee Program. I'm sad to say that the beautiful *Vincie & Josephine* sank during the late 1970s.

These other new-vessel headlines followed: "Gloucester Gets its First Bender Boat" (Feb. 1978) (Fred Lieber's 83 x 22 x 11.5-foot steel stern trawler *Hattie Rose* built by Bender Shipyard, Inc., of Mobile, Alabama), and "Tommy's Dream is Realized with 75-foot Trawler" (Oct. 1978)—(Gaetano "Tommy" G. Brancaleone's 75.5 x 21 x 11.2-foot stern trawler *Paul & Domenic* built by Rhode Island Marine Services, Inc., of Snug Harbor, Rhode Island). The *Paul & Domenic* was Gloucester's first vessel to be equipped with a knort nozzle, a collar device fitted around the vessel's propeller to increase its efficiency.

Every time you turned your head on the waterfront it seemed that another either new or second-hand dragger was arriving, built in Rhode Island, Alabama, Florida or Maine. Gamage Ship Builders, Inc., of South Bristol, Maine, built the beautiful white steel-hulled 110-foot combination purse seiner and stern dragger *La Regina* for Parisi brothers Charles, Nicholas and Anthony. The fleet's build up really got

Captain Salvatore Ferrara sits in the comfort of his new 105-foot-long *Vincie & Josephine*'s pilothouse.

underway with the arrival of the new 90-foot or longer extremely powerful raised fo'c'stle stern trawlers—*Sacred Heart, Stella del Mare, Our Lady of the Sea, Giacamo F.* and the *St. George II*, and the medium-sized ones *Italia, Italian Gold* and the *Gloucesterman*. But, some traditional fishermen had 81- to 97-foot-long steel side trawlers constructed then, too—the *Morning Star, Taormina B., Andromeda, Vito C.* and *Vito C. II*.

In addition, numerous Gloucestermen purchased these other second-hand vessels, often through boat agencies and brokerages: *Virginia Surf, Virginia Gentleman, Carol Ann, Jacqueline & Maria, Christian D., Cory Pride, Miss Trish, Constellation* and *Two Sons*. Captain Sam Ferrara's and Salvatore Costanzo's sunken *Vincie & Josephine*'s 1982 replacement—the new 105-foot red-hulled yellow-trimmed steel stern ramp trawler, also named the *Vincie & Josephine*, pretty much marked the end of Gloucester's big fleet build up. The next new stern trawler addition, the 92-foot *Italian Princess*, occurred in 1989.

With these new and second-hand additions, Gloucester's dragger fleet now had some fishing power. The 1980 total landings and their dollar value when cod, haddock and pollock landings each surpassed twelve million pounds. Some draggers and seiners netted over sixty-three million pounds of herring, while several purse seiners hauled over forty-three million pounds of menhaden during the summer. Dogfish, conger eels (ocean pout), monkfish, skates and even sand dabs—once "trash fish"—now had markets open for them.

Adding to Gloucester's total landings were the more than five hundred and fifty thousand pounds of delicious sea scallop meats caught by visiting scalloping fleets from New Bedford, Virginia and the Carolinas. These vessels bore such names as *Canton*, *Wesport*, *Kathy & Maureen*, *Kokina* and *Captain Jake O'Neal*. Many big Maine vessels, especially the O'Hara fleet's trawlers *Araho* and *Defender* from Rockland, added Gloucester landings, too. The men still had relative freedom of the seas and their livelihoods, even though the International Conference for North Atlantic Fisheries, or ICNAF, then mildly regulated their fishing with temporary closed areas and seasons, minimum mesh size, and annual quotas for haddock, yellowtail and cod. The Gloucester fishing industry was booming in 1980 when over two hundred and two million pounds of seafood worth over thirty-six million dollars went onto the wharf from the vessels.

This post-Magnuson Act boom allowed many fishermen to realize their dreams of having families, owning their boats and having new homes in the suburbs.

Also during this windfall, just about every other major East Coast port including Boston and New Bedford, Massachusetts, Portland and Rockland, Maine, Newport and Point Judith, Rhode Island dramatically built up their fleets with powerful stern trawlers, also funded by the federal government's loan fund program.

Besides the massive fleet build-up of new and used large draggers, there was a similar build-up of small- to medium-sized, mainly fiberglass fishing vessels, including high-bowed and beamy *Novi*'s (Nova Scotia-made boats) and 42-foot *Bruno Stillmans*. Bruno & Stillman was a popular boat builder in Newington, New Hampshire. The popularity of fiberglass boats soared then, not only because of their low maintenance but also due to their much lower new price compared to wooden boats.

The smaller vessels' fishing methods included long lining, gill netting, dragging and even Scottish seining. Scottish seining was very efficient for catching flatfish in shallow water. Many of these boats, crewed by one or two men, seasonally worked the hard bottoms of inshore grounds for cod, pollock, haddock, cusk and hake. Quite a few even fished smooth bottom for flounders and later spiny dogfish. I remember one late fall and early winter when gill netters hit the large pollock just an hour or two from Gloucester, each bringing in between fifteen and twenty thousand pounds daily. Some of these smaller boats ventured offshore to Cashes Ledge, Franklin Swell, Three Dory Ridge and Platts Bank, too.

Others dragged inshore for groundfish and northern shrimp during the winter and spring, and then switched over to giant bluefin tuna fishing and frequently lobstering. Even party boats increased in number all along the coast and some made offshore trips to Georges Bank and Cashes Ledge. This continuous tremendous fishing pressure, even when spawning fish bunched up, on both the smooth and hard inshore and offshore bottoms, added up to the future fisheries disaster. Improved technology, especially better otter trawl gear, color fish finders and even global positioning systems (GPS)—didn't help with fish conservation, either. The once-huge fish schools were being further broken up even on hard-bottom sanctuaries. The fish sizes got smaller as the stocks further declined.

Then the United Nations World Court dealt east coast groundfish, swordfish, lobster and scallop fishermen a hard blow in 1984 when its Hague Line decision

gave parts of the Gulf of Maine and, worst of all, most of Georges Bank's productive northeast peak to the Canadians. Gloucestermen felt that they lost the best part of Georges Bank. This ruling dramatically shrank the offshore fisherman's once-lucrative grounds, thus concentrating the huge U.S. fleet in the remaining waters. Fishing skippers often complained of seeing boats bunched up no matter where they went.

With fishing effort even more concentrated and more efficient because of better gear, the stocks further declined—this time due to U.S. fishing pressure. Consequently, government fish conservation regulations also increased. The New England Fishery Management Council came under more pressure to create fishery management plans to protect the declining species.

Soon, 1987 through 1991 Amendments 1 through 4 of the Northeast Multi-species [groundfish] Fishery Management Plan were formed. These further chipped away at the fishermen's once-independent lifestyles and freedom of the grounds. The amendments not only established minimum sizes for cod, haddock, pollock and flounders, but also increased the number of species to be regulated, limited the small-mesh whiting fishing area and placed restrictions on this fishery, banned trawlers from entering Area 2 during spawning season and finally, recommended shrimp gear modifications to reduce groundfish by-catches.

After this, many fishermen sensed troubled waters lay ahead, and some even decided to sell their boats while there was still some demand left in the industry. Several New Bedford scallop fishermen bought Gloucester draggers including the *Cape May*, *Joseph & Lucia II* and *Joseph & Lucia III*, and converted them to scalloping boats. A rash of Gloucester vessel sinkings, including many suspicious ones, also took place.

Up to Amendment 4, the National Marine Fisheries Service apparently tried to balance fish conservation and stock rebuilding while not hurting the fishing industry too much. But this balancing act didn't work, and the stocks tumbled even further, often exacerbated by some scofflaw fishermen who made big money by breaking the rules, especially by fishing in closed spawning areas. Enforcement was often a problem, too.

According to "History of the Groundfishing Industry of New England,"

> *Environmental groups sued the Federal Government, claiming that the Commerce Department didn't enforce its own rules mandating that overfishing of resources should not be allowed to occur. This set in motion sweeping new management plans intended not only to control fishing effort but also to rebuild groundfish stocks.*

Then Amendment 5 was born in 1994. According to the New England Fishery Management Council Northeast Multispecies Groundfish Fishery Management Plan Summary, this amendment "established a moratorium on new vessel permits during the rebuilding period; developed the "days-at-sea" (DAS) effort reduction program, established additional mesh size restrictions; developed interim gillnet regulations to reduce harbor porpoise by-catch; established a mandatory reporting system for landings and effort data; prohibited pair-trawling for groundfish; required

a finfish excluder device for the northern shrimp fishery; established minimum fish sizes appropriate to the increased mesh size; and expanded the size of the Area II closure." It also closed and kept closed most of Georges Bank's productive areas. "The main focus of Amendment 5 was Georges Bank," said Susan Murphy, fishery policy analyst of Groundfish Plan for the National Marine Fisheries Service. The message that the National Marine Fisheries Service got from the conservation groups and the public as a whole was to save the fish at all costs.

The grate requirement in the shrimp fishery was good for the entire industry. This allowed baby groundfish, especially flounders, to escape. Larger mesh in the groundfishery was also good. Millions of pounds of baby haddock and cod had previously been hauled up by groundfish boats and dumped back overboard dead.

Amendment 5 shocked and angered most fishermen and the fishing industry in general. The fishermen sensed that these new government regulations meant business, while others realized this Amendment would take away much of the profitability of operating large, high-overhead vessels.

Consequently, Amendment 5 drove much of the offshore fleet inshore, especially in the Gulf of Maine, where former Georges Bank 90-footers soon fished with 40-footers just off the coast. These regulations also forced vessels to make every day at sea count, and some to downsize their crews to just three or four men.

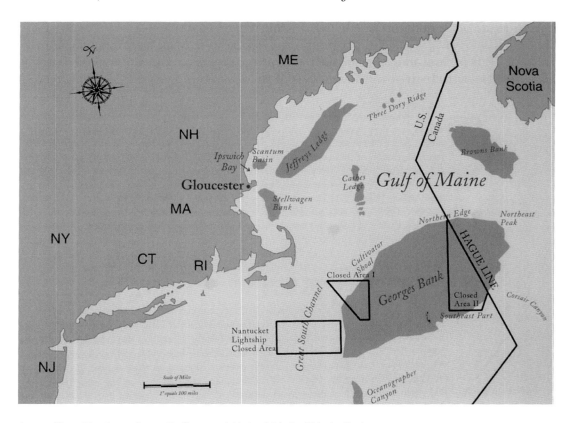

Areas affected by Amendment 5. *Courtesy of National Marine Fisheries Service.*

Shortly after Amendment 5, "I felt as though the Gloucester fishing community was coming apart at the seams and I had to do something," said Angela Sanfilippo, president of the Gloucester Fishermen's Wives Association (GFWA). After exhausting all political options to help the Gloucester fishing community, especially with health insurance coverage, she successfully pleaded her case with Cardinal Bernard Law, leader of the Boston Diocese. Soon the Massachusetts Fishermen's Partnership, consisting of eighteen Massachusetts fishery-related organizations, was formed in 1995, largely due to Angela's efforts. This partnership, in conjunction with Caritas Christi, the hospital network of the Catholic Charities of the Archdiocese of Boston, quickly made available an affordable Tufts HMO plan to the fishing community.

Amendment 5 was the final straw for some fishermen; they wanted out, yet who would buy their boats? Soon, the National Marine Fisheries Service, with their newly-established Fisheries Capacity Reduction Initiative (FCRI) gave them a way out, while returning much of their investments. This program's "goal was to take out the most fishing capacity for the amount of money we had," said Andrea Marcaurelle, loan specialist for NMFS Northeast Financial Services Office. Beginning with a $2 million pilot program, which bought out eleven vessels, the vessel buy-back program went into full swing by October 1996 with $23 million, which took out sixty-seven more East Coast vessels, including approximately thirteen Gloucester vessels along with their many fishing permits. Captain Donald Lowe's 87-foot-long stern trawler, *Anne Rowe*, was Gloucester's first fishing vessel to be purchased by this program. Ironically, many of these very vessels were funded under the NMFS's 1976 Fishing Vessel Obligation Guarantee Program. In 1998 the 87-foot-long and 97-foot-long stern trawlers, *Two Sons* and *St. George II*, respectively, were the last vessels to be sold to this program.

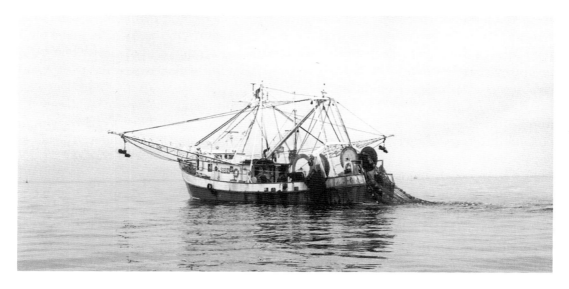

Here in Ipswich Bay during the mid-1990s, Rosario Maletti's 87-foot-long stern trawler, *Two Sons*, hauls back its fishing gear. The vessel was fishing for cod in the spring.

By the way, these bought-back vessels were either scrapped or sunk at sea if wooden, or transferred to a non-fishery use such as the Maritime Discovery Center in Rochester, New York, University of Minnesota in Minneapolis, Minnesota, or even to the Angolan Embassy in Angola, Africa. Ironically, several fishermen who sold their boats to the government later went on to purchase either larger or smaller vessels along with their permits. Brothers Peter and Captain Vincenzo "Enzo" Russo were two such fishermen who, after selling their 75-foot-long *Miss Trish* to the government, turned around and purchased Captain Leo Vitale's 97-foot-long steel stern trawler *Stella del Mare*. "The new *Miss Trish II* offers me much more flexibility than my old vessel; I can go offshore groundfishing, and I can go after the herring, too," said Enzo.

But the regulations only increased as Amendment 7 went into effect in July of 1996. This amendment "accelerated the days-at-sea effort reduction program; eliminated significant exemptions from the current effort control program; provided incentives to fish exclusively with mesh larger than the minimum regulated size; broadened area closures to protect juvenile and spawning fish; and increased the haddock possession limit to 1,000 pounds," according to the New England Fishery Management Council. Basically, "Amendment 7 sped up Amendment 5; the closed area focus this time was the Gulf of Maine. Plus frameworks were established; these are abbreviated Amendments, which can be done in six months rather than the one to three years for [regular] Amendments," added Susan Murphy.

Fishermen strongly felt that Amendment 5 was working, especially with its six-inch minimal mesh size, but that it just wasn't given enough time. They already saw signs of fish, especially haddock, coming back. Most of the fishermen never placed much credibility in the scientists' fish stock assessments, for their at-site catch observations often contradicted the scientists' sampling results. They couldn't understand the need for Amendment 7. Under Amendment 7 all size fishing vessels were now affected. Inshore boats, especially those in the Gulf of Maine, which didn't have the range to fish elsewhere, felt that they were being unfairly targeted by the NMFS because Amendment 5 drove the big boats inshore in the first place, and these were the ones that largely depleted the cod stocks.

To add insult to injury in the fishermen's minds, Framework Adjustments 20 and 24, added in 1997 and 1998 respectively, have further limited Gulf of Maine cod landings for vessels fishing north of 42 degrees 00' N latitude. And then along came Adjustment 25, another bombshell that went into effect May 1, 1998. "Fleet faces tough Gulf of Maine cod cutbacks. Council OK's Option 2: Rolling Closures, Trip Limit" read *Commercial Fisheries News*, February 1998 headlines describing this Framework. "The Gulf of Maine cod provisions adopted by the New England Fishery Management Council for Framework 25 are: one-month rolling closures (for various Gulf of Maine blocks); a year-round closure of the Jeffreys Ledge strip; and a 700-pound trip limit (subject to possible future change by the NMFS Regional Administrator's discretion). The goal of Framework 25 is to reduce the Gulf of Maine cod fishing effort by 60 percent," according to the *News* article.

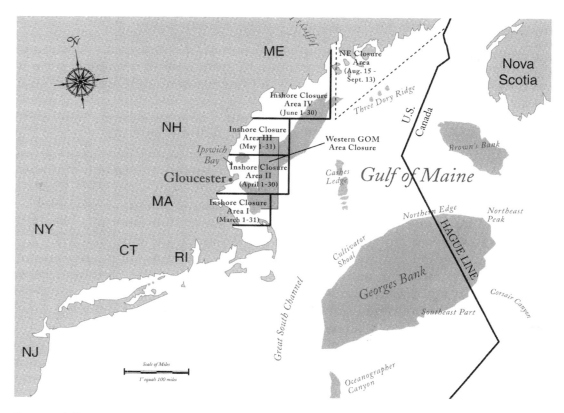

Framework 25.

Fishermen were infuriated and felt betrayed that NMFS used the fishermen's own landing records which were supposed to be kept confidential and used only for statistical purposes to determine which areas were the most productive and should be closed down. But the same laws allowed recreational fishermen and party charter boats to fish these areas during the rolling closures and catch spawning codfish. Anyone knows a party boat with forty to fifty people aboard catching four to five of the large fish apiece can land a lot of weight.

The NMFS's 1996 and 1997 total landings show this agency has apparently gotten closer to reaching its goal of reducing the groundfishing effort by 50 percent. During both of those years, herring accounted for nearly two-thirds of the total landings. Bluefin tuna landings significantly contributed to the total dollar values, too.

During a stormy day drive along the waterfront in 1997, I counted only about 53 draggers; 12 or so of these were 90-feet-long or greater, while approximately 24 draggers 40-to-60 feet long made up the bulk of the fleet. The rest were obviously medium-size draggers between 60 and 90 feet long. Many of these small draggers have survived the amendments by seasonally shrimping, groundfishing, scalloping, tuna fishing and lobstering. Several fishing vessels have switched to harvesting primitive jawless hagfish or slime eels (*Myxine glutinosa*) with traps made out of plastic barrels. The parasitic-scavenger hagfish are first packaged and frozen whole in

Gloucester and then exported to South Korea to be further processed for their meat and hides. Besides the fifty-three draggers, Gloucester still has well over fifty small and medium-sized long-liners and gill netters, as well as several large herring seiners and mid-water trawlers. The mid-water trawl fleet was just beginning to build up off of the northeast in the late 1990s.

Many of the fishermen then had enough of the government regulations, whose amendments are now up to nine. Consequently some have left fishing completely to start their own shore businesses or find employment elsewhere after being retrained by a Gloucester Fishermen Family Assistance Center program. Some two hundred fishermen and related industry workers have already gone through this wonderful free program.

Former boat owner and skipper Rosario Maletti, fed up with the regulations, sold his 87-foot dragger *Two Sons* to the federal government's boat buyback program, and he and wife Marie purchased a dry cleaning business in Gloucester. The surviving fishermen are making the best out of a bad situation and often get up mornings not knowing whether to go out fishing or to attend another government hearing. Their angers have abated somewhat, and they also know the government means business with its enforcement. Fisheries violations have resulted in huge fines, permit sanctions and even business closures.

But, during this gloom and doom stock rebuilding time, there are some bright spots on the waterfront and at sea. The December 1, 1997, opening of the Ciulla family's $2.5 million Gloucester Seafood Display Auction has added hope to the Gloucester fishing industry. The auction, sales of which include groundfish, farm-raised salmon, bluefin tuna, swordfish, and northern shrimp, has already attracted Massachusetts, Maine, Point Judith and Narragansett, Rhode Island, gillnetters, longliners, and draggers, and, most noticeably, big Rhode Island stern trawlers, including *Jason & Danielle*, *Bulldog*, and *Lightning Bay* into the port of Gloucester. "We love Gloucester, they [waterfront owners and workers] treat us well, and the auction gives us good prices and, most important, honest weights for our fish," said a crewman on the *Jason & Danielle*. Most of the Gloucester fishermen and their industry have long wanted a Gloucester auction to set Gloucester prices. A dragger fleet from Maine also lands their catches, including lobsters, in Gloucester. Maine allows only lobsters caught in traps to be landed in that state. The auction went electronic in 2006, and dealers can now go online and bid on fish during the daily auctions from at home or at their businesses.

Another bright light has been the refurbishing of the Jodrey State Fish Pier and the construction of a six-stalled multi-tenant building there. Financed by the Cape Ann Fisheries Development Corporation made up of the Massachusetts Development Finance Agency and the Archdiocese of Boston, this $5 million project is designed to provide modern processing facilities for the small seafood businessman and also to keep the fishing industry alive and growing. Cape Seafoods, Inc., Western Sea Fishing Company and Swan Net East Coast—all companies involved with herring and mackerel fishing, have already taken the stalls in 2001. Western Sea Fishing Company bases its large mid-water trawlers *Challenger*, *Endeavour* and *Voyager* here. Another herring/mackerel fisherman, Peter Mullen, bases his operation out of Gloucester. Mullen not only owns a wharf here, but also the purse seiner *Western Wave* and

This facility, the Gloucester Seafood Display Auction, has added new life to the Gloucester waterfront.

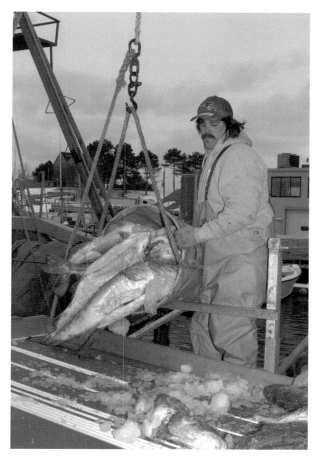

Gloucester fisherman Randy Beal helps unload large cod at the Gloucester Seafood Display Auction.

The *Princess Laura*, Gloucester's last new stern trawler addition to the groundfish fleet.

mid-water trawlers *Osprey*, *Westward*, and his latest addition, *Western Venture*—a brand new 164-foot-long combination mid-water trawler and purse seiner that just arrived on February 12, 2007.

The Gloucester herring and mackerel fishery helped push Gloucester's annual landings to approximately one hundred and twenty-four million pounds in 2005 and gave it the distinction of being the tenth-leading U.S. port then for landings.

Captain Bill Muniz's 44-foot Novi-style fiberglass gill netter *Lady Shannon*, was added to the small boat fleet in 1998. Captain Joe DiMaio had the 99-foot *Princess Laura* built in 2003. It was the last new vessel of a shrinking groundfish fleet.

Lastly, the signs of fish coming back are being seen by fishermen everywhere: "All of my old territory, Jeffreys Ledge, First Edge, and Middle Bank was full of fish, mostly market and large cod and a few haddock, this winter and spring. Lately, fishing has often meant filling our cod and haddock quotas with just one set and then steaming elsewhere for more fish," said Captain Vincenzo Russo. Also, "I've seen more fish—cod and haddock—this winter and spring. The guys who are going jigging and long lining, dragging and gill netting are all seeing a lot more fish inshore and offshore," said Mark Carroll, the ambitious young fishing captain and owner of the *Harvest Moon*. He continued, "With these regulations everybody has less days to fish, and they're using bigger gear, and there are a lot less boats out there. Now there's a whole cake [of fish] out there to be had."

The optimism proved premature. Since the first printing of "White-Tipped Orange Masts" in 1998 and just when groundfishermen thought the regulations

couldn't get much worse, they have. In 2007, the Northeast Multi-species Fisheries Management Plan is now up to Amendment 13 and Framework Adjustment 42. The plan has carved up the traditional fishing grounds off of the northeast into permanently and temporarily closed, special access, and Gulf of Maine differential days-at-sea and southern New England differential days-at-sea areas. Fishermen often find themselves bunched up in the remaining open areas.

The regulations have divided the fishermen's yearly days-at-sea allotments into A and B days and have since reduced the number of A days. The A days can be used to catch all of the fish species, while the B days are supposed to be used to harvest only healthy stocks like haddock and pollock. The B days also require the use of selective gear like separator trawls or longlines in special access areas. As of November 2006, every A day fished in the differential days-at-sea areas is counted as two days.

Groundfish vessels are now required to be equipped with vessel monitoring systems (VMS) so their whereabouts at sea can be tracked at all times. Fishing in a closed area can result in huge fines for the captain and vessel owner.

The rules have also closed down the directed dogfishery. Huge numbers of these small sharks, even the mature females, frequently plague the fishing grounds and the fishermen. The dogfish often drive away targeted species, clog and damage gear and eat catches, especially those snagged in gillnets and on longlines. As of 2006, draggers had hauled aboard 50,000-pound-sets of the dogfish after towing their nets just thirteen minutes on the bottom.

As of May 1, 2007, groundfish vessels in the Northeast will only be able to land three hundred pounds of whole monkfish a day. Monkfish have been a mainstay for much of the fleet. This low daily quota will result in even more discards. Low daily quotas for most of the stocks that need rebuilding, like cod and yellowtail flounder, force the fishermen to dump the excess. Many of the fish never make it back to the bottom alive and have benefited no one. The regulations over the years have resulted in millions of pounds of discards that have rotted on the bottom.

The rules have also pitted port against port, and fishermen against fishermen and increased the fishing industry's dislike and distrust for the National Marine Fisheries Service, the governmental agency in charge of rebuilding and protecting over twenty-five fish stocks. The industry believes the rules have been too strong and are bringing it to its death. The environmental groups feel the opposite, and NMFS finds itself in the middle, having to follow the Magnuson–Stevens Conservation and Fishery Management Act to the letter of the law. The NMFS still believes there is too much fishing pressure to sustain the groundfish stocks.

A new fishing industry advocacy group based in Gloucester, The Northeast Seafood Coalition (NSC), came to bat in 2002 for approximately three hundred fishing industry interests from Maine to Long Island. Its dedicated staff—Jackie Odell, Executive Director, Chris Sherman, Treasurer, and Vito Giacalone, a fisherman and chairman of governmental affairs—have added common sense to the groundfish regulatory process, even though their proposals sometimes get picked apart and altered before and after being implemented. The NSC was the author of Amendment 13 A & B days at sea proposal that was finally accepted by the NMFS

and put into place in 2004. NSC has already come up with what I believe is a fairer and more effective management alternative to Amendment 13's A&B days at sea program—The Point System—that could become the backbone of Amendment 16, scheduled to go into action in 2009.

Some Gloucester groundfishermen have had enough and they have sold their boats and permits. They also believe the industry is done, especially after—regardless of all of the existing closures and industry opposition—the state and federal governments let two liquefied natural gas companies come right in and take over about a mile of prime fishing ground off of Gloucester near Stellwagen Bank—a marine sanctuary of all places—to set up offshore terminals. Massachusetts Governor Mitt Romney, who had the final say in this project, gave the gas companies the green light in December of 2006. In the fishermen's minds, the recent actions of the energy companies and the government not only illustrate who controls this country, but also what a low priority the fishing industry is compared to the energy industry.

I did a quick survey of the Gloucester groundfish fleet during one stormy week in 2005. The fleet totaled approximately 105 vessels, including around 52 gillnetters and longliners and 53 draggers. The dragger fleet consisted of 37 small vessels (36- to 60-feet long), 12 medium vessels (65- to 84 feet long) and 4 vessels over 90 feet long. The gillnetters and longliners were all small vessels. Since then, one gillnetter and one longliner have been sold, with one gillnetter replacement, while four small, two medium and one large dragger have either sunk or been sold and not replaced. The medium dragger took on a new career as a banana carrier in the Caribbean, and the large dragger went to New Bedford and became a scalloper there. Whatever the case, the trend is definitely downward.

Some Gloucester groundfishermen still have hope in the industry. They are determined to stick around, keep adapting to new rules and reap the benefits of all of these years of sacrifice. These men have survived so far by participating in joint research projects, investing in separator trawls and longline systems, and by purchasing additional fishing permits or leasing days at sea. They are the best of the best and they know how and when to get the biggest return for every day at sea used. These fishermen also hope additional energy companies won't take over more of their traditional fishing grounds, especially on Georges Bank.

Sure, the fish will come back. But these very important questions will have to be dealt with soon. Will a few individuals and groups eventually own the ocean's once-common property resources? How much of the fishing "know-how" carried on for generations within families has been lost so far? Once fish have come back, will the markets still be out there? Will processors be able to handle the increased amounts of landed fish? Who will be left to harvest the fish? What young fellow can afford to get into a fishery, especially if he has to buy not only a boat and fishing gear, but also expensive permits which can cost tens of thousands and even hundreds of thousands of dollars? Lastly, will the waterfront real estate long held by the fishing industry be gobbled up by the marina and housing markets and be lost forever? "Our future is up to the government. They can make us work, or they can take us out of business," said Captain Russo.

The message on this tee shirt worn by vessel owner/operator Joe DiMaio symbolizes the status that many fishermen feel they fall under due to the increasing fishing regulations. While some, like DiMaio, are surviving, other fishermen have been driven out of the business or placed on the brink of extinction.

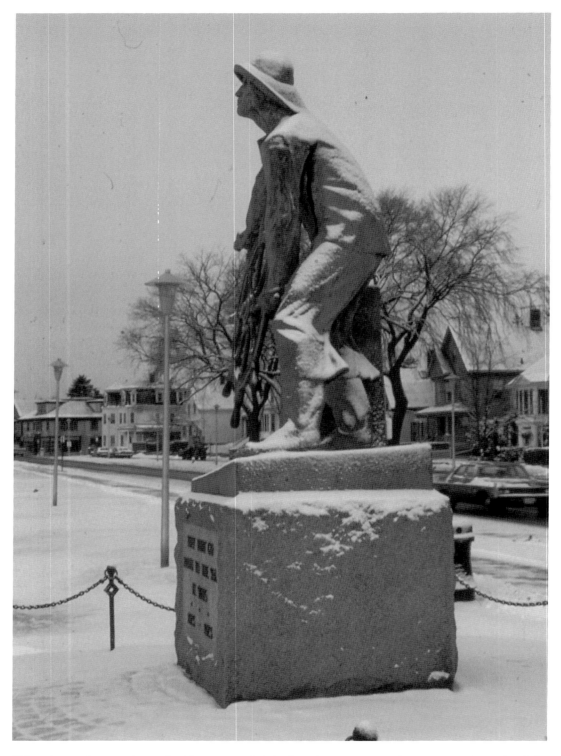

"They that go down to the sea in ships, occupy their business in great waters; these men see the works of the Lord, and his wonders in the deep" Book of Common Prayer.

In Memoriam
Gloucester Fishermen
and Vessels Lost at Sea,
1940–2006

Isincerely hope no person or vessel was omitted. The Fishermen's Memorial Cenotaph was dedicated on September 3, 2000. This memorial, located on the seaward side of the Man at the Wheel memorial along Stacey Boulevard, bears the names of 5,368 Gloucester fishermen who died at sea between 1716 and 1999.

1940
Michaelangelo Dimino
Lawrence Doucette
Baltazar Fernandes

1941
Samuel Cotreau
John Erickson
Andrew Faye
Joseph Roberts
John Sheehan
Edgar Vino

1942
Patrick J. O'Brien
Everett W. Staten
Manuel Viator
Captain Herbert Wennerborg

1943
Anthony Ciulla
Theodore Wolf

1944
Vita Asaro
Thomas W. Best
Arthur J. DeCoste
Captain John Orlando
Vincent Orlando

1945
Manuel DeAlmeida
Manuel Janardo
Virgil O'Brien
Antonio Rao
Frank Roderick

1946
Dennis Amero
James Currea
Jerome Liaicamo

1947
Edward W. Ernest
Abott V. Place
Thomas Rossiter

1948
Robert E. Cavanaugh

1949
Edgar W. Decker
George E. Gordon
George Hemeon
August Miguel
Percy Noble
Oke Peterson
Heinrich Schluter

1951
James J. Cavanaugh
W. Frank Cavanaugh
Arthur Davis
August E. Hill
Wilfred J. Mello
Harry W. O'Connell Jr.
Alphonse Sutherland
William H. Tarvis
Daniel Williams

1953
Albert K. Arnold
John R. Powers

1956
Patrick J. Hackett

1958
Salvatore Carollo
Arthur Kelsey
Edward Lane
Howard Lane
M. Tamarindo
Michael Marino

1960
Captain Francis J. Foote

1961
John W. Wagner

1962
Charles Mason
Joseph Parisi Jr.

1963
Ezra Hill
Joseph Muise
Eugene Naves
Captain Alvino Pereira Jr.
Henry Pina

1967
Frank Militello

1970
Jose Pinho Vinagre

1971
Robert Saunders

1975
Edward Gleason Jr.

1977
Leroy Amero
Forrest Dare

1978
John Burnham
Salvatore Grover
Glenn Guitarr
Benjamin Interrante
Captain Cosmo Marcantonio
Vito Misuraca
Jerome Pallazola
Captain Carlo Sinagra
James Sinagra

1979
Douglas Barry

1982
Bruce Fulford

1991
Robert Shatford
David Sullivan
Captain William Tyne

1994
Captain Nicholas Curcuru
Manuel Carrapichosa
Peter Govincosa
Salvatore Curcuru

1999
Anthony J. Militello

2000
Omar Inglesios

2001
Thomas W. Frontiero
James Sanfilippo

GLOUCESTER VESSELS LOST AT SEA
1945–1995

Mary E. O'Hara
Austin W.
Saint Anne
Sea Breeze
Inca
Capt. Cosmo
St. Christopher

Alligator
Gundrun
Andrea Gail
Agnes & Mernie
Italian Gold
St. Stephen

APPENDIX

THE 1980 TOTAL LANDINGS AND DOLLAR VALUES

SPECIES	LANDINGS	VALUE	$/LB.
ALEWIFE	0	0	$0.00
ANGLER	683,426	382,920	$0.56
BASS, STRIPED	65	40	$0.62
BLUEFISH	54,057	7,030	$0.13
BUTTERFISH	33,229	12,748	$0.38
COD	23,128,533	7,376,770	$0.32
CRAB, JONAH	0	0	$0.00
CRAB, RED	0	0	$0.00
CUSK	1,504,179	375,091	$0.25
DOGFISH (NK)	37,995	2,860	$0.08
DOGFISH SPINY	3,727,460	288,539	$0.08
FLOUNDER, AM. PLAICE	8,597,590	3,215,443	$0.37
FLOUNDER, SAND-DAB	3,255	841	$0.26
FLOUNDER, SUMMER	3,675	1,299	$0.35
FLOUNDER, WINTER	897,273	354,893	$0.40
FLOUNDER, WITCH	1,475,556	905,258	$0.61
FLOUNDER, YELLOWTAIL	2,974,137	1,193,625	$0.40
FLOUNDERS (NK)	5,523	1,320	$0.24
HADDOCK	15,770,913	7,317,735	$0.46
HAKE, RED	1,267,718	193,022	$0.15
HAKE, SILVER	8,214,428	1,356,539	$0.17
HAKE, WHITE	1,804,061	477,055	$0.26
HALIBUT, ATLANTIC	72,026	100,940	$1.40
HERRING, ATLANTIC	63,481,616	3,560,002	$0.06
LOBSTER	105,693	285,405	$2.70
MACKEREL, ATLANTIC	1,720,889	131,389	$0.08

SPECIES	LANDINGS	VALUE	$/LB.
MENHADEN	43,350,980	952,888	$0.02
OTHER FISH	1,189,278	334,773	$0.28
PERCH, WHITE	0	0	$0.00
POLLOCK	12,315,242	2,624,300	$0.21
POUT, OCEAN	140	11	$0.08
REDFISH	6,636,839	1,484,080	$0.22
SALMON, ATLANTIC	9	23	$2.56
SCALLOP, SEA	550,317	2,019,376	$3.67
SCUP	225	48	$0.21
SEA BASS, BLACK	845	558	$0.66
SEA ROBINS	15	2	$0.13
SHAD, AMERICAN	6,518	1,151	$0.18
SHARK, (NK)	2,387	1,035	$0.43
SHRIMP (PANDALID)	563,968	344,349	$0.61
SKATES	108,999	16,504	$0.15
SQUID (ILLEX)	558,434	52,804	$0.09
SQUID (LOLIGO)	36,012	34,262	$0.95
SQUIDS (NS)	4,690	343	$0.07
STURGEONS	823	234	$0.28
SWORDFISH	0	0	$0.00
TAUTOG	110	55	$0.50
TILEFISH	65	37	$0.57
TUNA, BLUEFIN	573,023	1,019,367	$1.78
WOLFFISHES	726,972	124,734	$0.17
GRAND TOTAL	202,189,188	36,551,698	

Source: NMFS CFDBS database—Courtesy of National Marine Fisheries Service

APPENDIX

THE 1996 AND 1997 TOTAL LANDINGS AND DOLLAR VALUES

SPECIES	1996			1997		
	LANDINGS	VALUE	$/LB.	LANDINGS	VALUE	$/LB.
ANGLER	1,920,467	$1,810,196	$0.94	950,339	$1,050,339	$1.11
BASS, STRIPED	0	0	$0.00	0	0	$0.00
BLUEFISH	82,856	17,841	$0.22	146,375	30,558	$0.21
BUTTERFISH	2,981	851	$0.29	6,320	2,117	$0.33
CATFISH	0	0	$0.00	0	0	$0.00
CLAM (NK)	0	0	$0.00	0	0	$0.00
CLAM SURF, ARCTIC	0	0	$0.00	0	0	$0.00
CLAM, RAZOR	0	0	$0.00	0	0	$0.00
CLAM, SOFT	0	0	$0.00	0	0	$0.00
COD	5,731,478	5,678,528	$0.99	5,114,952	5,139,874	$1.00
CONCHS	21	10	$0.48	203	110	$0.54
CRAB, JONAH	52,132	25,963	$0.50	3,924	2,025	$0.52
CRAB (NK)	140	70	$0.50	1,065	1,922	$1.80
CUSK	259,282	167,637	$0.65	159,010	99,892	$0.63
DOGFISH SPINY	3,721,999	588,133	$0.16	6,224,588	819,563	$0.13
DOLPHIN FISH	0	0	$0.00	32	56	$1.75
EEL, AMERICAN	0	0	$0.00	0	0	$0.00
EEL, CONGER	0	0	$0.00	105	10	$0.10
FLOUNDER, AM. PLAIC	1,349,723	1,567,291	$1.16	975,816	1,200,254	$1.23
FLOUNDER, FOURSPOT	0	0	$0.00	0	0	$0.00
FLOUNDER, SAND DAB	6,908	2,402	$0.35	4,852	1,981	$0.41
FLOUNDER, SUMMER	3	6	$2.00	171	164	$0.96
FLOUNDER, WINTER	394,248	484,697	$1.23	387,175	534,424	$1.38
FLOUNDER, WITCH	522,514	971,053	$1.86	396,971	737,078	$1.86
FLOUNDER, YLWTAIL	685,451	935,369	$1.36	613,934	834,290	$1.36
FLOUNDERS (NK)	13,105	13,934	$1.06	12,837	14,957	$1.17
HADDOCK	305,033	394,220	$1.29	686,477	830,003	$1.21
HAGFISH	3,415,106	945,327	$0.28	2,745,943	755,209	$0.28
HAKE, RED	697,231	160,633	$0.23	367,229	100,977	$0.27
HAKE, SILVER	1,916,433	587,404	$0.31	1,775,179	743,362	$0.42
HAKE, WHITE	1,102,536	823,939	$0.75	606,070	504,711	$0.83
HALIBUT, ATLANTIC	4,025	12,613	$3.13	991	2,736	$2.76
HALIBUT, GREENLAND	0	0	$0.00	0	0	$0.00
HERRING, ATLANTIC	47,766,250	2,209,994	$0.05	53,085,769	2,651,534	$0.05
JOHN DORY	0	0	$0.00	0	0	$0.00

Appendix

Species	Landings	Value	$/lb.	Landings	Value	$/lb.
Lobster	302,853	1,413,063	$4.67	114,398	505,024	$4.41
Lumpfish	0	0	$0.00	0	0	$0.00
Mackerel, Atlantic	319,825	71,668	$0.22	328,803	112,108	$0.34
Menhaden	0	0	$0.00	0	0	$0.00
Mussels	0	0	$0.00	0	0	$0.00
Other Fish	38,009	27,748	$0.73	7,306	2,404	$0.33
Pollock	1,552,527	1,133,330	$0.73	2,314,912	1,389,857	$0.60
Pout, Ocean	6,111	1,373	$0.22	102	12	$0.12
Redfish	166,457	84,351	$0.51	131,124	66,204	$0.50
Scallop, Bay	1,243	1,244	$1.00	0	0	$0.00
Scallop, Sea	20,161	103,720	$5.14	93,823	471,841	$5.03
Sculpins	5	2	$0.40	23	17	$0.74
Scup	325	147	$0.45	2,085	1,574	$0.75
Sea Bass, Black	0	0	$0.00	0	0	$0.00
Sea Robins	0	0	$0.00	0	0	$0.00
Sea Urchins	79,864	51,908	$0.65	323,107	268,619	$0.83
Shad, American	0	0	$0.00	592	167	$0.28
Shark, Mako	0	0	$0.00	180	336	$1.87
Shark, Mako Shrtfn	0	0	$0.00	0	0	$0.00
Shark (Nk)	5,432	4,440	$0.82	27,266	26,848	$0.98
Shark, Porbeagle	1,040	875	$0.84	817	728	$0.89
Shark, Thresher	165	115	$0.70	418	209	$0.50
Shrimp (Pandalid)	879,107	586,973	$0.67	378,275	291,228	$0.77
Skates	116,024	54,060	$0.47	85,522	27,606	$0.32
Squid (Illex)	0	0	$0.00	1,000	500	$0.50
Squid (Loligo)	625	162	$0.26	5,314	2,526	$0.48
Squids (Ns)	7,061	2,641	$0.37	10,979	4,676	$0.43
Sturgeons	0	0	$0.00	0	0	$0.00
Swordfish	5,782	31,080	$5.38	22	66	$3.00
Tautog	278	166	$0.60	43	35	$0.81
Tilefish	15	7	$0.47	78	76	$0.97
Tuna (Nk)	0	0	$0.00	3,169	6,813	$2.15
Tuna, Albacore	435	543	$1.25	140	70	$0.50
Tuna, Big Eye	550	1,650	$3.00	0	0	$0.00
Tuna, Bluefin	303,258	3,269,189	$10.78	35	70	$2.00
Tuna, Yellowfin	6,248	15,060	$2.41	28	56	$2.00
Weakfish, Squteagu	0	0	$0.00	0	0	$0.00
Whiting, Black	0	0	$0.00	0	0	$0.00

SPECIES	LANDINGS	VALUE	$/LB.	LANDINGS	VALUE	$/LB.
WHITING, KING	0	0	$0.00	0	0	$0.00
WOLFFISHES	139,265	68,486	$0.49	106,677	54,099	$0.51
GRAND TOTAL	73,902,587	24,322,112		78,202,565	19,291,915	

Courtesy of National Marine Fisheries Service

1965, 1970 AND 1975 FISH LANDINGS AND DOLLAR VALUES

SPECIES	1965			1970			1975		
	LANDINGS	VALUE	$/LB.	LANDINGS	VALUE	$/LB.	LANDINGS	VALUE	$/LB.
ALEWIFE	6,332,200	71,252	$0.01	1,056,320	13,732	$0.01	1,649,120	21,897	$0.01
ANGLER	6,825	220	$0.03	5,090	211	$0.04	449,661	93,003	$0.21
BASS, STRIPED	2,220	340	$0.15	14,554	5,045	$0.35	5,331	2,465	$0.46
BLUEFISH	100	7	$0.07	165	25	$0.15	31,053	5,602	$0.18
BUTTERFISH	10,775	1,411	$0.13	16,580	2,396	$0.14	505	127	$0.25
COD	5,707,269	519,136	$0.09	10,564,014	1,372,994	$0.13	12,148,377	3,193,447	$0.26
CRAB, JONAH	0	0	$0.00	0	0	$0.00	1,779	526	$0.30
CRAB, RED	0	0	$0.00	0	0	$0.00	44,280	13,223	$0.30
CUSK	593,865	34,569	$0.06	531,006	42,227	$0.08	1,267,020	206,304	$0.16
DOGFISH (NK)	190	9	$0.05	4,354	157	$0.04	3,005	370	$0.12
DOGFISH, SPINY	0	0	$0.00	0	0	$0.00	0	0	$0.00
FLOUNDER, AM. PLAICE	1,927,720	119,737	$0.06	1,482,682	187,631	$0.13	2,117,815	480,944	$0.23
FLOUNDER, SAND DAB	0	0	$0.00	0	0	$0.00	0	0	$0.00
FLOUNDER, SUMMER	1,297,577	131,780	$0.10	275	33	$0.12	3,006	1,377	$0.46
FLOUNDER, WINTER	480,523	36,886	$0.08	274,349	40,773	$0.15	382,792	112,416	$0.29
FLOUNDER, WITCH	24,940	2,537	$0.10	2,219,623	342,280	$0.15	893,392	434,691	$0.49
FLOUNDER, YELLOWTAIL	411,377	25,458	$0.06	546,181	63,896	$0.12	1,041,726	352,010	$0.34
FLOUNDERS (NK)	0	0	$0.00	0	0	$0.00	0	0	$0.00
HADDOCK	24,373,550	2,772,225	$0.11	5,402,218	1,468,915	$0.27	3,723,695	1,357,101	$0.36
HAKE, RED	122,405	3,765	$0.03	229,125	9,727	$0.04	574,084	36,664	$0.06
HAKE, SILVER	36,705,272	1,064,077	$0.03	19,718,209	1,668,794	$0.08	22,877,167	1,788,627	$0.08
HAKE, WHITE	781,505	72,750	$0.09	1,390,485	119,315	$0.09	1,614,050	259,202	$0.16

SPECIES	LANDINGS	VALUE	$/LB.	LANDINGS	VALUE	$/LB.	LANDINGS	VALUE	$/LB.
HALIBUT, ATLANTIC	83,859	30,769	$0.37	58,185	35,265	$0.61	32,370	32,554	$1.01
HERRING, ATLANTIC	54,930	580	$0.01	23,101,214	367,922	$0.02	28,237,909	836,667	$0.03
LOBSTER	51,820	26,348	$0.51	207,990	187,522	$0.90	221,708	375,642	$1.69
MACKEREL, ATLANTIC	253,358	22,227	$0.09	2,476,938	83,811	$0.03	642,930	45,136	$0.07
MENHADEN	0	0	$0.00	862,375	11,202	$0.01	20,325,583	267,123	$0.01
OTHER FISH	15,419,375	566,373	$0.04	5,137,680	528,802	$0.10	3,828,601	1,063,596	$0.28
PERCH, WHITE	0	0	$0.00	970	43	$0.04	700	49	$0.07
POLLOCK	3,477,609	222,669	$0.06	2,925,289	249,260	$0.09	6,178,977	824,840	$0.13
POUT, OCEAN	0	0	$0.00	0	0	$0.00	300	84	$0.28
REDFISH	22,486,597	976,551	$0.04	7,467,393	378,481	$0.05	8,144,500	920,921	$0.11
SALMON, ATLANTIC	0	0	$0.00	11	10	$0.91	0	0	$0.00
SCALLOP, SEA	475,055	326,403	$0.69	0	0	$0.00	0	0	$0.00
SCUP	0	0	$0.00	5	1	$0.20	25	4	$0.16
SEA BASS, BLACK	0	0	$0.00	0	0	$0.00	0	0	$0.00
SEA ROBINS	0	0	$0.00	0	0	$0.00	0	0	$0.00
SHAD, AMERICAN	5,735	264	$0.05	900	51	$0.06	1,080	90	$0.08
SHARK (NK)	0	0	$0.00	1,725	88	$0.05	0	0	$0.00
SHRIMP (PANDALID)	17,685	2,249	$0.13	6,383,940	1,164,393	$0.18	4,585,383	1,107,288	$0.24
SKATES	57,520	2,295	$0.04	78,863	3,555	$0.05	136,544	11,333	$0.08
SQUID (ILLEX)	0	0	$0.00	0	0	$0.00	0	0	$0.00
SQUID (LOLIGO)	0	0	$0.00	0	0	$0.00	0	0	$0.00
SQUID (NS)	44,365	1,650	$0.04	18,185	752	$0.04	78,305	6,093	$0.08
STURGEONS	235	31	$0.13	495	69	$0.14	586	131	$0.22
SWORDFISH	0	0	$0.00	5,000	2,750	$0.55	248,771	388,898	$1.56
TAUTOG	0	0	$0.00	177	13	$0.07	1,005	345	$0.34
TILEFISH	5,610	169	$0.03	15,600	1,899	$0.12	9,245	2,126	$0.23
TUNA, BLUEFIN	0	0	$0.00	0	0	$0.00	443,162	242,697	$0.55
WOLFFISHES	139,803	7,638	$0.05	135,525	8,132	$0.06	194,333	18,364	$0.09
GRAND TOTAL	121,351,869	7,042,375		92,333,790	8,362,172		122,139,875	14,503,977	

Courtesy of National Marine Fisheries Services

BIBLIOGRAPHY

Commercial Fisheries News, P.O. Box 37, Stonington, Maine 04681

Fisheries Management for Fishermen: A Manual for Helping Fishermen Understand the Federal Management Process, by Richard K. Wallace, William Hosking and Stephen T. Szedlmayer Auburn University Marine Extension and Research Center—Sea Grant Extension, Mobile, AL

Fishes of the Gulf of Maine, by Henry B. Bigelow and William C. Schroeder, United States Government Printing Office, Washington, D.C. 1953

Gloucester Daily Times, Whittemore St., Gloucester, Massachusetts 01930

Gloucester Fishermen's Wives Association: Protecting & Promoting the Gloucester and New England Fishing Industry, by the Gloucester Fishermen's Wives Association, 11-15 Parker St. Gloucester, Massachusetts 01930

Managing Uncertainty: Family, Religion and Collective Action Among Fishermen's Wives in Gloucester, Massachusetts, by Margaret Elwyn Clark, published in Social and Economic Papers No. 18, Institute of Social and Economic Research, Memorial University of Newfoundland, St. John's, Newfoundland, Canada, 1988

National Fisherman, 121 Free Street, P.O. Box 7438, Portland, Maine 04112-7438

Saint Peter Fiesta: 56th Year, St. Peter Fiesta Committee, 1983

U.S. Government Guaranteed Fishing vessel Financing Notes, U.S. Dept. of Commerce, National Marine Fisheries Service, 100 East Ohio St., Chicago, Illinois 60611

INDEX

Visit us at
www.historypress.net